# THE TASTEMAKERS

# THE TASTEMAKERS

## U.K. art now

ROSIE MILLARD

photographs by Geraint Lewis

artwork by Adam Dant

Thames & Hudson

Frontispiece: Art as event. Bloomberg's party for artists in the Turbine Hall, Tate Modern.

To Charlie Boydell, journalist and friend,
who showed me how to interview

**Author's Acknowledgments**

Thanks are due to a lot of people, not least all my interviewees. Also to Robert Hughes for giving me the idea, Erica Bolton and Jane Quinn, efficient as ever, and David Claridge, for finding me somewhere to work. Thanks too to Jamie Donald and art historians Barbara Todd, Ralph Willett and John Bernasconi. To my parents John and Rosemary, and Evelyn, Richard and Mary for encouragement and cheerful childcare, and to Phoebe and Gabriel for continuing to be so fat and friendly. To Adam Dant, the only artist capable of such drawings, and Geraint Lewis, for a portfolio of astonishing photographs. Amanda White, my agent and friend, has nurtured the whole thing for far longer than she ought, and deserves more than gratitude. Above all, I would like to thank my dear husband Pip who supports, listens, and encourages me every day.

**Photographer's Acknowledgments**

I would like to thank Jeremy Spencer, Fred Cook, Morris Newcombe, and everybody who has helped me over the years. Also thanks to Ann, John, Joanne, James, Olive, Maurice and especially Mel. I dedicate this work to my parents Mair Eluned Lewis and Melvyn Lewis and my daughter Mila. Also thank you to Chas Keeble of The Bert Hardy Darkroom for printing the pictures.

First published in the United Kingdom in 2001 by Thames & Hudson Ltd, 181A High Holborn, London WC1V 7QX

British Library Cataloguing-in-Publication Data
A catalogue record for this book is available from the British Library

ISBN 0-500-51060-1

Printed and bound in Slovenia

# contents

# INTRODUCTION

OK, let's see if it works.

Man, walking along road.

'Excuse me. Can you name a living British artist?'

Pause.

Man, suddenly: 'Alright. Tracey Emin. Er... Hirst. Damien. Damien Hirst. Those are the first two that spring immediately to mind. Alright?'

Two women, one pushing a buggy.

'Hello. Can you name a living artist?'

Woman One: 'Tracey Emin.'

Woman Two, in shrill voice: 'I was going to say Tracey Emin! You can't say her. Erm...'

Pause. Then, triumphantly: 'Damien Hirst. Ta-dah!'

Couple carrying shopping.

Woman: 'Tracey Ermine.'

Man: 'Oh. Oh no! Not her! Ha ha ha. Hum. A living artist. David Hockney.'

Cosy-looking couple with baby in sling.

Man: 'Oh, I know. The horrible one with sheep in formaldehyde.'

Woman: 'Is Salvador Dalí still alive?'

Man (witheringly): 'No. He is dead. Totally dead. Is Max Ernst still alive? What is that other guy's name?'

Another man joins us.

Other man: 'An artist? How about the chap who cuts cows in half? Damien Hirst.'

First man: 'Hirst! That's it!'

Other man (continuing on): 'I'm not sure if I regard him as an artist or not. Ha ha ha.'

It's a warm April evening for the opening of White Cube[2] in Hoxton Square, East London. What was a light-industrial factory from the early twentieth century has been converted by Mike Rundell and Associates into a light-industrial factory for the early twenty-first century. The unremittingly white space inside is entirely top-lit, thanks to a roof that filters light from the north through translucent panels. The formal pediments and pilasters on the front remain, but the round analogue clock (old time) has been replaced by a digital one (new time). The overall effect is of an elegant and unrepentant salute to the great new British product – Culture.

For the opening, the guest list is closely guarded, the press presence is high; there are paparazzi and television crews loitering and PR people roaming about with clipboards. Bastions of culture both high and popular – Bob Geldof, Neil Tennant, Alan Yentob – lend explicit approval by turning up. It is fashionable and sophisticated. This is what Cutting Edge Culture looks like these days.

It's a contemporary art event, but not in the old-fashioned sense of creative people turning up and doing mad things in damp-ridden basements with sealing tape or revolvers. This is the new style of contemporary art event, where the avant-garde mingle with High Society. It will be referred to in both the highbrow art magazines and the high-profile glossies. It has one foot in *Frieze* and the other in 'Jennifer's Diary'. The day Charles Saatchi's favoured dealer opened in the East End was the confirming moment that the hearty, wealthy backslap of established art and the nervy invention of 'alternative' art were as one.

I am wandering about with a camera crew attempting to interview people about the desirability of contemporary British art (this is a press launch and therefore such things are expected). Various luminaries long accustomed to

instantaneous commentary are standing about drinking champagne. Tonight, however, they don't seem to be in the mood. Perhaps they feel nervous about giving cheesy comments and drinking champagne in the middle of the East End. So I turn to the pair of 'living sculptures', artists Gilbert and George. They are particularly friendly this evening, possibly because they have just left their stuffy Cork Street gallery for the extremely unstuffy White Cube. They are only too pleased to help with my question.

'It's fantastic,' they say. 'We live around here. When we first moved in, you couldn't walk from our house to Oxford Street and find one person who knew the name of a living artist. Not one. Now it's all different. If you ask anyone about the name of a living artist, they will give you at least one.' They stand before me, resplendent in matching houndstooth.

Anyway, this is a commercial as well as conceptual business. Are they pleased with their new gallery? 'Indeed. It's just what we wanted.' Of course it is. To be a successful artist in Britain at the beginning of the twenty-first century – that is to say, someone who is not painting unironic landscapes or portraits of dogs – is to have hit the career jackpot. To have signed to the hottest gallery with the most fashionable space, the best clients and the most column inches in the papers is to have won on Rollover week.

On my way out I bump into the writer Will Self. He surveys the heaving room. 'It's all about consumerism. All of this. It's not about art,' he says. I'm not sure that's the whole story, but whatever it is, it's working. There are about 400 people outside the gallery trying to get in. I leave White Cube$^2$ and go to my car, which I discover has been broken into.

Three weeks later the crown of British contemporary culture, Tate Modern, was inaugurated. Britain's first new national gallery for a century was officially opened by the Queen, and sort of unofficially opened five hours later by Tony Blair, anxious to remind the nation that his good ideas for public engagement didn't begin and end with the Dome. Allegedly Alastair Campbell insisted that, after HRH had finished, the PM should have a special, personalized tour which

was also to be covered by the media. Blair needed to be photographed standing in Tate Modern on its opening day. For a nation which has traditionally greeted modern art with sniggering derision on good days and outright hostility on bad ones, the excitement and national celebration surrounding the arrival of a refurbished building holding an already familiar collection of modern art was unprecedented.

It happened so fast. The transformation of visual culture from monster to national hero. For a country which, culturally speaking, looked inwards for its literary heroes and abroad for its artistic ones, it was a true revolution. Philistinism, with regard to the visual arts, had been something of a national sport. FURY AT £50M LOOTO FOR DEAD COW ART GALLERY said *The Sun* in October 1995. Five years later it sent its creation, White Van Man, to Tate Modern. Once inside the Turbine Hall, White Van Man – a person defined by van insurance specialists Gladiator as 'an insensitive lout who drives aggressively and dangerously', and almost certainly no particular fan of contemporary art – calmed down and quite enjoyed himself. Indeed, *The Sun* was proud to reveal photographs of White Van Man pronouncing Tate Modern 'A Good Thing' – a sign of popular acceptance if ever there was one.

Taxi drivers, the nation's grumpy touchstone, suddenly became enthusiastic cultural leaders when Tate Modern arranged for them to have a special preview. Hundreds turned up. They all wanted to be part of the excitement. No matter that the new Tate contained the same weird stuff that was at the old Tate, unloved and uncommented on for years. The entire collection, not just on Bankside but across the nation, had been subject to some sort of alchemy. It had changed from something inexplicable and unfriendly into a monumental crowd-pleaser. U.K. Art was becoming the new cultural currency of the nation.

Overleaf: The Mystery of British Culture, 2001. Hand-coloured lithographic print.

Location Finder, 2001. B/w map drawing.

# CHAPTER ONE

# THE STORY
# BEGINS

## the way things were

Twenty years ago, British contemporary art was serious stuff. It probably felt it had to be. European art had at last begun to steal the limelight from New York, which had held centre stage since the 1960s. With the arrival of Georg Baselitz and Anselm Kiefer in the German Pavilion at the 1980 Venice Biennale, the focus was about to come back over the Atlantic.

When it returned, it did not inherit the playful lightness of touch and determined street style characteristic of New York. European art of the 1980s was bombastic, large and serious in intent. It was interested in myth and history, not in popular culture. The exhibition 'A New Spirit in Painting' at the Royal Academy in 1981 did much to reawaken an interest in painting, but here the interest was not so much modern as pre-modern. Artists were into the heroic idea of the male painter, whose gloomy brushstrokes expounded timeless, Wagnerian themes. Politically alert artists such as Leon Golub were, to a certain extent, marginalized, while the international attention was given to artists whose work could have been done at any point over the last two or even three decades.

709.41    33333 01014411 7

While it was not pointedly political, however, politics was implicit. There was no notion of art as celebration: a divided Europe was still thrashing out the last stages of the Cold War and the Berlin Wall had yet to fall.

Meanwhile, in Britain, the legacy of Pop-meisters such as Richard Hamilton, David Hockney and Peter Blake had gone precisely nowhere. British painting was characterized by the likes of Lucian Freud and Frank Auerbach. Many artists were tending to carry on in much the same way as they had been doing since the 1940s. Or the 1930s. Their art was painterly, it was masterly (particularly Freud's), but it was just a bit dull. To be sure, Howard Hodgkin had a yen for colour but, in the main, British painting was still trooping along in the wake of the lively line of Walter Sickert, the painter who aimed his art to be 'like a page torn from the book of life'. This was fine for Sickert, but what dull pages his disciples ripped out!

Buses rambling along a hill. Out-of-focus streets populated by dreary commuters in hats. Tortured portraits of droopy mistresses who looked as if they had been standing in the same pose for years. Auerbach's vistas of Primrose Hill lamp posts and Leon Kossoff's Kilburn car parks with their five-inch layers of muddy brown impasto may have meant something to people at the time of the Festival of Britain but by the time punk, the *Godfather* films and Rubik's Cube had achieved a Scorched Earth policy through the cultural environment of the nation, they were irrelevant to anyone outside a quiet honeycomb of British dealers and their anonymous clients. This, of course, was not strange: until the 1990s, British artistic culture was good at being private.

British sculpture was, if anything, even more awful. British sculpture of the 1980s was regarded as something of a School. The lesson it taught was that sculpture had to be big, ponderous, mainly abstract and male. And worthy, in a sort of organic countrified way, for which read pompous. Modern British Sculpture calls to mind works of the Brothers Richard, Deacon and Long. Their pieces consisted either of weird, gyrating circles in dovetailed wood, slabs of stone, or texts painted on walls analysing long, lonely walks done in perfect solitude on the Iberian coastline. It was holistic and holier than thou.

It brought a few acolytes solemnly padding round galleries. That was it. Being publicly funded (usually), it was deathly serious. No one dared question its worth; no one was shocked or amused by it. No one dared to be. The artists were reclusive. Forget the cult of the personality. There were no personalities, apart from David Hockney, and he lived abroad.

Culture was dull. It cost a lot, but that didn't matter because no one ordinary bought it. It was sold to institutions, most likely banks or galleries. It was unconcerned with popularity, so the populace was unconcerned with it. Another decade would pass before it gathered force and exploded.

There were a few notable exceptions: Paula Rego, Susan Hiller and Helen Chadwick spring to mind. And there were a few spirited outsiders. Like performance artist Bobby Baker. In 1990 I was employed on the cult ITV daytime programme *This Morning*, and I invited her on. I thought *This Morning* could take performance art. I was hopelessly wrong.

Ms Baker is a formidable and energetic artist whose work satirizes and questions gender issues, women's roles; indeed, the very quixotic essence of daytime television. Charming, funny and quirky, she also has nerve. On live television she made a swinging skirt out of dough balls, and a pastry breastplate ('to protect you when you are walking home'). Then there was the pièce de résistance, a pair of dough antlers, to be tied onto the head with ribbon. Three million viewers were treated to the unrepeatable sight of Bobby Baker dancing around in her dough ball skirt, holding up the antlers to her head, and saying merrily, 'This will cut the ice at parties!'

The idea that an artist might use popular culture to comment on popular culture, however, did not go down at all well with the programme's presenters. The steamrollering of art into everyday life, which Bobby Baker had so joyously commandeered, was about to happen. But not quite then.

In the catalogue of The British Art Show 5, which opened in 2000, Tony Godfrey ponders on the first British Art Show, which kicked off 21 years earlier. 'Since 1979 it seems that the art world has changed from something like a gentleman's club to a website, and that the large group show has been

transformed from an anthology to an argument.' Art was restrictive, classified and polite. Furthermore, check out the alumni. The Class of '79. 'We see a crew of somewhat dowdy and unsmiling art school teachers, invariably dressed in unbuttoned shirts and/or jumpers,' writes Godfrey.

Tracey Emin now has a personal fitter to pour her into couture dresses by fashion queen Vivienne Westwood. In one giant leap the British artist has scorched from dowdy art school boffin to glossy designer's muse. From unbuttoned shirt to bespoke velvet bustier. From nobody to a household name.

'People feel [art] is for them,' says Tom David, head of britart.com, an online site with 50,000 hits a month, selling contemporary prints, paintings and photographs. 'Art is sexy. The Young British Artists started it. Tate Modern confirmed it. We have had the cult of food, we have had the cult of wine. Art is the next thing.' For whom? For everyone.

I pick up a copy of this week's London listings guide, *Time Out*. By happy coincidence, in the centrefold is a sheaf of stickers from britart.com. 'Girlfriend 2000. Skin, hair, make up, neuroses. 169 x 48 cm', 'Badly Dressed Person 2000. Artificial fibres, cheap shoes, clashing colours'. And so on, through mobile phones, CD players, tourists, pint glasses, boyfriends ('for a limited time only'). The jargon of the commercial art gallery, applied to the stuff of life. The dot in britart.com is even a single red spot, which is the 'sold' sign for art dealers.

Britart.com have done this gag all over the place. Their publicity campaign includes posters which they have plastered over lamp posts, junction boxes, paving stones – all in gallery jargon. There was even a tree with a poster on it. 'Tree. 80 foot. Leaves, bark, insects. 200 years old.' Apparently someone rang up the company asking to buy it. How they laughed. Because these days people know about art and about artspeak. New York website The Jacobyte has acclaimed britart.com. 'Branding lamp posts and sidewalks as "works of art" is great offline branding,' it enthuses, accurately suggesting that the campaign will 'attract people on the fringe of the art-buying community'. Because even if you will never plonk a red spot on a painting yourself, you are interested in artists; you even care who wins the Turner Prize.

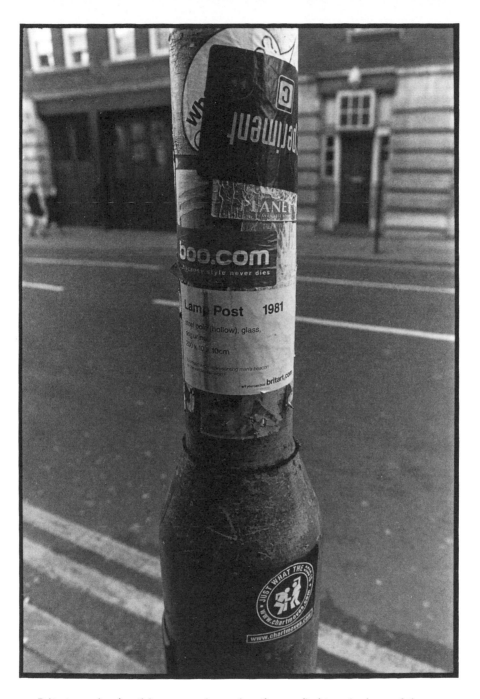

Britart.com's advertising campaign using the rarefied terminology of the art gallery on ordinary high street objects.

CHAPTER TWO

# THE TURNER PRIZE

from token to trophy

What a small and well-intentioned pet it was. What a monster it has become. Invented back in the Dark Ages, i.e. in 1984, by the Tate's innovative fundraising body, the Patrons of New Art, the prize was designed for the British artist who had made the 'greatest contribution to art in Britain in the last twelve months'.

In a rather wonderfully archaic, public service kind of way it was hoped that the prize would help spread the good news that modern art was not scary or threatening but something worth getting into. Abroad, there were signs that the terrifying iceberg of modernism was beginning to thaw a little into art that people could 'understand'. It was hoped that the Turner might reflect this, and in addition, might pull on the cult of celebrity and scandal enjoyed by artists such as Georg Baselitz or Julian Schnabel abroad. By making British art sexy it was hoped that the Turner might dare to scale the Olympian heights of publicity and sales garnered by the unchallenged leader in the arts prize stakes, the mighty Booker.

It began modestly, as properly befits an award hosted by a publicly funded gallery. The Master of Ceremonies was the current Minister of Arts, the acoustics were dreadful and the winner, Malcolm Morley, displayed the correct British attitude to accolade by not turning up to receive his cheque. Indeed, he refused to leave America, his chosen home since 1958.

There was no accompanying exhibition, there was no razzmatazz, and there was no row, unless of course you count the critics who were horrified that such a potentially loaded event had been utterly thrown away. Waldemar Januszczak, who several years later as Channel 4's Commissioner for Arts was to give the Turner its perfect incarnation as televised blood sport, wrote in *The Guardian*, 'Whatever Morley's historical significance ... it has had absolutely nothing to do with art in Britain and merely confirms the continuing cultural dominance of the New York art world.'

I went to the Turner when it was still in this Cro-Magnon phase. However, by November 1987, it was vaguely discernible that the Tate had begun to understand that the Turner might be a good vehicle for something. It was not sure what, but certainly something BIG. 'We hope in future to offer the winner a small exhibition at the Tate Gallery in the summer after the award has been made,' reads the catalogue. Ten months later? A small exhibition?

I was a student and, as such, not a very credible guest, but I had an NUJ membership card which I vaguely waved in the direction of a security person. Inside the gallery everything was very quiet. I don't think the work on display was that of the nominees, who included the sculptor Richard Deacon, Patrick Caulfield, chosen for selecting a show of Old Masters at the National Gallery, Thérèse Oulton, who had had a blockbuster show three years earlier, and the curator of Derry's Orchard Gallery, Declan McGonagle, who appeared to have been chosen because everyone agreed he was a good egg.

There was one reporter covering the event, from the BBC Radio 4 arts show *Kaleidoscope*. There was one camera person, from *Newsnight*. Caterers wandered about, handing out glasses of wine. It was all very nice and civilized. At a certain point in the evening, a glass was tinkled and everyone gathered around a red rope. Behind the rope was a small podium. The atmosphere was not unlike a village pet show.

Veteran jazzer George Melly, in an ice-cream-striped suit, did the honours. Without much fuss, he announced Richard Deacon had won the 1987 Turner Prize. Fortunately, Deacon was in the country and stepped up to accept it. The

media presence, that is to say, me and *Kaleidoscope*, had a go at interviewing him, and then we all went home. It achieved one minute of airtime on *Newsnight*.

Fast-forward thirteen years. The invitations for the Turner Prize 2000 are numbered and checked off, with obligatory RSVPs. Broadcasts from the Tate, now rebranded as Tate Britain, have been going out about the Turner all day on TV and radio. Including Sky, and Channel 4, and Radio 4. And Radio Five Live. Is this good? Well, the press officers are delighted. The viewers and listeners are, presumably, interested. Who knows what the shortlisted artists think?

Various things happen outside the Tate. The Stuckists, an 'anti-anti-art movement', turn up and protest in clown outfits. Someone purporting to be Damien Hirst's godmother appears, dressed as a fairy. There are flower arrangers, caterers and furniture companies who hump hundreds of gold chairs up into the galleries.

It's evening. The guests troop up to Tate Britain past paparazzi, television crews, a BBC live radio car, a BBC live television truck, a man carrying a protest placard ('Come Out, Serota!') and several would-be gatecrashers. Of course, any notion of gatecrashing this event is an utterly sterile one. Guests practically have to get their passports out for name validation.

After an hour's worth of champagne, the evening moves smoothly on to a sit-down meal for 260. The guests munch on delicacies including a timbale of wild mushrooms, a seared leg of lamb marinaded in cardamom, and then move gently to crop a selection of hand-crafted puddings served on a vast banquette in the middle of the gallery. The evening also includes a speech from Nicholas Serota, an hour-long broadcast on a national TV network, Paul Smith giving away the award and the appraisal of at least 25 photographers and four TV crews.

At a table of foreign art dealers, television directors and multimillionaires is the Director of Arts & Business, Colin Tweedy. A big, enthusiastic man who spends his time persuading important business people to give their money to arts companies, Tweedy is finding his job easier and busier. In 1983, when he took over the Association of Business Sponsorship of the Arts, sponsorship was worth about £60 million. It's now worth nearly £200 million.

The season's hot ticket: enjoying pudding at the Turner Prize, Tate Britain.

Wolfgang Tillmans basking before the snappers at the Turner Prize,
Tate Britain.

'Art is chic, and it is smart. And we know we are very fashionable. But we have to deliver. I remember the days when I used to go to the Booker Prize. And little old ladies would pour gravy down your black tie.' He shudders.

'The food was repellent *everywhere you went*. Now every catering company serves their food on rock crystal, or slate, or velvet-covered mirrors. We expect the champagne to be in the best flutes. People beg Nick Serota to be on the Turner Prize guest list. The smart social parties of the 1950s and '60s are over. Then they were held in private houses. In the 1980s it was the film previews. And one or two fashion shows. Now the parties of smart society are at the galleries.'

Out on the floor, press officers wearing earpieces and walkie-talkies are in charge. Erica Bolton, whose PR company handles much of the press for the Tate but who is merely a guest tonight, is nevertheless on hand to help confused journalists. It's easy to know who she is since she is walking about in a dress made out of flashing light bulbs. After Wolfgang Tillmans has won the award and spoken at a press conference, there is a huge party at Shoreditch Town Hall in East London, for which several coaches have been hired. The Turner used not to be important enough to turn up to. Winning it now means instant stature for both the artist and his/her gallery. Losing it has caused breakdowns. Is this good for art? No, but the Tate presumably believes the trickle-down effect is worth sacrificing a few artists for.

After the big bash I am allowed lunch with the director, Sir Nicholas Serota, chairman of the jury. I meet up with him in the black and glass basement experience that is Tate Britain's restaurant. It's always exciting meeting Sir Nicholas. It's always interesting to meet someone in charge of such a huge hulk of British cultural life (Tates Modern, Britain, Liverpool and St Ives); a marketing, fundraising and curating genius, who achieves universal acclaim and respect.

With Serota, however, there is also something of a frisson going on. Perhaps it is because he always looks flawless. From the crisp handkerchief in his pocket to his gleaming shoes, by way of his perfectly cut suits, this is a man who simply must employ a valet. Perhaps the allure lies in his wire-rimmed,

slightly menacing glasses. Or his loud, amused laugh. Or that he only uses the slightest hint of irony when he admits to being incorruptible.

Anyway, I am in the stellar presence of the Tate director. We are eating perfectly cooked risotto and Sir Nicholas is trying to explain the phenomenon of the Turner Prize as the award of awards. 'It's the competitive element, of course. When I first came to the Tate we abandoned the shortlist. And the media lost interest. A competitive element disclosed to the public gives interest. And somehow in the 1990s the visual came to the front of everyone's consciousness. It doesn't matter whether it is design, or art, or sculpture. And compared with a book ... well ... it's more immediate.' He toys with a roasted pepper.

'You can take three people off the street, take them into the Turner Prize exhibition and I will get a reaction off them in five minutes. You aren't going to get a reaction to Brian O'Doherty's book about life in Ireland or the latest Ian McEwan in the same way. There is something very instant about visual imagery. Which is very dangerous as well, because you run the risk of ending up only with the instant.'

Perhaps art is easily assimilated in a world where speed is king and comprehension needs to be immediate. But does that explain the infatuation of business with visual art, the celebrity of the artists, the grip of the galleries on social events? Does this explain why advertising campaigns use jokey art jargon which we are all meant to understand? Does it explain why we buy records by Damien Hirst? Or why at the Saatchi Gallery there are over 120 framed cartoons from the national press lampooning modern artists, or why the names of these artists can be cited by non-art people sampled in a hurried questionnaire on an ordinary street in North London?

The Turner has clearly overtaken the Booker. It is Art Gong of the Year. As a signal of the prime position visual art currently commands, it is a perfect indicator. But it still doesn't fully explain why people are now willing to go along with something that only a decade ago they simply hated.

# CHAPTER THREE
# BRITAIN
## turning the nation on

'They hated it,' says artist Michael Craig-Martin, 'because they never accepted it.' Michael Craig-Martin is the godfather of British contemporary art. He has always been a perfect complement to the scene, with his tripping name, a plume of now white hair, a fantastically smooth East Coast American accent and the sort of amused face which looks unshockable. Born in Ireland, but brought up in Washington DC, he has the classic American charm with the media, but he has been in Britain for ages, as artist and teacher. Damien Hirst, Gillian Wearing, Gary Hume, all the artists who came out of Goldsmiths' College in the late 1980s were taught by Craig-Martin. They were a generation he had waited years to teach.

'When I first arrived from the States in 1966 it was clear that theatre represented the present. Pop art was around, it's true, a smattering. But essentially the contemporary voice was presented by the world of the novel and the world of the play. Not the visual arts. Why? I would say that the British were never happy with, or accepted, modernism.'

I look around Craig-Martin's house. It's pretty modernist. Open plan, stripped wood floor, white walls, gravel outside the picture window. One *huge* painting (by Craig-Martin; no false modesty here). One large, long desk.

Everything in the kitchen put away into cupboards which meld into the wall and have no discernible handles. A sink like a cut-out circle.

'There was a cultural rejection of modernism,' he continues, 'at every level, but especially at the highest level, the visual arts.' He has a point. Remember the row about the 'Tate bricks', Carl Andre's *Equivalent VIII*?

Craig-Martin noticed the British allergy to modernism when he came to curate 'Drawing the Line', a brilliant and stimulating exhibition surveying one thousand years of human drawing. 'I got every drawing which dated before 1900 from four or five great museum collections, all of which in turn came from great private collections ... because in the eighteenth to nineteenth centuries, the British collected on a scale which was just fantastic, particularly in drawings. But when it came to representing the twentieth century, and modernism, I wasn't able to borrow a single great Picasso, Matisse, Léger or Miró drawing from any public collection. Not one. There are no great examples in the V&A, none in the Tate, none in the British Museum. Collecting had simply stopped. Because there was a refusal to take on certain ideas of modernism.

'Modernism is involved with a certain abstractness of thought. The interest is not in the subject of the art itself, but the actual object. In the form of the work itself. In how it is made. Critics might say, "What is this about? It has no subject matter. It has no skill." In fact modernist art has all these things, but they are just not as overt. The artist is simply *foregrounding* things that art in the past had included, but included below the surface.

'It's not that there weren't people in Britain trying to pull this to centre stage. There were artists trying very hard. But they were fighting against a fantastic resistance. In the post-war period the people who put together the Arts Council and the British Council saw their role as bringing pleasure and comfort to the people. British modernism was domesticated. True modernism has to be edgy and critical, and tough. British modernism was something which would look good in the kitchen.'

True modernism is cool and objective. It looks like it is all about the thing itself. Carl Andre's bricks look like a pile of bricks. Andre himself explained that

they were a reference to a day he spent canoeing on a lake, but that was not necessarily the first thing that came to people's minds when they encountered *Equivalent VIII*. What happened next? 'What happened was that in the late '70s and early '80s in Britain there arrived the clear beginnings of post-modernism.'

Call it our literary heritage, or our pedantic manner, but according to Craig-Martin, we Brits like a bit more going on with our pictures. Think back to Victorian narrative painting. Why is Sir John Everett Millais's *Ophelia* the most popular postcard in Tate Britain, and John William Waterhouse's *Lady of Shalott* the second most popular? It's simple. They tell stories. 'There is an aspect of Victorian painting in post-modernism,' agrees Craig Martin. 'Post-modernism uses references which widen the whole thing out. Art starts to tell a story again. Take Damien Hirst. His art is to do with themes of life, death, sex. What it is to be human. Carl Andre's work is also about very simple human experiences. But because of its abstraction it's seen as obscure or phony. However, when there's a subject matter which people can associate with, there's a much greater access route. Look at Tracey Emin's bed. It's very clear. And very literal. You don't have to make a painting. You just present the actual bed.'

See? Carl Andre's bricks (modernism) = difficult objectivity. Tracey Emin's bed (British post-modernism) = easy subjectivity. And that is the story. Literally.

'There is always a point of contact,' says Craig-Martin. 'If not the subject matter, then some kind of popular referencing that allows an easier point of entry.' Think of Richard Billingham's photographs of his socially deprived family, of Steve McQueen's famously collapsing barn. You may not like the story, but there clearly is one to tell.

The new generation of Young British Artists – the YBAs – had invented a different way into art; they were concerned with ease of comprehension rather than perplexing intelligence. Because people found it unthreatening and potentially enjoyable, they were willing to buy into it. Even if they hated it, people felt they could have an opinion, because they understood what was going on. On one level Tracey Emin's tent *Everyone I Have Ever Slept With 1963–1995* hardly needs a huge amount of explaining.

Businesses underscored this public appreciation by utilizing the work for their own aims, which in turn reinforced public exposure to the work. Mass media and advertising began to use the art of the YBAs as a conduit. Consequently, because it was suddenly mainstream, art became more easily comprehensible. Who could have a problem with a Gillian Wearing video when the same idea was used in a Volkswagen ad?

'In my view it never occurred to artists of this generation to make art that people wouldn't get and wouldn't like,' says Craig-Martin. 'They thought that if people didn't get it, then they must have done something wrong. Now that is not what artists of my generation behaved like. There is now a transparency to it all.'

Just as the idea of the artwork changed, so did the notion of the artist. The idea of the creator as a Brancusi-type figure stolidly stuck in his studio, away from contemporary life, was over. And the idea of the artwork as the key was also over. 'British contemporary art shifted its focus from an interest in the object itself to an interest in the artist as genius,' says Craig-Martin.

Artists were now as important as their art. Commercial entities in their own right, they made films, records and shows. They became DJs, restaurateurs; they played in bands and designed clothes. And as they worked across all areas in the open market, so activists in other fields followed their lead. Fashion designers became as idiosyncratic; product designers as individual; curators as demonstrative and unafraid of radical change.

One of the most forceful places to take up the new modishness of visual art was the National Portrait Gallery, which received a multi-million pound Lottery grant and generous donation from the philanthropist Christopher Ondaatje to build a dizzying new wing in what was once merely a small space of air between the NPG and its neighbour, the National Gallery.

Whether its daring and resourceful director Charles Saumarez Smith consciously knew it or not, the NPG held several trumps in its hand. Not only was its collection historical as well as contemporaneous, it was also produced by a legion of famous names, and the paintings themselves were of famous people. The NPG could be reborn as *Hello!* via the Royal College.

In one admission-free visit you could glide up the longest above-ground escalator in Britain, take in an achingly hip modern portrait of, say, Jean Muir, consider Cate Blanchett's Elizabeth while cruising past the Tudors in their newly elegant gallery (all forbidding grey walls and halogen spots), followed by a cocktail in the fabulous, fashionable rooftop restaurant. A visit to a place you were forced to go to on a school trip had become the apotheosis of almost every important trend in Britain of the early twenty-first century.

The people active in all this still remain, largely, one central group: they are the Tastemakers. They wield a huge weight of influence, and we, the consumers, have gratefully accepted what they have to offer. They have used a fascinated media to disseminate their ideas all over the nation and across the globe; they have turned British culture generally and visual culture particularly into the communication of choice.

If post-modernism is about telling stories, Britain itself became a story that artists could tell. Britain, with its uncool symbols, was the reference. The streets, the cities, the cars suddenly became OK to mention. 'In Britain we suffer from the fact that we haven't mythologized our world,' says the film producer Duncan Kenworthy. 'America is deeply mythologized now. We, a British audience, know just how it feels to drive down Santa Monica Boulevard even though we may never have been there. And we are perfectly willing to see stories set there. Whereas a story set in Hull or Leicester, or on the A303 rather than Route 66, is a very odd idea. The more we make films in our country the more people will accept these stories and want to see them.' One reason why Kenworthy chooses to film on location in Britain – from *Four Weddings and a Funeral*, through to *Trainspotting, Notting Hill* and *The Parole Officer*, his latest picture which is filmed entirely on location in Liverpool and Manchester.

Even the Union Jack has been reclaimed by artists. A decade ago, fans of the Union Jack essentially consisted of National Front members and football thugs. It was about as hip as the Confederate flag.

At The British Art Show 5 one of the galleries is dominated by a vast silver Union Jack by Jonathan Parsons. On the opposite wall is Tracey Emin's quilt

The perfect venue for a location shoot: Duncan Kenworthy on the roof of his penthouse, Soho, London.

with a Union Jack design. On opening night Jeremy Deller is handing out DIY Union Jacks that you can colour in yourself. Deller, like Emin, like Kenworthy, like Parsons, is asking us to look at our own popular culture and reassess it.

Desiree Mejer is owner and inventor of Fake London. Since she launched the design label in 1992, she has achieved a 'repositioning' of her trademark, the Union Jack. Helped by the fair wind of celebrity patronage (Liam Gallagher, Zoë Ball et al.) plus the ultimate accolade of art approval from Damien Hirst, Mejer's flag has become both art object and fashion staple. Fashion people wear her shirts because nowadays they want to look as knowledgeable as artists. Artists wear her shirts because nowadays they want to look as stylish as celebrities.

We meet at Tate Britain. Mejer has designed a tiger-striped Union Jack shirt which is being sold at the William Blake show. It's a perfect example of the intricate circles of fashion meeting art meeting commerce. She arrives in a sparkly diamante cashmere Union Jack top.

'We put the flag in a positive light by being irreverent and happy about it. We were copied a lot.' Remember Geri Halliwell at the BRIT Awards?

'If you take over certain symbols which may have slipped into a negative way, and use them in a way which is obviously lighthearted, then you can reverse it. I wasn't a Londoner,' says Mejer, who is Spanish, 'but I chose London for my base. Then I chose Fake London as the name for my label because when I arrived people were not bothered about style. Which I thought was quite cool really. And the other reason is quite personal. My mother was here in the '60s, and she made me here. On a red sofa in the Dorchester. Or so she says.'

It's a two-way street. If artists and designers have chosen to mythologize Britain, British culture has picked them up and mythologized them. Thus we see the British film *Purely Belter* including shots of Antony Gormley's *Angel of the North*, and comedians French and Saunders using a Damien Hirst-inspired set for their 2000 Christmas show. Ten years ago, would they have used a Richard Deacon-inspired set? I don't think so. French and Saunders may be huge Deacon fans for all I know, but they'd no more dream of using his work on stage than they would a gag about Henry Moore, or Ben Nicholson, or any of the people

who used to be at the top of the British art tree. Audiences wouldn't get it. But a reference to Damien Hirst? Yes, please.

Contemporary art has been inspired by popular culture, but popular culture has equally consumed it as quickly. Which of course brings its own problems. But the interesting thing about it is that it hasn't been watered down. In the olden days it used to be believed that when art entered the Real World, it would need to be guided around the place. Today it is just bunged about, pure and undiluted.

I go and see Vittorio Radice, chief executive of Selfridges. In his light, sunny office which has Mediterranean-style sun awnings on the windows, there is a lot of art. Gary Hume paintings. Eduardo Paolozzi heads and small figures. On the wall, a couple of light boxes. I sit in a metal and white canvas chair, am served coffee in a perfect cup and wait for Radice. While I'm waiting I pick up a couple of magazines. One is *Wallpaper\**, the über-guide for stylish and arty living, and the other is a dummy for the new Selfridges magazine.

In comes Radice, charming and relaxed, as well he might be. Selfridges has undergone a phenomenal transformation, thanks to a £100 million face lift. In 2000 its trading profits were £30.9 million, and to cap it all early in 2001 it was granted the Royal Warrant of Appointment to the Queen. Radice has excited customers by radically upgrading the stuff on sale in the shop. But it's unarguable that he tempted them in with contemporary visual art, which effectively rebranded the shop as fashionable, dangerous and desirable.

In 1999, he commissioned *Glam Genie* by Nike Savvas, an installation of hundreds of sparkling discs which hung the length of Selfridges' atrium. And in 2000, when the store was having its face lift, he commissioned Sam Taylor-Wood to create the longest photograph in the world to wrap around the scaffolding. A 900-foot Olympian frieze of contemporary culture, it told a story, presented itself as art *and* bestowed upon Selfridges the tricky but crucial imprimatur of being high-end but popular. It was seen by an estimated 26 million people. Things that had previously been confined to the Tate were now out in the open on Oxford Street.

'A hundred years ago, we were a verbal culture,' says Radice. 'Things were written down. Words were used to sell everything. Then it became graphics. Now it is a totally visual culture. The picture is everything. Everything is conveyed by the image. People are bombarded with visual communications. When I left Italy there were four channels. Now when I go home there are 140 to choose from. So of course art has become the medium of choice, because people understand it.

'They see the artist as celebrity. They know these people.' Radice gestures to his office. 'They know Gary Hume, Eduardo Paolozzi. They know their signature of work. And they point up to things like the Sam Taylor-Wood piece and say, "I want to be like this person."'

According to Radice, there are more links between Tate Modern and Selfridges than just the escalators. 'More people go shopping than go to museums, so why shouldn't shops borrow from museums and put art inside them? I want to give people a wider experience than just shopping. Because speaking as a retailer, which is what I am, then if they get an added experience, they will come back and buy something.'

He is busily planning a vast £300 million extension on the site of the old Selfridges hotel. Designed by Lord Foster, the complex will include a new 244-room hotel and increase the floor space of the store by a fifth. Will he include an art gallery in it? 'Yes. I want a gallery. Would I curate it myself?' He laughs. 'I don't think so. Would we borrow artworks from the Tate? I don't see why not. If they are willing to lend them. They must know that millions more people come here than go to the Tate, popular though it is.'

Radice, who comes from Lake Como, has not only plunged into the fashionable world of contemporary British art, but has maintained what I can only describe as a typical Italian approach to it. 'Art should be part of everyday life. As it is in Italy. Where it is all around you. My wife is Venetian, and every day she would go through the Piazza San Marco. It was free for all. And the Palazzo Ducale. Not with some fence around it just for the few, but for everyone. And you can just go into churches and see the art. That is how it should be here, and it is not. Too often art here is closeted away and only a few special people can

see it. We get the idea that it is hard work and that it should be worked at. But art needn't be like that. It can be easy and fun and accessible.'

No wonder this man is on the board of the National Gallery, where director Neil MacGregor has long championed the idea of true accessibility. Radice's ideas are both radical and friendly, which is a remarkable combination.

'Museums should get more like real life. If people are in the Tate Café from 11 am to 7 pm, what does that say? It says they enjoy being there. So learn from that! Would I have loud music in galleries? Yes! Would I have a restaurant in the middle of the National Gallery? Absolutely. It would be a marvellous idea. What could be a better way of taking in art than sitting down, enjoying conversation and food? People relax, let themselves go, and you find out much more about your fellow man. It's much better than standing in front of a work of art and not being able to talk. I can't stand art being admired as a precious thing that only a few can experience. What is the point of having a work of art if no one sees it? It's not as important as life, as your son or daughter. Even the *Last Supper* in Milan. It's great. But it is only a painting.'

He toys with a small postcard of the vast Taylor-Wood photograph. 'Oxford Street has 400 million people walking down it every year. What does that say? Art should be out on the streets. It should be out in real life.'

You only have to look at the photographic work from the likes of Wolfgang Tillmans, or Rankin, to see how this challenge has been taken on. With these photographers the high art aesthetic has been delivered into contemporary magazines other than *Vogue* or *Harpers*. This has been a hugely influential step.

'I was taught about photography and art at a time when conceptual art was taking place,' says Rankin. 'We came out of college at around the same time as Damien and that lot. I think we were taught the same syllabus. We were influenced by the same things. I love the fact that Damien Hirst's work touches the public but more often I think, "Give me a break." Which is why I like photography. Photography is still in the place where it's not just photography, or just fashion, or just art. There is a real space there for doing something that is different. We have got miles to go... Miles.'

In 1991 Rankin founded the style bible *Dazed & Confused* with Jefferson Hack. 'Jefferson and I tried to bring a conceptual art photography element with a fashion element to the magazine. But my big thing was to make it amusing and accessible to whoever read it. We therefore influenced a lot of fashion photographers and, in doing that, we started to influence fashion advertising. We had loads of imitators.'

After an exhibition of his work at Proud Galleries he made a formal allegiance with its director Alex Proud. Together they run a publishing company, Vision On, set up in 2000, which publishes books of the exhibitions shown at Proud Galleries. 'So much is to do with fashion,' says Rankin. 'People now think it's fashionable to go to galleries. It comes down to peer pressure. *Dazed & Confused* was about getting our ideas, when we were students, into the mainstream. So we set up a magazine. That was the cleverest thing. We then wanted to do exhibitions as well, so that we could get our ideas over to other people. What I find unusual is that there are still galleries who miss the mark. Because they aren't putting the right stuff forward.'

Other people have understood what's going on, too, and not just the usual suspects. The London-based beer company Young's, for example. You may not know this but Young's Triple 'A' Bitter, according to the blurb, 'meets the demands of the younger repertoire drinker with a cask conditioned ale that is served cool and enjoys a smooth, creamy taste'. Whatever that all means, the British 'repertoire' drinker is also someone who knows about contemporary art. Otherwise how could you possibly explain this ad?

A ram stands solidly in a white space. Next to the ram floats a nerdy youth in black boxers and nothing else. He is floating because he is in a glass case. One suspects he is dead and suspended in formaldehyde. The punch line underneath this photograph reads 'New Triple "A". Not Your Usual'. What a perfect use of pub speak, combined adroitly with a reference to Wild Lad Mr Hirst and his piece *Away from the Flock*, which revealed a lamb similarly suspended.

Of course, Damien is the perfect role model for the 'younger repertoire drinker', having conquered both the art house magazines and *Loaded*, not to

mention having starred in his own band, Fat Les. Sophisticated, yet boozy. A little bit of Gagosian with a little bit of Gazza. You bring pub culture into the art world, you end up bringing the culture into the world of the pub. Artists have always been drinkers, yet Hirst has also done popular culture more brilliantly and publicly than anyone else. Who can be surprised that his idea has ended up promoting beer on 660 prime sites in London and the South East? It's so perfect one might almost suspect it was a stunt from the artist.

Stephen Goodyear is Head of Sales and Marketing at Young's. He is only too happy to talk about the Hirst advert. 'In research it appealed greatly to our target audience. It got noticed. Some people didn't connect in the first place, but that is also good news. Because then people go to the trouble of finding out about it. If you see it up there enough, you question it. But most of the target market connected straight away. The impact of Damien Hirst is such that they understood completely. He is a *lad*. He is very well known to, ahem, to that part of the drinking public.'

How about other artists, then, also no strangers to the drinking scene. Would you use a work by, say, Lucian Freud to promote beer? 'Damien's works have had a lot more coverage than Lucian Freud's,' says Mr Goodyear. He ponders my question. 'Basically Damien is more than an artist.'

Would you continue along this line, using other famous contemporary art pieces? The ram in a domestic setting, perhaps? 'That bed? We don't want to be offensive in any way. As long as it is lighthearted and fun, that's good news. This poster is perfect for the creation and promotion of Triple "A".'

I visit the design company Fashion Architecture and Taste, otherwise known as FAT. I have been told to take biscuits. FAT is a friendly, five-strong design team, much beloved of the style pages in newspaper supplements, whose work has the great advantage of looking like art.

Back in the 1980s British urban planners might have gone for the Prince Charles/Heritage look or, if they were really daring, technological. But not now. It's not just advertisers who want the imprimatur of artists on their product. Everybody wants mainline ART. For which they now go to companies like FAT.

Our kind of artist: Young's beer does a Damien. Billboard advert, London, 2000.

'We started before this all began to happen,' says Sean Griffiths. 'When art was really something which didn't make news headlines. Architecture was even further off the radar screen. Radical architecture was buying a modernist chair. We are now asked to do things which are pure art. Urban projects, where we put art into unusual situations.'

FAT created the big illuminated clock/non-clock outside King's Cross Station. The hands on one hemisphere whizz round while the hands on the other do something else altogether. It looks like a clock, and lots of people use it as one. But in fact it's ART. They have also been hired by Bristol Council to work on Legible City, a project which will rebrand the entire city from transportation signs to pedestrian signs.

'We have been commissioned to have an artistic input,' says Sam Jacob from FAT. 'Ten years ago no one would have considered artists would have a viable input. The idea is not necessarily to pepper the streets of Bristol with lots of culture, but to be involved in processes that artists are not usually involved in, like the development of an integrated transport system.'

'Art has a great value at the moment,' says Charles Holland, biscuit-cruncher number three. 'It is part of the great brand that is Britain plc. Everyone thinks that artists are a panacea for all kinds of problems, and that artists are incredibly interesting people.'

I think of something Michael Craig-Martin said. 'Today, the artist is looked at as a priest-like person who holds the secret. Which they let out in little bits.'

City planners have always wanted art in the middle of their urban vista. But whereas before this meant parachuting down some complex piece created by an artist in his or her studio, which was then vandalized and/or urinated on, today this means something different. 'I mean, Park and Ride is a big issue in Bristol at the moment,' continues Sean. 'At the moment the Park and Ride stations are a sea of car-parking with "amenity" buildings in the middle of them, which are slightly unattractive buildings with no amenities in them. We are thinking of turning these places into destinations in their own right, where you can do things like have a cup of coffee. And that might extend on a grand scale to

The boys at FAT chew over their mission to graft art onto everyday life.

having drive-in movies. Artists are being asked to be involved with everything. It's not about making a sculpture and bunging it in.

'Adidas asked us to come up with a campaign around streets and bars to run through Euro 2000. And the brief was, "It has to look like Art." The guy who commissioned it normally does things like give trainers to David Beckham. We designed a scoreboard on the back of a van with things which gleamed and fluttered in the wind. So after every game we drove around London with the score of the game on it. Unfortunately this was usually the score of the England game.' He pauses. 'Which made Adidas's campaign something of a hostage to fortune.' Well, that's art for you.

We sit around for a bit contemplating the fantastic paradox of sports corporations – whose very existence depends on the cut and dried, win/lose nature of sport itself – choosing to use art as a statement of their social sophistication.

'If you make something in a gallery,' says Jacobs, 'that has its own context. Of what you might call the art industry. It's much harder to do art in the public environment because the idea might then be shaped by forces in the public environment. But isn't that what we are trying to do? I think gallery art is boring now. I mean, are white cubes on the way out? Should we be watching art in people's houses?'

Near FAT's offices are a clutch of sandwich bars, juice emporia and coffee shops, all with funky, slogany names like Toast or Sittingroom. Meanwhile, across Britain, one pub closes every day. A pub with its royal name, horse brasses, plastic stools and plain glass glasses. At almost the same rate, one zinc-topped, leather-seated, chrome-decorated bar opens, plastered with contemporary art and zany coloured glasses. Most of them are probably designed by FAT. Or someone like them who can make real life look 'arty'.

One last thing. Tell us about the T in your name, as in 'Taste'. How do you define it? 'We don't advocate any particular taste,' say FAT, sphinxishly. 'Just more of it. Everywhere.'

# CHAPTER FOUR

# PARENTS

## the prophets and leaders

The idea must have come from somewhere. The idea of taste, and of contemporary art supplying it for the nation. Crucially, it happened across the board. It happened in the public sector, and in the commercial sector, and it happened in the art schools. These three elements fused together and changed British visual culture. A revolution was brought about in the only way possible: that is to say, by upsetting the old order and replacing it with something else.

The public symbol of the whole phenomenon is of course Tate Modern, the vast national museum of modern art which opened on London's South Bank to global acclaim in May 2000. Three million people tramped round it in its first six months. It has been written about in religious terms; it is indeed above criticism. When a New York arts journalist and a Parisian lifestyle journalist dared to condemn it on Radio 4, the sheer cheek made headlines in the national press the next day.

It is the Millennial gesture that institutions both large and small have eagerly welcomed. When banks want to entertain grandly, they hold their parties at Tate Modern. When tourists, continental design magazines, American lecturers, families, art buffs, PhD students, style pundits, gastronomes and architectural practices want an unmistakable, impossible mix of spectacle, style,

People sitting on Jasper Morrison leather chairs at Tate Modern.

Catholic hedonism and Protestant self-improvement rolled into one sexy, para-doxical package both easy and hard, they go to Tate Modern.

Its severe profile has become so clearly etched on the city it seems hard to imagine that for the last fifty years St Paul's Cathedral ever faced anything else. Yet who remembers Bankside Power Station before it became Tate Modern? Probably only Nicholas Serota. Wandering about London in search of the perfect home for his dream – a bespoke museum of modern art – toying with but reject-ing various locations including Battersea Power Station and King's Cross, he found Bankside.

It had the perfect combination of vastness, dour economic surroundings and a highly fashionable industrial provenance, plus, joy of joys, it was designed by Giles Gilbert Scott of Liverpool Cathedral and telephone box fame. With such a powerful package, Serota could get the public sector behind him by appealing to the forces for regeneration (money and jobs into Southwark), heritage (the Gilbert Scott card) and street cred (the hipness of industry) in one smoothly tailored swoop. Chuck in the cash from the newly invented Lottery, and it was a done deal.

Of course the disused power station had to be changed from twentieth-century edifice of Old Power into twenty-first-century bastion of New Power; and, as shown by the suitably named Channel 4 documentary *Art into Power*, it was. Bankside was transformed by the architects Herzog & de Meuron into a great, glazed, light display. Inside it reflected all its glory with glass and light boxes; outside, it shimmered with confidence, from a two-storey light 'beam' running along its immense horizontal front.

It's strange to think the gallery could ever have looked otherwise, but the competing designs are still worth having a look at. If the job had gone to Tadao Ando, Bankside would have been scythed by two glass shafts piercing the build-ing from front to back. Rafael Moneo would have 'scooped' the roof out and put the restaurant out to grass behind the building, while David Chipperfield would have got rid of the huge tower altogether and replaced it with a huge glazed central tower as blockish as an ice cube. These proposals seem like heresy now.

Not only that, but the accompanying photographs taken before Tate Modern was, well, Tate Modern are just ghastly. They show an area as bleak as moonscape. Southwark, with a great roaring unused power station full of old machinery slap bang in the middle of it. And although Tate Modern, in the way that all successful ideas do, now resembles an irrefutable, immovable *thing*, one extraordinary document reveals that back in the hazy days of the early 1990s, Tate Modern needed a lot of push before everyone was convinced that it was worth building.

A confidential document produced by the external consulting group McKinsey, written before the Tate Modern machine really got going, proved crucial. It assessed the 'Economic Impact of the Tate Gallery of Modern Art at Bankside', and was finally revealed in 1995 on a wet weekday morning in Southwark. The entire arts press was assembled in a building site. As the country was in the midst of Lottery rebuilds, this was quite normal.

We were sitting in the as-yet-unbuilt undercroft of the privately funded Globe Theatre, next door to Tate Modern. The room was carpeted, but next door were rooms with no ceilings, full of wet concrete, piles of steel poles and men in hard hats. Through an unglazed window you could gaze up and see people struggling with piles of specially grown 'Elizabethan' reeds, authentically thatching the authentic roof of the Globe. Our morning was to be all about the brave new world of modern art, yet we were surrounded by Shakespearean accoutrements being assembled quicker than you could say 'hand-turned balustrade'. After breakfast and a speech from the then plain Mr Serota, we were introduced to the McKinsey document.

It is a very clear read. It shows that modern art works. That modern galleries work. That culture is important. Of course, we all know that, spiritually, this is an unmovable Truth. Every attempt to sum up human existence from the American Constitution onwards refers to the sanctity and presence of art in civilized life. However, the paper said nothing which spoke of the soul, or of beauty, or of the self-understanding and contemplation which art can bestow upon a society. The entire forty-page, ring-bound paper is full of hard data. It is

focused on profit, on jobs, on regeneration. It seeks to prove by examples and graphs and statistics that modern art is a modern urban necessity. And, crucially, that without it, London will fall far behind in the global competition to be top dog. It will lose out to New York and Paris; even to Houston and Toronto. It will Fail.

It starts off with the bad news. 'London does not currently realize its full potential to capture art-based tourism ... has failed to attract a number of major touring exhibitions ... lacks a large institution dedicated solely to modern art.' There is even a small map of the world, showing how well-off other countries are in this respect. There are bar charts and pie charts revealing how New York and Paris command vast swathes of tourists and pots of money by hosting block-busters like the Barnes Collection or the 1992 Matisse retrospective.

According to McKinsey, 70% of the out-of-town visitors to New York that year predicated their decision to visit the Big Apple on the fact that the Matisse show was on at the Museum of Modern Art. In case we, the British press in our benighted capital, didn't know what an art blockbuster actually was, the paper helpfully reminded us.

1. A large collection of works of a single artist, a group of artists, a movement, or a theme
2. Involves assembling a collection not typically visible in one place
3. Often, though not always, the collection will travel to different galleries
4. Subject of the collection appeals to a *broad audience* (my italics), not just art lovers.

This last point is the killer. We are not talking specialism. We are talking the Tate's Cézanne blockbuster (audience figures 408,668). We are not talking their show of the American abstract artist Ellsworth Kelly (audience figures 34,589). This is broad-brushstroke art from artists we already know, not artists we can discover. With the Monet, the Cézanne, the Picasso comes cash, in great big bags marked TOURISM. In 1993–94 the estimated contribution to London's economy from exhibitions was £17 million. Visitors to exhibitions spent £47.89 a day. They spent an average of 4.7 days in the capital per visit. Do the maths.

The Tate did; the Guggenheim did, discovering in Frank Gehry's spectacular titanium-clad winged giant of a ship of a museum that art not only revitalized Bilbao, but also a huge chunk of Spain. Pilgrims came from across the world to drink at the waters of the new religion that was modern art.

'The model of the museum that we had all come to know and love was more or less obsolete. New things had to happen,' says the director of the Solomon R. Guggenheim Foundation, Thomas Krens. His museum in Bilbao replaced the idea of the art gallery as a refined, quiet holding place where art takes centre stage, with the concept that paintings can be as useful as a car factory in recharging an entire region with financial stability.

No wonder that cities are now hammering at the Foundation for a Guggenheim of their own. Or that in Britain, Stratford-on-Avon – a town one assumes is drowning in cultural tourism – has actually contacted the Tate since Tate Modern arrived, equally keen for Sir Nick to give it the nod.

However, even though a calculated, mature pitch had been made to the nation that day in 1995, and the McKinsey report had given final authority to Serota's Big Idea, surprisingly the money did not come easily. In the end, Tate Modern, as the unwieldy TGMA was rechristened, got some £70 million of public money. £50 million came from the Millennium Commission, £6.2 million from the Arts Council of England, and £12 million from English Partnerships. The remaining £66.3 million had to be ground out of the private sector.

'I'm sure that it's easier to fundraise now than twenty or even ten years ago,' says Serota over lunch. 'But it's still not as easy as it should be. The government has not done enough to remind people that they only pay 40% income tax, which compares very reasonably with the rest of Europe. And yet since that lower rate was introduced we haven't seen any notable increases in the amount people are giving away. The climate of giving is not like it is in the States because the government hasn't encouraged it.'

That's not all. 'A surprising amount of the big money for Tate Modern came from abroad. And when I say the big money, the largest donation we had from anybody was £3 million, which is not very much when you consider that

'I remember what it felt like not to know.'
Sir Nicholas Serota, Director of Tate

the Sainsburys gave thirty or forty million to have the Sainsbury Wing at the National Gallery. Other than that, most of the money we had was between half a million and one million pounds for naming galleries.' Companies who gave a million got big galleries. Skinflints who parted with half a mill got tiny galleries. 'We also had 24 companies who gave us £250,000 each, for the privilege of entertaining in Tate Modern for the next three years. And those were the largest corporate donations we had.'

Serota is never anything other than perfectly polite. However, he has clearly been exhausted and irritated by the struggle to wrestle cash from the tight-fisted British. 'In this country, systems of social advancement don't tie around money in the way they do in the States. The class system remains a significant factor here. In America, if you make a lot of money, it's expected that you will give it away. Whereas in Britain, there are people supporting the Tate who have given £100,000 over three years. We discovered that was the biggest financial commitment they had *ever* made to a charity. And these are people earning £2 million a year in the City. Seventy per cent of the money we had from British donors came from the Jewish community. Because there is a cultural imperative there that if you have made money, you give it away, and all of them were self-made. This is not true of other areas.'

Art, for Serota, is something of a mission, it's true. He may look like a fastidious aesthete – *chez* Serota he probably is – but the idea of a place where people can run about his galleries in shell suits is more his bag than a private collection like, say, the Frick in New York, which bars children under the age of ten.

'I remember going to see an exhibition in Cambridge when I was a student which was a show of three Pop artists: Jim Dine, Richard Hamilton and Peter Blake. About five years later when I was working at the Arts Council I met the person who made that show. And I said what a fantastic show it was, and how much I had learnt. He was very deprecating, he said it was very insignificant. And I said, "Well, I remember what it felt like to learn a great deal, and what it was like not to know." My biggest difficulty now is trying to remember that.'

Yet instead of drumming art education down people's throats, Serota does it by stealth. He hangs great exhibitions: retrospectives of Picasso, Cézanne, Jackson Pollock. He even chooses to water down the McKinsey insistence on a broad audience by including exhibitions from unfamiliar names. He makes the galleries fashionable by peppering them at reasonable intervals with celebrities. Princess Diana celebrated one of her birthdays at Tate Britain. Agnès B gave away the 1998 Turner Prize. Jarvis Cocker was at the opening of Tate Modern. Serota also insists on the experience being entertaining. You can get an exciting sandwich and pick up a book, or a nice bag, or a Paul Smith T-shirt or a Dinny Hall necklace on your way out of Tate Modern or Tate Britain.

Then he focuses on the public service ethos. A glance at the Events Programme reveals a myriad of courses, lectures, talks. During one month at Tate Britain last year you could have played Patience all day with installation artist Tomoko Takahashi, heard someone from *i-D* magazine talk about Wolfgang Tillmans, attended at least six gallery talks, or signed up for a two-day course on the culture of the West End.

And, bar St Ives, the Tate's galleries are free. Other museum directors in the country may grumble that to secure free admission for Tate Modern, Nicholas Serota grabbed an extra lump of government cash (£30 million, to be precise), which, it had been thought, was to be shared amongst everyone. This may contain a grain of truth. However, the fact is that his empire has not only an enviable combination of sex, art and shopping, but also a Unique Selling Point. It contains the word 'Tate', a brilliant global brand which Serota has taken pains to hammer into the minds of the financial and cultural leaders of the world.

Of course he denies this. 'We didn't invent a brand name,' he protests. 'If there is a brand called Tate it comes from the fact that we have produced some things that people want, not that we sat down and decided to market a new brand called Tate.' Oh, come on. When the Tate changed the typeface of the *word* 'Tate', there was a press release about it. 'Of course we want people to notice what we are doing. We will try to produce information which will encourage people to

notice. We are competing for attention with other galleries... It would be disingenuous to pretend that we weren't,' he says, disingenuously.

A perfectly attired waiter appears at his elbow. Instantly, Sir Nicholas morphs from brand-meister into charming dinner party host. He even becomes a little bit coquettish. 'Would you like some double chocolate fudge cake? Some pear and hazelnut tart? Hmm.' He scans the page. 'They have clearly gone onto the winter menu here.' He looks up. 'What sort of coffee would you like?' What *sort* of coffee? How things have changed.

He agrees. 'This summer you couldn't go to a social gathering without meeting people who had an opinion about whether pictures should be hung chronologically or thematically.' He laughs delightedly at the seeming absurdity of it all. 'People are much less hostile to modern art. They are much more ready to grapple with it. I went to a dinner party and met someone who was plainly not interested in modern art. But she had heard I was coming to the party. And whereas ten years ago, she would have said, "What's all this modern art nonsense?" she actually said, "I've been to Tate Modern and why is it art?" She was prepared to sup with the devil. Even if it was with a long spoon.'

Serota finishes his coffee, rises from the table. He is being completely charming. I mumble something crazy. (I was once so flustered by the Serota Thing that when I was next to him at a press lunch I managed to throw an entire glass of water over his plate.) 'I have a trustees meeting. Can't be late for the trustees,' he says, raising a complicit eyebrow as if suggesting that I, too, run a national cultural empire and know what a pain it is to have trustees to meet.

Of course I am not alone in this. 'He is an unrepeatable man,' says Penny Govette, collector, hostess and self-confessed art groupie. We are sitting around a dining table which can host meals for forty at Penny's East London home. Penny is dressed in a Jean-Paul Gaultier orange jumpsuit. On the wall are a dozen huge signed prints by her friend Damien Hirst. We are eating olive-infused bread and roasted peppers. Truly, this is a British contemporary art experience. 'Nick thinks of everything. If he is behind something, we really have to watch it. Unlike previous Tate directors, who all wrote books, his passion is

contemporary art. He was the first director to really have this passion. They could so easily have hired a scholar but they didn't. To raise all the money for Tate Modern he must have spent the best part of his life chatting up captains of industry, which is normal in America but unusual here. And he can really decide who is an artist and who isn't.'

Just up the road is Maureen Paley at Interim Art, one of the grooviest commercial galleries in town. Maureen Paley is a fastidiously groomed American with a self-confessed shoe fetish. Black hair scraped back, bright red lipstick, black suit. She is the archetype of what the art world now calls a 'gallerist'. Dealers don't call themselves dealers anymore. It's too blunt for people who have a curatorial urge as well as a selling one. Anyway, Paley has been a gallerist, style icon and art leader in London for years. And she's a bit of a Serota fan too.

'When he was at the Whitechapel [1976–1988], it was very important. Openings there were glamorous. They were exciting. You never wanted to miss them. People came from far and wide to see what Nick was doing. And he always did things in a completely intelligent way. There was a high degree of professionalism about the way he ran things, even then.'

However, she's no slouch herself. Interim Art started off in 1984 in the front room of her own home in Beck Road, E8. Now it's quite the thing to have art in a domestic setting. Then, it was a revolution. It's also become something of a cliché to open a gallery in the East End, but back in 1984 the idea was akin to opening in Bognor Regis. Cork Street and the blue-chip galleries ruled the art roost, and that was how it was meant to stay. The only place where innovative new art could be seen was at Nicholas Logsdail's Lisson Gallery in West London. However, Paley and a fellow dealer, Karsten Schubert, had noticed something was going on. 'I think I realized it when I first met what is now considered the original Brit pack in 1987, just before the time of "Freeze".'

Ah, 'Freeze'. The show which has long reached the status of myth. Conceived and curated by Damien Hirst when he was still an art student, it launched not only him and most of the first wave of YBAs but also the idea of art as a young, sexy, commercial event. Here are the key points about 'Freeze'.

It took place in a warehouse. Critics were ferried to the show by taxi. Charles Saatchi turned up. Important companies sponsored it. Loads of young artists went to it. The term YBA was coined. That was 'Freeze'. On with the story.

'Being avant-garde was part of my position. But it is indeed something which goes *before* everything else. Often the ground is prepared by people who arrive too early. However, what you want is that the rear guard and the troops are also about to turn up. What is interesting is when people arrive after the ground has been prepared and they can legitimize all that earlier activity.'

Paley was ready with her gallery. 'It was more like a project space. Making an occasion. The whole idea of hosting events, of artists meeting artists. I was doing it in the East End and Karsten was doing it in the West End. It created an atmosphere. It made people sit up and take notice.'

Her approach was a clever combination of authority and innovation. 'I realized the way to create a magnet would be to show the known and the unknown. Early on I managed to show artists who were very established, like Robert Mapplethorpe or Cindy Sherman in group shows. I put new artists back to back with international artists. And it was the first time that young artists could show with a gallery that had an international atmosphere. Suddenly there was an alternative outlet.'

There were dinner parties for artists. The artist Georg Herold came over and showed caviar with Karsten Schubert in the West End and cod's roe with Maureen Paley in the East End. Clever stunts which now, in our marketing-saturated climate, seem more like gimmicks, but in those sincere days were anything but.

Suddenly the door bell rings at Interim Art. I should say at this point that the gallery is no longer in Paley's front room but in a fabulous new space, all chrome accoutrements and metal sliding doors and big white walls. She rushes out of the office and greets an old friend, a collector who was just passing by. In the old days, people would make appointments before venturing all the way out to the wild East End. Now there are so many galleries here that people simply get on the tube and walk from one to the other.

'It's more than a movement. It's a phenomenon.'
Maureen Paley at Interim Art

In the interim I look around Interim. There are lots of books, mostly about Paley's stable, which includes Paul Hamlyn award winner Paul Noble, and Turner Prize winners Gillian Wearing and Wolfgang Tillmans (he has a studio upstairs). There are some interesting faxes on the desk. One is from a gallery in Germany desperate for some images from Interim. One is from the Tate asking for a quote from Paley for its new show, 'Century City'. The other is from Tracey Emin, appealing for money for Great Ormond Street Hospital.

The letters say a lot about the status of modern art and also the status of Maureen Paley. She acknowledges that, in the past, in order to get respect from taxi drivers she would say she worked in advertising. 'Nowadays I admit I run a gallery.' Paley is trendsetter, historical presence and establishment figure rolled into one. She appears in *Vogue*. She even gives style tips to tabloid newspapers.

She marches back in. 'Again,' she says, crisply. 'When I think of our times and the way that things have emerged, I realize I began by trying to break new ground. But it is never about one person. It is like a Renaissance tableau. The iconography is very much about how everyone is playing their role.' She puts her manicured hands palmside up, as if supporting a myriad of pedestals. 'It is completely about the sense of how everyone fits ... and makes the miracle.'

It is rather miraculous. How in the mid-1980s a few curators who worked in middle-sized, publicly funded galleries, and some dealers, some collectors, some teachers and a flock of artists in their early 20s all had the same idea almost at the same time. Popular culture, the experience of urban life and a self-confidence perhaps born of the Thatcherite years, mixed with a huge amount of showmanship and a fastidiously professional acumen for business, ignited something which set off a chain reaction.

'In the '80s art people would say you don't need to stop off in London,' says Paley. 'You would go straight to Basle or Cologne. London is now a necessary stopping-off point. There is not just one wave, but a second and a third. You are not talking about a scene. It's more than a movement. It's a phenomenon.'

Was it a product of the Thatcher years? At the Royal College of Art I request an audience with the rector, Sir Christopher Frayling. Cultural historian, writer

and broadcaster, Frayling is a person who has a lot of ideas and is only too keen to chat about them. 'Of course, of course. Always ask a busy person! They can always fit you in! How about tomorrow?'

We are in the rector's nice big office while legions of traffic shoot silently past the window along Kensington Gore. The thing about Frayling is that once he is in an institution he is very difficult to winkle out. He was about the only luminary in the Arts Council to survive a cull in the mid 1990s when business über-meister Gerry Robinson rolled in, and he has been at the RCA for about a thousand years. Which suits my purposes very well.

'Hirst and all the "Freeze" generation were absolutely children of the 1980s. In the 1980s there was a convergence of advertising and art. Until then, advertising used Old Masters. If you launched a brand of cheese you used the *Haywain*. An oil rig owned by Shell would be shown alongside a Turner. Then slowly, in the middle of the decade, people decided to use something a bit more hip, as if to say, "Hey! We know who the in-crowd is." They started to use avant-garde art for the first time. Well, the first time in recent years. Of course, Magritte and de Chirico did ads too, don't forget.'

I won't. 'Something happened in the mid-1980s. It was partly to do with the medium, with the advance of digitization which made the capturing of images easier. It was also to do with a new emphasis on marketing, a richer culture in the high street and a radical interdisciplinarity in art schools where all the old hierarchies between art and design and engineering broke down. All these things seemed to come together.

'Fine art students had to start learning business skills. I had to break that news to the students, and I really thought I would have to wear a tin hat for fear they might chuck things at me. I remembered artists in the 1970s who thought their role was to put two fingers up at the establishment and deliberately produce art which was unexhibitable. They didn't want to be marketed. But these were the children of Thatcher. There was an idea that they ought to be more hip to the real world. I was swamped. They wanted to know how to get on, how to charge commission, how to get an exhibition in Cork Street.'

The art schools were and still are to a certain extent the obvious place to foster a cultural revolution. They employ a huge variety of freelance teachers, whose ethos is not about vanishing into some ghastly campus culture but getting their students to join them in the real world.

Let's go back to the pristine modernism of Michael Craig-Martin. The giant painting which hangs in his house shows everyday objects cut out and crystallized in bright colours and black tape outlines to a flat, planar system. There is no depth. There is no expression. One has to focus on the nature of the things. It looks both modern and also ancient, with its lack of scale or perspective. A vast ring of keys floats beside a bucket, itself wedged alongside a globe. It is a clear, instantly recognizable signature. The school of Craig-Martin.

The other school of Craig-Martin was at Goldsmiths' during the 1980s. Craig-Martin and his colleague Jon Thompson, who was head of the Fine Art Department, essentially allowed their students to believe that they could forge their own careers as artists. 'I would plan on seeing all of them once a week. But the other thing that happened at that time was that every six to eight weeks I started to give seminars,' he says. 'I asked my tutees to bring along everything they had done since the last seminar. I said, "If you haven't done anything, you can't come. There is no audience. There is only participation. And you have to have done work in order to come."'

Who were the students? Damien Hirst, Sarah Lucas, Gary Hume, Simon Patterson, Mat Collishaw, Michael Landy, Abigail Lane, Fiona Rae... Most of the now-familiar list of YBAs.

Craig-Martin continues. 'At that time the school was in the Millard building. And it was a very small building. Very compact. I could arrive in the morning, run up the stairs and run back down through the studios ... and I could see every single thing that a student had done since the last time I was in. And if I found anybody else who I thought was doing something terrific, I would say, [in a laconic voice] "Wanna come to our seminar?" I was trying to constantly bring in one or two new people, because it would be a good experience for them and it would enrich the experience for the others.

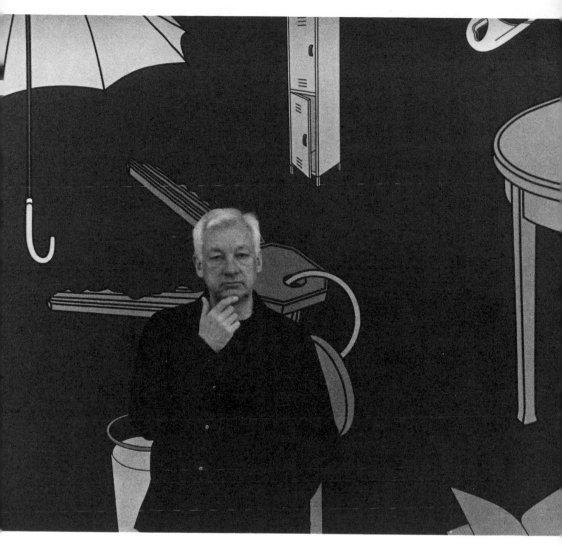

The enabler: Michael Craig-Martin in front of a Craig-Martin.

'The seminar would start at 10.30 am in the biggest room we could find. Every single thing they had done was ranged out. And every single bit of work was looked at, and every single person had to talk about every other person's work. We would go on until the end of the day. We might have painting, sculpture, performance or video. People got used to criticizing stuff. What was right and what was not. What was working and what was not. And you didn't bring one thing. You brought everything. So if you had more than anyone else, you dominated the room. It was very simple.' Craig-Martin clearly loved it.

'In the beginning I did most of the talking. By the end all I had to do was introduce people. Some people spoke more than others. Some you couldn't shut up. But the thing that was fantastic was that if a person had done a work which had *dramatically* improved, if they did a work which was *really* successful, then everybody in the room knew it. It was *obvious,* each week, whose work was the most successful.

'Well... people learned from that experience. And people became jealous of each other. These were very ambitious people. So Gary Hume might go away and by the next seminar, six weeks later, he would come back having done these fantastic new paintings. And the next time it would be someone else. So there was a momentum of *upping the stakes.* And by the time they reached the end of their time at Goldsmiths' they had upped the stakes more than any other group of students. Now I encouraged that, but you can't say I was teaching this. It is a very complex thing that happens in education.'

It explains a huge amount. The group ethos. The group shows. The competition. The blaze of desire to win. Anything. Sponsorship deals, television shows, the Turner. The best galleries. Did Craig-Martin know it then? 'Even I, at the time, did think those kids were so unbelievable that there was a real possibility they could be the next generation. And I had never thought that before. They were something special. I tried doing the seminars again when I came back to Goldsmiths' in the '90s, and it didn't really work.'

Did that matter? Not really. The work was done and the chain reaction had begun. 'It was all Goldsmiths' people at first. But the net was constantly being

cast wider and wider to draw in more people. Usually if you have a success with a certain group of people the tendency is to close ranks and draw the net in as tightly as possible, to exclude everyone else. Here, however, the absolute opposite happened: by the time of the second exhibition there were people not from Goldsmiths'. And of course the effect of that was that it mushroomed.'

Craig-Martin, who famously exhibited a glass of water and insisted it was an oak tree (apart from when he once took the piece through Customs for a show overseas and then had to admit it was a glass of water), is a master of definitions. Here he has no illusion. 'I know there were people – international people – who thought it was a flash in the pan, over by 1991. And I always thought it wasn't like that. If the thing that initiates it is strong enough, it produces a ground level of things which is so rich in itself that it isn't going to collapse when the people who began it start to become less interesting. London has become so powerful that now it is self-generating. It doesn't depend on the Tate, or Nick Serota, or Charles Saatchi. It doesn't depend on Damien Hirst or Rachel Whiteread. It has its own organic existence and there is no need to imagine it can't go on.'

# CHAPTER FIVE

# FUN

## the feel-good factor

It's a sunny afternoon. A small band of people are standing on the concrete terraces surrounding London's Hayward Gallery. A tall, thin man is facing them. He beats time on the ground with a long stick. 'Okay. Read through this in a deep voice. One, two, three.' The choir starts to read from sheets of paper. 'Cin-dy Lau-per Said The Rock Cakes Were For Chuck-ing At The Cop-pers.' Welcome to an art event by Bob and Roberta Smith.

Several passers-by stop. One is carrying a bag from the London Eye. His partner is carrying one from Tate Modern. The carriers reveal the perfect fusion of tourism with art, entertainment with soul-improving aesthetics.

'It seems to sort of fit. Instinctually. Doesn't it?' says the conductor. The choir giggles. The crowd looks bewildered. 'Now. Again? Deeper. And louder.'

'CINDY LAUPER SAID THE ROCK CAKES WERE FOR CHUCKING AT THE COPPERS!' shouts the choir.

'Again. I am going to speed up here. Keep your voices low!'

He beats his bamboo stick faster and faster on the paving stones. The choir gamely keeps time.

'Higher! Lower! Faster!'

The choir yells the catchphrase.

Eventually the baton breaks.

The choir collapses into laughter.

'That's good. Well done.'

Under the instructions of Bob and Roberta Smith (who is one person), the choir then divides into two. Some people play *The Star Spangled Banner* on toy instruments. Others play 'Improve the Cat', which basically involves putting plasticine heads onto decapitated china felines. Finally everyone carves up parsnips and carrots and makes mini fighter planes.

Of course, the concrete terraces of art centres up and down the country have long been exposed to this sort of malarkey. Art 'events' have long been around, from Yoko Ono being cut out of her clothing, to the sculptor Jean Tinguely setting a cavorting piece of machinery to self-destruct at the Museum of Modern Art, New York, or Joseph Beuys taking full personal responsibility for any snow that fell in Düsseldorf during February 1969.

Yet now the tone has changed. The audience for Bob and Roberta Smith's choir consists of tourists, a trio of confused Koreans, some parents with small charges and four young women in flares. Which is important because not so long ago, there was a time when such events were private, coded things.

Unless the event was something absolutely huge, like the artist Christo wrapping a million square feet of the Australian coastline in plastic sheeting, art spectacles tended to be witnessed by an invited audience. Tickets were only reserved for the keepers of the flame. If 'ordinary' people did get involved there could be a hell of a reception. I was once at an extraordinary live art experience in the Lake District which ended up with fights in the village disco between infuriated locals and nude Neo Naturists, and policemen standing guard all night on the door of the 'art space'.

Another event, about ten years ago, involved prostitute-come-performance-artist Annie Sprinkle doing her Lurve thang in a Newcastle hall. There were restrictions, but only with regard to who came to watch. It was by invitation only. We had to do things in our seats like shake canisters of beans while Annie did things on stage like reveal her cervix with the aid of a concave shaving mirror.

People either queued up for the cervix experience or merely sat quietly on plastic chairs, shaking their canisters and nodding their heads seriously.

The next day there was a Sprinkle Seminar at a local hotel. Again, it was for invited 'delegates' only. The whole publicly funded event was deeply liberal but only to the right people. I remarked upon this dilemma in print. What followed was extraordinary. Abusive messages on my answering machine. Haughty articles in art magazines. A heated exchange on the letters page of one of them. And an Edict. 'Rosie Millard is persona non grata with the Arts Council.'

Are artists more confident these days? Are they more 'people'-orientated? Whatever it is, they appear to be happier working in the polluted air of real life than in the rarefied atmosphere of the in-crowd. And the mood has changed, too, from one of serious despair ('What's going on in this mad world?') to one of hilarity ('What's going on in this mad world!'). Art Events used to be nothing but faux-seriousness and pomposity during which you looked at the artist three times and your watch 300 times. Now they are full of delight and amusement. Hurrah. I'd rather have a good laugh with Bob and Roberta Smith on the terraces of the Hayward and come away with a sculpted parsnip.

'I have a serious purpose but the interface of my art is very important,' says Bob and Roberta, who is in real life called Patrick Brill. 'There has to be a point of conversation. One of those points is weight, but the other is humour. If you make someone laugh, you have totally got them. Totally. There are people who make you laugh, and they are called comedians. But they are artists as well. It's all about communication. My art is driven by the aim of having the best means of communication.'

Last year at Tate Britain he encouraged people to write down ideas for Bob and Roberta Smith to turn into posters, using a childish script which has become synonymous with his work. He got 15,000 suggestions in one week. 'Bob and Roberta Smith is really about exercising one's freedoms; a model to show people they can think in different ways. My idea is that we are all mad people who can come up with concepts. I don't think everyone should be making model aeroplanes out of parsnips; it's just to inspire people. Bob and

Roberta Smith are a fiction, allowing people to take part. The whole choir could be Bob and Roberta. There are Bob and Robertas in Japan. There are two in Germany. It's like James Bond, or Dr Who.'

He has a devoted following. I chat to one of the choir members, former policeman and Sunday watercolourist turned art student, Roger Adams, who was happy to explain why he has abandoned dainty brushstrokes in favour of playing *The Star Spangled Banner* on a kazoo. 'I've done all sorts of things with Bob and Roberta Smith,' he enthuses. 'Walking round Aldgate shopping mall singing about Joseph Beuys as if we were in the army was one adventure I remember particularly well. This sort of thing just allows you to enjoy life and do art. There is no great intellectual thesis about art. Everyone can go out there and do it. It's so different from twenty years ago. We have done away with post-expressionist abstraction and all those gloomy paintings. There is a great new British art movement that is about fun, and it is brilliant. It's about doing your own thing. Everyone can catch on.'

But it's not really about marching round shopping malls singing silly songs. Is it? 'My thing is to try and make the interaction – where someone thinks that they are encountering "art" – as relaxed as possible,' says Bob and Roberta. 'So that it is not charged or edgy. I try to get people involved in all sorts of different ways. I am not just a maverick character with a mad vision of the world. My vision is much more of being a sort of conduit, where you can reflect people's desires and ambitions for the world to be different.'

And fun. Yes, FUN. Art hasn't been so amusing for years. Possibly inspired by the slacker scrawl of New York artist Sean Landers, a whole mini-culture of jokey cartoon artists has arisen. Biro scribbles from the likes of Georgina Starr and Sophie Calle; the hilarious drawings of David Shrigley, who was also selected to design the canteen plates for financial communications giant Bloomberg (he wrote the company name as a squirt of tomato ketchup); the comic capers of Adam Dant, Cartoonist in Residence at the *Independent on Sunday*, who has done work for Internet gallery eyestorm.com and whose Donald Parsnips alter ego has been exhibited at Tate Modern.

FUN

Keith Tyson's *Spellbook*, which describes the 'creation of magic items', is another good example of the giggly feel swarming around the art world. Armed with a Tyson *Spellbook* you can wave an artistic wand and turn a normal 100W bulb into 'The Light of Awareness', a window into 'A Supermicroscopic Window Pane', or a piece of pavement into 'The Paving Stone of Trailing Desires'. And how about Tyson's *Tabletop* series, an ongoing display which presents maps configured and inspired by the coffee stains on the surface of tables? Or his work which used a torch to send a Morse code message to the moon? Or his cast of a Kentucky Fried Chicken order in lead? Shall I go on? Tyson says much of his work is inspired by the unpredictable outpourings of a computer. Maybe so, but the tone perfectly fits a current jocularity of spirit epitomized by the Louise Bourgeois fairground attraction sculptures, with their mirrors and spiral staircases, chosen to decorate the Turbine Hall during Tate Modern's first six months.

You can even take part in the vogue for Art Comedy by joining the Band of Nod. Sign up, and in two days you could be marching down the road in a Dalmatian outfit singing *Spirit in the Sky*. The Band of Nod is the choir of artist John Strutton.

'It's a forty-piece band,' says Strutton, painter, print-maker, performer and leader. 'It's a project which is less about the performance and more about the logistics. I supply all the costumes and the instruments. There is no ideology or theology, but it is very cultish. The whole thing is to do with how people, in a faithless age, can behave as a group.'

He slides a video into a recorder. 'Watch this.' I watch. Thirty to forty adults, the sort of people who normally settle down to *Cold Feet* and a Chinese takeaway of an evening, crowded into a smallish room and all going bonkers. Screaming and shouting out the words of *Blockbuster*.

'I choose the sort of songs which sort of burst onto your consciousness. The songs where, when you hear them, you simply *have* to leap up and dance. They break into your memory,' he says. 'Twenty people are playing kazoos. Twenty are playing guitars. The kazoos are screaming at the guitars. As they lean forward, the guitars go back. Now the guitars go forward. We are all dressed up

in matching kagouls. I have done all the choreography for this. No one pays me to do it. I sustain it on my own enthusiasm. It serves as a purpose for people. Look at them! They are off their heads! And this is just a rehearsal! It's about an ecstatic experience. If I cancelled the performances, people would still turn up to rehearse. It's just wild. Who are they? Everyone.'

He points to the various crazily yelling people. 'Builder. Builder. Art lecturer.' They have moved onto *Shout*, by Lulu. The atmosphere is, if possible, less contained than before. 'A vintner. My brother, a scientist. It started out as a one-off but people loved it so much, I kept on doing it.'

Strutton says his art supplies a need, and I believe him. If your life is bounded by the work ethic and money and commuting and *Cold Feet*, then there is nothing quite like donning a Dalmatian outfit or a kagoul and getting into some 1970s pop anthem. Because it is conceived by an artist, it somehow becomes a credible activity. It's like playing a team sport without Wednesday night training sessions, or supporting a football team without having to be a bloke. It's like amateur dramatics without the embarrassment factor.

'Most people would love the group activity of going to church. But what bogs people down is the morality. Whereas this doesn't have any morality,' explains Strutton. 'It is a pure belief in nothing. Or the belief that you can be Brian Connolly from Sweet, or Cruella De Vil. People come to the Band because they want to be close to someone who has the key to that sort of space.'

On the screen is the Band in white boiler suits, their faces painted orange. 'They are doing Willy Wonka and the Oompa Loompas!' he says excitedly. 'I've dramatically slowed down the tape. They are singing *Blockbuster*. But you know what? When you slow down *Blockbuster* you get the sound of speaking in tongues. And it's a sound that I interpret.'

I go and see Strutton at one of his artistic 'one-offs' where the core of the Band of Nod is playing for the opening of a Strutton show at AVCO in Shoreditch. The usual crowd of thirty-somethings has arrived: beer-drinking (but not too much), baby-toting. We are all herded downstairs into a tiny basement where we sit on the concrete floor. It's a bit like something in the 1960s.

'OK, everyone, can you all turn your mobiles off?' shouts the curator. Well, maybe not.

The band consists of John Strutton, his brother, his father John Strutton Sr and two friends, one of whom plays the cello. All wearing black tie, they walk in through some French windows. A body, totally covered in a blanket, lies on a campbed near the amplifier.

The band start to play. They are playing a really familiar song; an anthem, even. From the 1980s. What is it? I have what Strutton has defined as a 'memory moment'. What is the song? What is it? I know it... I know it really well... Oh *God.*

'Good evening,' says John. 'We are gathered here tonight to reach out through the darkness... To listen for a voice calling out through the wilderness... And remember our dead... Tonight's attempt to communicate will be conducted by the legendary Mr Bert Kwouk!'

The band gets into the song proper. John Strutton Sr steps up to the microphone and begins to sing. Well, speak, actually. 'Monday mornings. Going slow.'

What is it, what is it? *Nightmare.* What is it?

'Memories of the night before. I think it's time to cook a meal... To fill the emptiness I feel... Waiting for a visitor but no one knows I'm here for sure. Dancing. Laughing. Drinking. Loving... And now I am here all alone in Bedsit Land... My only home...'

Of course. The incomparable Marc Almond. Brilliant. Everyone around me is looking bright-eyed and bushy-tailed at John Strutton Sr. We all used to dance to this. There's a wave of the nostalgics going on.

The song finishes with a flourish. Weird horns sound. The body under the blanket stirs, sits up. The blanket falls back. It's Bert Kwouk! He holds an old radio to his head. Meanwhile a soundtrack from *Hancock's Half Hour* plays. It's some jest about London radio talking to Tokyo radio. The gag is that the Chinese correspondent in Tokyo cannot say, 'It's not raining.' Instead he says, 'It is are raining not.' Kwouk plays it out manfully, saying the punch line about forty times. Everyone is laughing. He plays with some plastic toys on a bench. He then reads

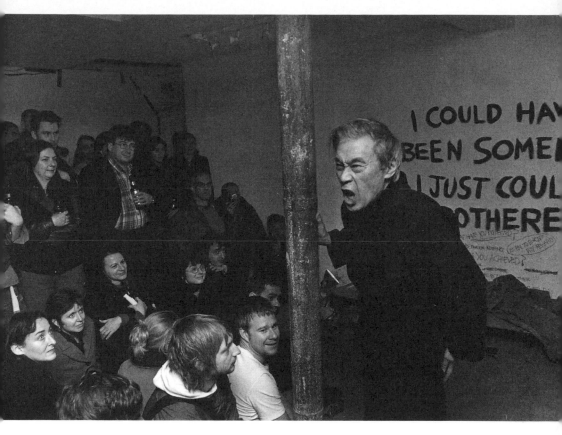

Bert Kwouk helping to make John Strutton's private view memorable
in Shoreditch, East London.

some BBC Producer Guidelines from the 1950s which are delightfully predictable ('There must be no mention of lavatories or suggestive references to honeymoon couples...'). Bert Kwouk is very charming and sings along to Joy Division's *Love Will Tear Us Apart*. He even does a Peter Sellers/Cato 'Ah-So' kung fu movement. Everyone applauds. He falls back on the camp bed.

Afterwards people line up to shake Kwouk's hand and call him a superstar. I ask him if he often does art 'happenings'. 'No, never. I did this because no one ever asked me before. Do I like contemporary art? Not really. Who can afford it? You have to be called Saatchi. I just go to the National Gallery and look at El Grecos.'

John Strutton comes and sits beside Kwouk on the bed. I tell him about remembering that Soft Cell track. He is very pleased that I achieved exactly the sort of 'halting breakthrough' he had intended.

Perhaps Michael Craig-Martin was right. Artists have been given the reins of some type of command. We want to be associated with them. It does us good. We feel it will do us good. We are all in the Band of Nod.

Of course, you can always go back to church. It's a crisp autumn evening in the Tuscan city of San Gimignano. You are standing beside Il Duomo, the Cathedral. Its bells suddenly begin to ring with a vaguely familiar tune. There is a very faint answering peal from San Agostino, about 200 metres away. The bells are duetting for about two minutes before you realize that the tune they are playing is *Frère Jacques*. This happens every night at 7 pm.

Don't the Italians mind it? 'No, not really. Apparently they are really into it,' grins artist and creator of the piece, Martin Creed. Creed is like a big Airedale terrier, with a nice friendly face and an absolute need to be loved. 'It was actually very hard to orchestrate,' he says of his church piece. 'Between them the churches only had seven bells, and they play in two different keys. It was rather like a Les Dawson thing. You know, where he plays off-key all the time.' He giggles. Like Bob and Roberta Smith, Creed takes his art seriously. But he also wants it to be fun. He wants his art to be accessible and, to make it so, has chosen the path of amused delight.

The man who sent a crumpled ball of paper to Tate Britain: Martin Creed.

His work includes other dynamic installations, such as 39 metronomes beating time, all at different speeds; Work No 254, 'The lights in a building going on and off', which is just as it sounds; Work No 142, 'A large piece of furniture partially obstructing a door', wherein a large table ... obstructs a door; and sculptures such as Work No 121, 'A crumpled ball of paper' (apocryphally, he sent one of these to Nicholas Serota at the Tate, from whence it was returned in an envelope, neatly smoothed out).

Creed is joyously free-ranging. He is in a band, owada, for which he has written out his visual pieces as pieces of music for the band to play, or for anyone to sing. In fact, anyone could imitate him by doing something really quite simple, like turning a light on and off. Or opening and closing a door. Or blocking an entrance with a large dining table.

Creed loves neon signs. One of them is affixed to a former orphanage in Clapton in Hackney, East London. It says EVERYTHING IS GOING TO BE ALRIGHT. The neighbouring borough of Tower Hamlets could learn a thing or two from Hackney. In 1993 Rachel Whiteread installed in Bow a life-size cast of a terraced house. It won her the Turner Prize. Ten weeks later Tower Hamlets Council insisted on tearing *House* down. Creed's EVERYTHING IS GOING TO BE ALRIGHT went up in 1999 and is still going strong – although the neon might have run out by now. It's a major sea change. This could perhaps be due to more people liking Creed than Whiteread, but I doubt it. Councils, and companies like Adidas, used to be hostile to art. Now, like Adidas, they want things to 'look like art'.

Although there's a lot of Idea going on with Martin Creed, he denies he's a conceptual artist. Even the Crumpled Ball is, according to him, 'an attempt to make something, to find beauty in a piece of paper, in something discarded as rubbish. I just hope the public finds it, too. I wouldn't say my work is conceptual. I think my work is about feelings. I simply make art because I have a feeling that I want to make it.'

Or not. Martin Creed's works poke out of the wall, and dive back into the wall at the same time (Work No 172, 'An intrusion and a protrusion from a wall').

They are something and at the same time nothing, which goes some way to explaining the curious formula he produced on the front of Tate Britain for its relaunch. Written in neon on the neoclassical Victorian façade of the rebranded, rechristened gallery were the words THE WHOLE WORLD + THE WORK = THE WHOLE WORLD.

'For a long time I was trying to work with air,' he says. In Work No 202, 'Half the air in a given space', he semi-fills a room with balloons. 'Using balloons is the simplest way to package air and make it visible.' It's the ideal medium for the artist who wants his work to appear and disappear in an equation. It is also a joyous experience, if you can pluck up enough courage to wade into the buoyant centre of a balloon-filled room.

However, as Creed explains, 'Lots of people can't face it. I half filled a whole house with balloons in Sydney at the Biennale. There was a major panic attack as people tried to get out, and couldn't.' It was the reverse of his aim. 'My favourite pieces of art make me smile. I would like to say I want to make people smile, but I hesitate to say that because I am scared of failing in that respect. It's like being a stand-up comedian. You simply can't fail. You have to be funny. And it is much easier to be funny if you are working in a serious context. Which is art.'

I begin to think about his name. It would be just perfect if it was another pseudonym. Did he make it up? 'No, no, it is my own name,' he giggles. 'But I'm happy with it.'

If the current Art Creed is one of getting the audience to smile, then it's not surprising that contemporary art is so popular. Of course it's crazy to imagine that art should be universally hilarious. But when it has been down in the dumps for so many years, the comic relief is welcome.

Which came first, audience approval or artistic gambolling? Impossible to say. But it's a vein which has begun to pleasurably throb throughout all the visual arts. Even the dreaded subject of modern architecture has become ... well, rather amusing. I visit Will Alsop, winner of the Stirling Prize for Architecture for his extremely funky Peckham Library.

FUN

'A library today needs to be integrated with all the things you do in your life. So we built it at the end of Peckham Rye, adjacent to the new pool and gym. The idea was to feed your body and feed your mind. I rather wish we had put a bar in the library. That was a bit of an omission. So you can answer your bodily requirements with a sense of enjoyment. Very often, architects don't think like that at all. They don't think about buildings as enjoyable and consequently the public don't enjoy them either. There is a lack of joy in the whole situation. Whereas architecture is actually the only profession that deals with delight. All the other professions – law or medicine – they deal with doom and gloom. We deal with things that should be delightful and enrich life, and make life better.'

Indeed, it's important to remember that with or without guidance from the heir to the throne, modern architecture was once the thing everyone loved to loathe. Now, a significant number of modern buildings are celebrated, attended, crowed over by their particular local bodies. Alsop thinks it's because the whole method of working has changed, from grass roots on up.

'We have learnt a lot about public consultation and having a genuine trust. And working with the public goes beyond the written or verbal request. Before the 1990s a lot of consultation was just people sitting around housing estates and saying, "What would you like?" But if you give these people a paint brush or a pencil, and get them to do a painting, and then make a few funny old models and discuss them, and then meet up again, very often you find that their ideas are better than yours. They just couldn't articulate them in a formal way. I'm doing it in Wembley at the moment, with a community centre and housing, in an estate where people have been messed around for years.'

Clearly, a dialogue between people and architects is far more desirable than plonking down buildings in an area and asking people to get on with it. What has encouraged this? Possibly the consultation requirements of Lottery grants, which have funded many new builds. Perhaps a growing sophistication in both client and architect, a confidence in the public that modern architecture isn't all Neo-Brutalism. Or perhaps it is merely a wish of contemporary architects to be loved? Who knows? Alsop calls it 'collective creativity', and says it is working.

Will Alsop plus assistant, hanging out at his hangar in South London.

'A dialogue encourages acceptance of modern practices. You could say we are in a post-style, post-theory age. Which is quite interesting. We are at a cross-roads, where tapping into an innate creativity that exists within society is very important, if used in an intelligent way. And it can unleash all sorts of things.'

Even the re-growth of a town centre. Alsop's Cardiff Bay Visitors' Centre was built with the expectation of 25,000 visitors a year. Three years on, visitor numbers have reached 450,000 a year, with a significant impact on the extension of the city limits to the waterfront. The new Peckham Library gained 3,000 extra readers in its first year. Is this because the building is new, fresh, encouraging, modern? People want to be involved with new buildings. Contemporary architecture, like art, has linked up with the public in a reciprocal way that breeds confidence and participation, not fear and loathing.

Driving down the road I see a large installation by Bob and Roberta Smith high up on a billboard. PEAS ARE THE NEW BEANS, it says, in the peculiar Bob and Roberta Smith font of bright household colours and childlike capitals. This is probably what Bristol Council want from FAT's signposts: art on an ordinary street. I recognize the poster as art and I also recognize it as a Bob and Roberta Smith artwork. I am happy to do so. Obviously there is still a buzz you can get if you feel you are part of some club. The only difference is that in the old days the Art Club was private. Now everyone, whether via posters, bells in a Tuscan town, or antics with Bert Kwouk, can be at the party.

# CHAPTER SIX

# FAME

## when artists turned into celebrities

According to Freud, all artists want is fortune, fame and women. 'Or the three Fs', as a senior curator at Tate Modern succinctly put it, observing that in his experience many older artists have got the first one, but it is the lack of the second which irritates them. Particularly as an entire generation of British artists now enjoy their fame quite casually. Fame is part of their story.

'The other day I was coming away from the luggage carousel at Heathrow,' says Christopher Frayling at the Royal College of Art. 'I saw a photograph of Tracey Emin, who was one of our graduates. In the picture, she has bright blue eyes. And her face was next to a bottle of Bombay Gin, which has a blue label. The slogan said "Bad Girls like Bombay Gin". They didn't even have to say who she was. I have no idea what people arriving from Saudi Arabia make of that, but the assumption is that people in this country know who she is, associate her with radical art, and in some strange way associate it with a glass of gin. And I thought, that is celebrity. That really is.'

What's Fame got to do with it? Quite a lot. One of the signifiers of contemporary art's power is the fame its chief proponents enjoy. Glossy magazines, broadsheets and tabloids are fascinated by them; other celebrities want to be photographed with them, which is always a clue. You are far more likely to bump

into David Bowie midweek at a Cork Street gallery than at some contemporary music event. Elton John agreed to appear on the façade of Selfridges because it was in the context of a portrait by Sam Taylor-Wood.

Naturally the incremental celebritization of the contemporary artist has been fuelled by big sales and a buoyant market, which helps, but it is not the whole picture. Lucian Freud garners vast prices, but he is not quite a celebrity in this sense of the word. His is Old Fame, acquired by talent, years of exhibitions, collectors and a constant body of work, and I'm quite sure he wouldn't want it any other way. New Fame, however, is achieved via headlining, instantly recognizable work, sexy galleries, high profile events, media ease and an extraordinary cross-fertilization into other arenas. Top of the Pops. Advertising. Food. Fashion. Film. Brands. Not since David Hockney painted the fashion guru Ossie Clark have artists fused their traditional world of private creativity with such a popular market of commerce and publicity.

The interesting thing is that these artists are clearly not overly bothered about presenting a 'cutting edge'. Just as French and Saunders waltzed about under the Alternative Comedy flag for years, the YBAs will always seem young and daring for two reasons: because no one has really supplanted them, and because that is how they first appeared. And people are always loath to drop first impressions.

In the foyer at the Saatchi Gallery for the exhibition 'Ant Noises 2', there are over 120 framed newspaper headlines, cartoons and front pages inspired by the Famous Lot; that is to say Damien Hirst, Tracey Emin, the Chapman Brothers, Chris Ofili and Sarah Lucas. Publications ranging from *The Spectator* and *The Telegraph* to the *New Yorker* and the *Village Voice* centred their jokes on sharks, elephant dung and unmade beds, applied to a variety of world leaders including Rudi Giuliani, Bill Clinton, John Major, Peter Mandelson, Tony Blair, Kenneth Clark and an Australian senator. Popular culture has always satirized our leaders. What's different here is that a conventionally highbrow form – the visual arts – is now the satirical semaphore for the general public. It has joined popular culture. It *is* popular culture.

The most famous have of course, become a brand. They are happy to appear in public as a group, which helps create public awareness, but not too often, which could create overkill. And once achieved, fame is wielded carefully.

Damien Hirst only did a few interviews for his exhibition at Larry Gagosian's in New York in 2000. One was for Channel 4, an outlet which would guarantee him more than a soundbite. One was for *Vanity Fair*, an outlet which would guarantee him upmarket glossy coverage. And he had his longtime interviewer of choice, Gordon Burn, trailing him around. Hirst is famous enough to choose how he appears, in order to achieve maximum impact in the 'right' kind of way. *Vanity Fair* is never going to do a hatchet job on him. The photos will be great. And the copy can be syndicated across the world without him needing to do many more interviews, which is indeed what happened.

Hirst has, in effect, realized his prophetic statement and the title of his book: 'I want to spend the rest of my life everywhere, with everyone, one to one, always, forever, now.' It's the same dream as the one less subtly expressed by Madonna, who allegedly came to New York with the ambition of being 'the most famous woman in the world'. And, as with Madonna, Hirst has cultivated his own brand via a series of instantly recognizable totems. His motifs of sliced-up cows, sharks in formaldehyde, flies, butterflies, rotting meat, spinning paint and hovering balls need neither explanation nor introduction.

Has this dulled his edge? Not with his spirit for reinvention. If you keep moving, everyone else has to keep up with you: Hirst is only 36.

I wander around 'Ant Noises 2', investigating Hirst's ash-tray, Emin's bed and Gavin Turk's eponymous model representing the dead Che Guevara. Che is chilling and moving and looks as if he could wake up at any moment. I overhear two women talking. 'Why does this interest anybody? I mean, it's just nonsense...' The other woman picks up. 'Well, when I was at the Serpentine...' And that is the point. The visitor is outraged yet willing to engage. People now wish to know more; they are willing to sup with the devil.

The devil is equally willing to sup with its audience, if you pay for it. Hence the phenomenon of Tracey Emin's Club dinner at the Groucho, famous Soho

drinking and dining club beloved of Hirst and frequented by Emin. Tonight it's Tracey's night. The menu includes hummus, roast rack of lamb and rice pudding. Traditional British fare with a Turkish twist, just like Emin herself. Even the menu is autobiographical. We love Tracey because we know her. We know her because she has turned her life into her art's work, not the other way round as artists in the olden days conventionally did. You don't have to understand art in order to get Emin. You simply have to understand what it's like to grow up in Margate in the latter half of the twentieth century. And to have a riotous old time of it. Cinema has been using this type of plot for donkey's years. Why not art? No one had thought of doing it before Emin, but now it seems obvious.

At the beginning everyone mingles with drinks. It's a rather odd guest list; middle-aged bankers, solicitors, a few people from galleries. Not exactly the sort of type you would imagine would be interested, but when you are a national phenomenon, it can be safely assumed that *everyone* is interested.

The hostess arrives, dressed in her chosen fashion house of Vivienne Westwood. She is extremely friendly, chatting to everyone nicely and checking that we are all fine. After she goes past, people raise their eyebrows to one another as if to say, 'Wow! I just met the scandalous Tracey Emin, and it was OK!' We all sit down at allotted places. Emin's personal fitter from Westwood is at her table. Emin rises to her feet and greets everyone. We murmur gratefully. Then she makes a rude joke. This is more like it.

The programme of events is announced. First we will watch a film which she has just made. Then, after supper, there will be a charity raffle for the Polaroid photographs which are on each table. These signed snaps are of Emin holding her pet cat Docket. I catch various people looking regretfully around as if they had already planned to quietly nick them. There is also a charity Celebrity Wine on the menu. This particular item is a perfect symbiosis between the Groucho wine cellars and tonight's hostess. A 1998 Pouilly Fumé. Château Tracy. A snip at £27, particularly because Emin will sign the labels afterwards.

The film is short but memorable. With her peculiar knock-kneed gait, Emin walks over a small bridge. On this bridge sits a large boxer dog, which

drools appreciatively. A small conversation ensues between Tracey and the boxer in which it transpires that the dog has desires upon Tracey and wishes to go the whole way with her. Tracey tells the boxer to forget it. The boxer looks up at Tracey with large yearning brown eyes. For one mad moment I tinker with the phenomenal idea that we are about to see bestiality on screen with Tracey Emin. So, clearly, does the boxer. But it is not to be. La Emin turns him down and walks off. The End.

The film presents Emin's now classic mix of blatant shock tactics and knowing urbanity. Everyone is very happy. After supper she takes questions from the floor. The questions are reverential, the answers not so. 'Was your *Bed* a real bed?' ('Of course it was. Do you think I would invent those knickers?') 'I thought you were great on the *Today* programme.' (When Tate Modern opened, Emin was interviewed on the phone by John Humphrys and given a typical grilling.) 'Aaahh, cheers,' says our heroine. 'Ah mean, he was the one who rang me up. What a cunt.' The room rings with delighted cheers. Tracey is being Shocking to a Pillar of the Establishment. Someone pulls me to one side. 'Did you know that Tracey was asked for her autograph once. And she wrote, "Dear Cunt, Fuck Off". Isn't that just wonderful?!' This is probably untrue, but such is Emin's fame that she has gone beyond mere reality.

Everyone is now thoroughly warmed up. It's a bit like a wedding. Emin's dad is the guest of honour. He gets up and makes a speech about how his famous offspring was conceived. 'It was July 1959 and [her mother] and I had done everything in the book,' he begins, to a delighted crowd. It couldn't be better. For an artist who has publicly stated, via an embroidered tent, the names of everyone she has ever slept with, almost the only secret we have yet to learn is who slept with whom to create Tracey.

I win one of the photographs in the Docket/Tracey raffle. The night has been an all-round Emin experience. The couture-dressed star has delivered shock value, good jokes, solid British/Turkish fodder, intoxicating drinks, rudeness and a bewildering array of homespun Art. Like any true celebrity she has played up to her archetype while revealing nothing.

Two weeks later she is at the announcement of the shortlist for the Beck's Futures award. The press has turned up, too, but it's not really about the shortlist, which is announced as briefly as is humanly possible. The event is all about Emin, who wears another Westwood outfit to reveal another film, this time sponsored by Beck's, to be shown in cinemas across the country. Beck's is delighted to have made such an exclusive catch. The Head of Branding talks about the deal he made with Emin.

'Yes, you were pissed at the time. Ha ha ha,' says Tracey. Everyone laughs. 'They asked me to do whatever I wanted to do,' she says. 'But they said if it was too rude, there would be no money. I was quite tempted to make it absolutely disgusting, but then I wanted it to be shown in the cinemas, so I couldn't, could I?' Everyone laughs.

In the event the Beck's film is not quite as daring as the sex/dog one, but it is still full of good old English comedy, again starring Emin (naturally), this time running up a hill dressed as if for a Turkish wedding with paper money stuck all over her dress. Afterwards a slogan comes on the screen. 'Sometimes the dress is worth more money than the money.' Emin explains this is a reference to the Turkish custom of pinning money onto a bride's dress at the wedding. She then goes into further detail about the assumed virginity of the bride, and the necessity for bloodstained sheets and so on. 'But she's lost her virginity. So she does a runner!' Everyone laughs.

I catch up with the sponsorship man from Beck's. 'What do we gain from sponsoring this sort of thing? Well, as we say, it's "arts not darts".' He looks around nervously. 'The beer business is full of sports sponsorship. It's a very cluttered market. This helps us *stand out*. You see?' He pauses. 'Although I must admit I would be more confident with sports sponsorship. I understand sports sponsorship.'

Beck's says this film represents the return of the cinema short. A Great British Tradition, exhumed and given back to us by Tracey Emin. Is there nothing she can't do? Although the film cannot really be described as a supporting movie, since it is only six minutes long, it could quite easily pass for one of those

The medium is the message: a recording of the young Tracey Emin
beginning the long walk to A-list status.

inexplicable adverts for beer, which presumably is what Beck's is hoping. The sponsorship guy may not understand it, but that is the point. Beck's wants to appeal to young arty people, not middle-aged marketing men.

When you are this famous, you can simply make it up as you go along. Emin can make films for Beck's and adverts for gin or Vivienne Westwood; Hirst can make records, design restaurants or direct films. Having entered the mind of the public, celebrity artists may roam across the public realm.

If they feel like it. At the opening of Tate Modern's big exhibition 'Century City', I have been offered an interview with Emin for BBC News. This is no sponsored event, no special dinner. Just Emin talking about her art. As an artist. Not as a famous person. Sadly, she's not too keen.

Initially the planned interview is live, at 08.50. No, that's too early. How about the day before. In the afternoon? Five? OK. Then the gallery rings back, very apologetic. How about 6 pm, before the big Tate dinner for all the artists? Fine. No, make that seven. OK. 'Sorry, Tracey's been working at Sotheby's all day. Can you make that eight, just before dinner?' OK, fine. Anything. Whatever you want. The Tate press officer rings back again. 'Look, just hang around. She might give you ten minutes. We can't say when. But you're lucky. She's already told another film maker to get lost.'

We are all standing on the balcony at Tate Modern. People are eating sushi and drinking home-made lemonade. The Tate's press people are rushing around. Suddenly, Emin arrives. Two photographers take a few snaps. The press officer goes up to Emin and engages her in a long, long, *long* conversation about whether she might feel up to chatting to us about her art. Eventually she comes over. We are very humble.

'Have you met each other before?' asks the press officer.

'Yes,' I say.

'No,' says Emin.

OK, fine.

'Yeah, look, only make this a couple of minutes,' she snarls.

Sorry. How was Sotheby's?

'Christie's,' she snaps.

Sorry, sorry.

'Don't ask what I think of the show. Cos I haven't seen it,' is the next order. OK, that's fine, too. I wonder what sort of autograph Emin would give me tonight.

The media. Scum of the earth. But Tracey, dear Tracey. You encouraged us to come in and take an interest in your life. And now mainstream life is interested, and this is, after all, an official dinner at the Tate to which we were invited.

'Good luck,' murmurs the cameraman.

Emin manages to say something about the shop she and Sarah Lucas ran together. We talk about being a Famous Person. Oddly, she does not consider she is one. 'Unfortunately I am not in the position to have the spoilt fits that other people have in my position.' To give her credit, she does laugh a bit when she says that. 'I am still an artist. I still get on the tube. I don't have a chauffeur.' So, still an ordinary woman from Margate. 'No, I come to have a night out and I get besieged by photographers and people like you, and in a way this is kind of working, isn't it?'

Emin agrees it is extraordinary that we are all so interested in her opinions. 'It is weird. But I am very opinionated. But it will fade off. Give it another two years and you won't be interested any more. Or only if I am. It's a two-way thing, isn't it?' It sure is.

Last Christmas, Jake and Dinos Chapman, along with about eighty other celebrated contemporary artists, produced designer ties for an exhibition. Retailing at about £300, they were also stocked by upmarket West End shops. Dinos Chapman, like Hirst, like Emin, is utterly unconcerned with the notion that he may be muddying his talent in the waters of the commercial spin-off.

'Critics said we were selling out with the first thing we made. Just the idea that you may be making art which is in some way successful makes people criticize you. A lot of people think that artists are altruists who starve in freezing garrets. The moment you decide that's not the way you want to work, you are accused of selling out. It goes with the territory. The tie is just another thing to do. If someone asked us to decorate all the London buses, we would do it.'

Dinos has done a tie with a skull on it. And Jake has done a tie covered with suppurating wounds. How perfectly Chapmanesque, for the pair who specialize in maimed bodies and hideous, sexually disfigured child mannequins. Once you have cornered the market in a particular line, you need to carry on with it. Of all the celebrated YBA generation, only Hirst seems to have the lightness of touch to avoid being buried by his signature style.

'Yeah, we have a brand. The image on this tie, this double skull image, that is the Chapman Industry logo. We use it on T-shirts and prints, and it is instantly recognizable. I guess this tie is recognizable as a Chapman product,' says Dinos. 'It wouldn't be very interesting to make something that wasn't like our work, on a tie. Anyway, the tie is another way of getting an image into the mainstream. The kind of person who buys this is going to be the kind of person who buys art.' According to Dinos, this market is surprisingly small. 'Art is not in the mainstream. However much it would like to be. You are not mass-producing things on a scale which would ever make them a mass product. You are always preaching to the converted.' Would he deny he was a well-known artist?

'Within a very small group of people there are a few known names. But apart from people who go to galleries, no one cares or knows about us. More people are interested in art than perhaps a few years ago. But not everyone goes to galleries. It's not like the music industry. We do not sell art like CDs. You don't get mobbed by crowds of people,' says Dinos. Is there a touch of regret in his voice? 'Art is an object booted around in the media. The art object serves a purpose, which is not necessarily the purpose of the artist. The artist himself may not be known. People know about the mannequins but not us.'

Could this be a whiff of professional envy, a sense of rival positioning? Perhaps he feels he and Jake have not quite reached the apex of what is so clearly possible. He admits he has used the 'Do you know who I am?' statement to get into night clubs, yet one senses a peeved frustration that the Emin/Hirst stratosphere is not yet his. The Chapmans are shocking. But they haven't got the hyper-octane celebrity shock power of Tracey or Damien. Neither have they quite achieved the respect meted out to someone like Rachel Whiteread, an artist who,

since winning the Turner Prize for *House*, can break a commercial art practice merely by leaving it. Do they want it? Is it important to them? 'We have never been nominated for the Turner,' he says. 'I think it is either because they think we are louts. Or because we are immoral. Or something. And now if we were asked, Jake and I would have to think about whether we wanted to accept or not very carefully. Very.'

Dinos is the sort of artist TV producers love to have on their shows discussing art. For a successful artist he is still so very antagonistic. 'Jake and I are constantly told we are special. But it doesn't wash. We have a draughty, cold studio and that is where we spend most of our time. OK, we may appear in the papers once in a while. We look at them and laugh. And then we get back to shivering in our studios and wondering at the mismatch between the perceived image and the real image. It's the same for everybody.'

It's well known that Hirst, with the help of his accountant, has managed to wriggle out of the 50% cut levied on his work by his gallery, White Cube. Dinos Chapman is also clearly frustrated by the old system. He tells me how it is. He and his brother sell *Hell*, their piece in 'Apocalypse' at the Royal Academy, to Charles Saatchi for £500,000. Half that money goes to the Chapmans' gallery, also White Cube. That leaves £250,000 to be split between the two brothers. Which is not that much. Certainly for this pair. 'Saatchi will eventually probably sell it on for about a million,' says Dinos.

Hirst's attitude is not dissimilar from recording artists who have started to demand freedom from the grasp of their company and assert that they, the talented and famous ones, should have the power.

And it's not just seeping into the contracts. With their flair for self-reference the YBAs could hardly leave fame from the output itself. Gavin Turk examined celebrity long before he became one. From his first piece, the iconic English Heritage blue plaque exhibited for his Royal College degree show ('Borough of Kensington/Gavin Turk Sculptor/Worked here 1989–1991), through to waxworks of himself in the guise of Sid Vicious or Che Guevara, Turk has long mulled over the impact of fame as a very real cultural phenomenon.

'The thing about fame and celebrity and such forth is that it takes up such a lot of space,' he says. We are sitting in Turk's airy studio, next door to Dallas Fried Chicken on the Charing Cross Road. Three storeys down, Oxford Street and Tottenham Court Road seethe around Centrepoint. Inside, we are listening to Miles Davis. Turk's assistant Esther sands down a box. Turk is chatty, but considered. He and his partner have just had their third child, a boy. Due to the surgical manner of his arrival, they have named him Caesar.

'I am very interested in looking at the world in cultural terms,' he continues. 'I made a piece based on *Hello!* magazine covers. I am interested in what happens when you become a celebrity. People stop being interested in the work you are doing and become more interested in the sort of lifestyle you have. In a way, it's finding out the human aspects of someone but, as you look for them, this in turn becomes problematic; it clouds things.'

Good examples of how this phenomenon pertains to his own work are in his sequences of signature paintings. His first solo show, 'Gavin Turk Collected Works 1989–93', exhibited works covered with the artist's signature. Before he was famous, that was fine. However, now that his signature has become something of a prized autograph, the point is lost. 'I wanted to comment on and be critical of the value attributed to artists' signatures. Obviously the moment it became recognized that my signature might be valued in itself, this became problematic. Before, what I enjoyed about my name was that it could simply carry a question of its value. Now, it's possible to read my name in the paper. It suddenly has these other things that people bring to it. It becomes shorthand for something. People say, "Oh, not like the work of Gavin Turk," as if they know what that is. Changing my name is obviously something I think about quite a lot.'

He has just completed a ten-day 'residency' in an empty office in Hoxton, where he enthusiastically examined the legacy and life of Che Guevara. He placed adverts in the paper for Che followers to come and talk about the legendary Cuban revolutionary. He exhibited posters of Che and plates of Che's favourite food. Halfway through the residency, Caesar arrived. Turk continued

The artist who mistook his autograph for a signature:
Gavin Turk in his studio.

the stint alongside daily trips to the hospital. Of the residency he says, 'It was a self-help, self-learn thing. I kept refuting the idea that it was art. It was simply about opening up a forum where people come together.'

Turk appears genuinely unconcerned about the need to take a 'position', or adopt a 'brand'. Does he have one? 'I don't think so. My work is still changing and, although a lot of it is all about brands and logos, that is not what it is. Hype and PR exercises intrigue and revolt me. When put together they have a big take on the world. But at the same time I really appreciate things like home-cooked food and primitive things. I need some balance between things that are "real" and things that are *real*.'

Turk likes putting himself at a distance. He is quick to remind people that he never went to Goldsmiths', he never showed in 'Freeze'; that he is not necessarily part of the clique. He understands the role of a YBA, but has maintained an appealing, thoroughly uncynical position as one. 'If you want to be in a place where you get your art seen, then you have to do interviews and have a public profile. And there are these spaces, which open things up. Maybe artists can take that step and put themselves into the frame, and say, "I may be able to help you understand art ... help you look at art."'

He is looking forward to revealing his work, rather than his opinions, in a straightforward gallery exhibition in Berlin later on in 2001. 'The media is not always the best commentator. There is a tendency to find the lowest common denominator, and not deal with the more awkward and edgy sides of work; just to go for a common hit. There has been a sort of rounding-off effect, which isn't necessarily a good thing. Art starts to lose some of the more refined qualities that it could, and should, and I think does, have.'

He's just taken a new piece up to the New Art Gallery in Walsall. It's a sculpture of a squashy, shiny, filled bin-liner. It looks soft, but should you kick it, you would probably break a toe.

Meanwhile, in Hoxton, the Chapman brothers' new gallery – Chapman FineARTS – has opened. And although Dinos scathingly predicts that one day 'there will be enough TV for every person on the planet to have their own show,

it is that dull', he hasn't stopped the TV crews from covering the gallery opening, and interviewing both Chapmans, along with their similarly fashionable counterparts, Tim Noble and Sue Webster.

Sue and Tim, Tim and Sue. If you haven't heard of them yet, you will. These two are so determined to reach the parapet of command it is breathtaking. In his delightful cultural guide to the capital, *art london*, Martin Coomer writes of Tim and Sue as 'Olympic standard attention seekers'.

It's a phrase which could be illuminated in one of their neon signs, or splashed on one of the posters that feature them in various character guises, or put above one of their signature shadow sculptures where their portraits are created by piles of rubbish. I meet them for lunch in an authentic East End pub where they tell me that they are currently being filmed for a BBC documentary and have several major art projects on the go. I mention that an art dealer has been talking about them in connection with next year's Turner Prize. As ever, the bewitching Prize is inflammatory stuff.

'Of course we won't win the Turner Prize,' dismisses Sue. 'Because people are too stupid and too slow in the art world. We should have been there already. You know. I don't know if now is our time or not. We are always ahead of our time.' Tim laughs nervously. 'I don't know about that. I'm a late developer.'

'It doesn't mean anything any more. When you are in a position that it might happen, you don't give a shit about it,' says Sue. 'And if you look at the current state of the nominees for this year [2000], I wouldn't want to be nominated at all. They are diabolical. They are nothing. I used to go and see it every year because I used to think it meant something. Now I don't think it means anything at all.'

It's not as if they haven't achieved a certain position already. It's just that Sue and Tim know a bigger position exists, and that is what they want. On the face of it, it looks as if all the boxes have been ticked for them to become the Next Big Thing. They have easily marketable 'art personalities'. They are a double act. They work and live together. They dress up in weird boxing gear for adverts in the art press. They have attitude. They have the obligatory East London dealer.

FAME

**87**

Sue Webster and Tim Noble negotiating their way onto the Turner Prize nominees list.

They've been bought by Saatchi, exhibited a pile of rubbish at the Royal Academy and shown in New York. Perhaps the problem is that they are too perfect.

'We are unfashionably ambitious,' says Tim. 'We have a lot of drive. We are constantly doing things when we should probably be sitting back.'

'When we began,' says Sue in the sort of tough bovver girl accent one senses is not quite bona fide, 'no one would touch us. We was ahead of our time. We had loads of ideas. But we was dangerous. And wild. And no one would touch us. We financed all our own work. We presented stuff to various galleries, but no one would support us. So we went ahead and made it ourselves. And then the Chisenhale offered us a show. Once we had made it.' She settles back on the sofa. 'Someone wrote in *Art Monthly*, "Prize winners win prizes." And it is absolutely true,' she says. 'Cos Tomoko Takahashi [one of the Turner nominees] won that East thing. Some people are made to win prizes.'

Our baked potatoes arrive. They are stacked with glutinous fillings. Sue points to one. 'Look at that. If you shine a light on that you could make a silhouette!' She stabs the air with a fork.

'They are too slow here! Nick Serota might come round eventually to Modern Art [their gallery] and see one of our shows. In two years' time.'

Has he been round?

'No!' she yells.

'We make a point of doing over-the-top adverts. We are not very subtle,' says Tim, by way of explanation for Serota's perceived lack of enthusiasm.

'Why should it be about subtlety? Who said it was? Who says it's supposed to be?' shouts Sue.

'I know there are a lot of people who don't like what we do,' says Tim. 'Which is *good*. But there are certain magazines which are, well, they refuse to acknowledge we even exist. These are proper art magazines. Like *Art Monthly*. But I find that quite interesting.'

'That's censorship,' says Sue. 'It will get up their noses anyway. In the History of Art, no one is going to remember your magazine.'

There is a pause while we all contemplate this.

'Well, they might,' says Tim quietly.

Sue gives him a withering look. 'People will remember *artists*. These are just *fanzines*. Am I annoyed that Nick Serota hasn't been down to see us? I am not annoyed that Nick Serota hasn't been down. I just think it is *pathetic*. When we've had the Guggenheim down. Nick Serota doesn't even know we exist.'

Although the pair do acknowledge they have a waiting list of 'about sixty people' for their work. Isn't this good?

'I want to throw that list away and burn it,' says Sue. 'Because I don't want to be dominated by it. Art has got to mean something. Otherwise you start churning it out. It's supply and demand. Of course we are bombarded with requests for things.' Of which the current pinnacle is a commission to show at Larry Gagosian's LA space. The idea is that they will possibly build a 'rubbish' silhouette sculpture from money.

'I couldn't believe we had got away with it,' says Sue. 'To have a show there. Because we are just a couple of scruffy kids from the street. And we are going to be showing after Jeff Koons. It doesn't make sense, but it makes perfect sense. People tried to warn us off doing it because they are jealous. Damien Hirst is allowed to do it. But we aren't allowed to. But why can't we be the ones it works out for?'

# CHAPTER SEVEN
# THE GALLERISTS
life after the deal

But you can't make it on your own. Talk of the revolutionary gusto of Damien Hirst, and someone will usually mention his dealer. Jay Jopling, graduate of Eton and Edinburgh University. Dealer to the rich, friend of the famous. The man whose first gallery, White Cube, brought new artists to Mayfair and whose second, White Cube², brought blue chip respectability to the East End.

The original White Cube is in St James's, long-time home of Berry Brothers wine and the Queen Mother. The art market also thrives in these quiet streets. This is a market typically represented by Christie's auction house and some sombre, curtained-off places which discreetly reveal one or two Old Masters in small front windows. Perhaps a Dutch still life or a Spanish equestrian portrait. While over at White Cube things are getting groovy with a display of photographs, huge contemporary paintings, or something equally modish. Although he has his own stable, Jopling never shows the same artist twice, treating the gallery as an 'agency', with an internationally selected programme.

Such is his influence that he is practically credited with inventing the whole British Art Thing. That is to say, the parties, the fame, the PR manipulation, even the artists themselves. 'I wonder whether Damien would have done it without Jay,' says Penny Govette. 'Probably. But Jay has been the greatest enabler

for all these artists.' He started with nothing behind him, which was ideal for attracting young art school graduates who didn't want to show in a formal gallery anyway. Work by unknown artists in unknown places; it's a tough combination but the one which made Jopling's fortune.

'It's a lovely position to be in,' says the man himself, sitting behind his desk, eating a biscuit. He has just been having a cup of tea with Stella McCartney, a person whose first name neatly encapsulates the world in which he now moves. 'To think I can make careers. But I don't think I have.' He laughs. Although he is about six foot four and is wearing a formal suit, he also sports an extraordinarily large pair of Buddy Holly-style glasses. Maybe he wears them to amuse his small daughter, Angelica. Or to underline the fact that he has a famously great eye. Who knows?

'I was lucky to arrive in London in 1988, having finished my Art History degree. It was an extraordinary time to arrive. There was an energy bubbling under the surface, yet it was a difficult time to make artists' careers. All the artists we started working with [like Marc Quinn, whose show opened White Cube] are very well-known now. But they all did it through the quality of the work. It's certainly possible now that if we show a young artist people will pay attention, but equally you are then liable to be knocked off your platform.

'The first thing that was different was the language. Artists were making art about what it means to be alive now, just out of art school, as a 25-year-old in London at the end of the twentieth century. Tracey Emin comes from a very ordinary background. But she is a phenomenal communicator, and the fact that her work is autobiographical makes it extraordinary because she is prepared to share it. Damien's work is about issues which great artists have been making work about for years. It's actually very classical.' Although the language he uses is anything but. Jopling clearly believes Hirst's legacy will last. 'In ten years' time people of my parents' generation will be surprised if they walk into a museum and do not encounter a Damien Hirst.'

What about the hype, though; the PR infatuation with which White Cube has often been associated? 'The shock is so important with art,' admits Jopling.

Jay Jopling at the original White Cube.

'The avant-garde has got to grate. It's by no means necessary, but one of the ways you can draw attention is by having the artists be a little bit outspoken, because that can precipitate the attention that good artwork can get. But if it's not good it falls flat. There are many cases of people who are trying to stand out as personalities but the work is dreadful, truly dreadful, so they fail. And we all know who these people are.'

He admits the gallery deliberately tempted the media. 'I remember discussing it as a strategy. How we could get their work covered by the press. Marc Quinn's *Blood Head*, or Damien's cabinet with fish in it at the Serpentine. In those days no one would write about contemporary art, even on the arts pages. So we got the *Daily Star* to go down to the Serpentine and call it the world's most expensive fish and chip shop. With a journalist standing beside it with a bag of chips. It was a clear strategy to push up the profile, to get the artists into the public consciousness.'

Why wait for critics like the *Evening Standard*'s Brian Sewell to diss your work? Far better to feint self-ridicule. 'It means more people will walk into an exhibition. And although they may have been seduced into going there by reading sensationalized press reporting, they leave having been quietly affected. You can up the ante by negative reporting, and then turn it all on its head. It's a test of a really good artist, although it is a much more risky experience.' Risky, but masterly. There is no recommendation as strong as a personal endorsement from a convert.

Nowadays, Jay isn't courting journalists so much as fending them off. He almost never gives interviews. Neither do most of his artists. This one took four months to arrange. But you can't get away from his output. His creative stable is everywhere, from the poster advertising London Fashion Week, to the *Angel of the North*, via the Selfridges installation by Sam Taylor-Wood, Jopling's wife. 'It was the largest photograph in the world. And to do it as a contemporary, classical-based frieze was an amazing thing,' he says proudly. 'It was a very brave commission and a sign of how art really can be integrated into daily life. And it certainly made Oxford Street a much happier place for six months.'

Although he bemoans the lack of a serious collecting culture in Britain, obviously Jopling is aware of the bottom line and is a dealer at heart. I have seen him in the role of salesman, touring Charles Saatchi round some work, and he looked pretty focused while doing so. But there is something else going on. He mentions the notion of democracy, with regard to the opening of White Cube[2]. He talks about the public project fig-1, of which more later. He sounds like a younger version of Nick Serota. Or his brainchild. There's a different cashflow funding those smart suits, but Serota and Jopling use the same tailor.

'I have always believed there is a public responsibility to running the gallery. It is not just about selling art. It involves making exhibitions which are open to the public. Anyone can walk in here. Over the last ten years the gallery has become a point of contact for anyone who wants to know about British art. Students, academics, interested members of the public. We have spent a lot of money on our website. It's the only commercial gallery site I know which has a full archive. And I think that is a public service role. Because unless you want to have a big distribution from a sales point of view, and sell editions online, I don't see how a website can really be an effective commercial tool. But I do see it as a great method of enhancing awareness.'

'You want people to be familiar with things,' says Jopling's alter ego Sadie Coles. The dealer who has almost effortless cool, she is very friendly and very nice. She calls her gallery Sadie Coles HQ, as if she is a one-person mini-corporation. We meet in a Moroccan casbah just off Regent Street which even she admits is 'excruciatingly trendy'. Moments later she confesses that when it expands into a Moroccan emporium round the corner later in 2001 she will be decking it out with art. And for years she has worked with the businessman Oliver Peyton, advising him on his contemporary art collection which adorns the Atlantic Bar and Grill, Mash, Isola; all those fabulous restaurants which are so important for stylish Londoners.

We sit on decorated cushions, drinking fresh mint tea which comes with torn-up leaves poking out of the pot. Sadie opened HQ in 1997 but before that she was a director of the Anthony d'Offay Gallery just round the corner. She's

seen the whole scene throughout its changes. Generously she credits her rival with kicking it off. 'Jay understood the publicity thing right from the beginning. With Damien. And once they started, they opened the floodgates. Everyone wanted to hear about new art. It will never go back to where it was before then; where people thought art was elitist and not for them.'

Coles has one foot firmly within the established perimeters of the art world, and one without. She curates temporary projects: sound installations, events which happen at mysterious locations, destined to achieve 'mythical' status long after they have happened. She is determined to promote her artists outside the terrain of the gallery. 'If you see art in a restaurant and are familiar with it there, then it will be familiar hanging in your own home.'

What about familiarity breeding contempt? 'By its nature it remains exclusive, because it is unique. I am not making posters here. Corporate clients, banks, they are all buying new art because they want to look modern and with-it. It is all about image, and they want to be part of it.' Sadie's artists – Sarah Lucas, Angus Fairhurst and Elizabeth Peyton – have the vision that corporations want. Goodbye boardroom decorated with boring old pictures of liners or aeroplanes. Hello luscious oil paintings by Peyton of popular icons such as the Gallagher brothers, or the bawdy work of Sarah Lucas, whose work satirizing and distilling gender clichés has amused and horrified audiences on an international scale.

These are the totems which identify companies as being hip with the future. And if your company is actually meant to be hip with the future, i.e. in Futures or some other financial necromancy, then it's a perfect liaison. City brokers don't want old-fashioned art.

It's not just the City, either. 'My artists are constantly being bombarded with silly requests, collaborations, press things, endless feature ideas, stupid questionnaires. I always tell them they should say no, it's trivial,' says Coles. I suddenly feel guilty just writing things down in a pad. 'Things like what is your favourite food.' Even I would feel nervous winging that one over to Sadie, let alone someone as terrifying as Sarah Lucas. 'We are bombarded with

'It will never go back to when people thought art was elitist and not for them.'
Sadie Coles

merchandising offers, offers for multiple versions of artworks, requests for images to be used in advertising. Contemporary art has been utterly appropriated by the mainstream.'

She has had the perfect vantage point. 'When I first worked at d'Offay's around 1989, 1990, the market crashed, and it was just awful. People stopped coming over the Atlantic. Their disposable income disappeared. The phone stopped ringing. People went out of business. It was very frightening.' And now? 'The majority of my shows sell out. My problem is getting work out of my artists. It's a problem for all dealers at the moment. London is such an art community now. It is really special. No city is like that, not even New York.'

Later on I go to an opening night at asprey jacques round the corner. You can tell this is a funky new gallery because of the lower case affliction. There are loads of free bottles of Pils chunkily sitting in a big vat of ice by the front door. The main gallery is filled with one huge abstract piece of sculpture by Graham Little. It's called *Why be discreet when showing off is so much fun?* This could be a witty slogan for the London art scene, but is sadly only a reference to a fashion piece in *Vogue*. The piece is very fashionable itself, being large and multi-faceted and colourful. It is covered with Ben Day dots, glittery swirls and a large piece of lettering which says 'Ahhh!' In the back gallery Little has produced some rather fey drawings, supposedly in the style of seventeenth-century fashion plates.

People are wandering around to see who else has turned up. There are young women with Gwyneth Paltrow-style tresses and trainers, and young men juggling bottles of Pils against record bags. People are talking on their mobile phones. No one seems that interested in the work apart from one older guy who is chatting up co-gallerist Alison Jacques, but they all appear quite happy to be where they are. They are wearing leather coats and are on their way home from work. Or on their way from the office to dine at an Oliver Peyton restaurant.

Perhaps because the crash in the art market is still within recent memory, commercial galleries have wisely tailored themselves to be the venue for the perfect urban leisure activity, far more than their cultural cousins, theatre, music or even film. There you have to make a booking and donate the whole night. Here,

you can swing by, pick up a Pils, chat to some mates, look at some art and be on your way in twenty minutes. It costs nothing but you can be social and fashionable *and* use Culture to assuage that Protestant guilt thing about not going straight home after work.

You can then spend the money you have saved by not going to the theatre on a fashionable meal, where you will spot *more* contemporary art hanging above your partner's head. On the way home you buy a copy of *Vogue* where you read a review of the exhibition, or an evening paper in which you see a 2,000-word profile of the artist. You note its approval in a wider world, so you are assured you did the right thing; indeed, so fulfilled are you that the next time you visit a gallery, you might shell out and buy a piece of art yourself. That's the idea, anyway. It's what the marketeers call 'the perfect moment', a moment where the 'everyday is lifted out of the mundane'. Apparently this is what we are all seeking, alongside 'deep time', a term meaning your precious moments of leisure have been properly spent doing something a) social, b) relaxing and c) escapist. Does there exist a better description of going to a gallery?

Art dealers have grasped this formula, even on South London's Deptford High Street where the Hales Gallery, run by Paul Hedge and Paul Maslin, is doing big business. Of course, first-timers arrive clutching their A–Z maps and looking terrified, but after that it's quite easy.

After his Fine Art degree at Goldsmiths', Hedge worked as a postman for nine years before amassing enough cash to open Hales in 1991. He wanted to open a gallery but he didn't bother going for public funding. He simply opened a café upstairs. 'For the first three years we funded the shows through the café. I would much rather pay for what we did through cooking than through filling in forms. I cooked for six years. On and off,' says Hedge. 'We did two hot meals a day and loads of sandwiches and coffee. And we still do. The only difference now is that we employ a café manager and seven other people to run the café. And four people downstairs in the gallery.'

His ambitions for high-end art go beyond just selling it. 'The generations of the '60s and '70s who went to university were grant funded. No one in my

Paul Hedge, who made Deptford High Street blossom.

family had been to university before. For the first time ordinary working-class people could be involved in the art world in a dynamic way. I felt a very strong need to make something available to someone with a background like mine. I wanted to open something applicable to the twenty-first century and accessible to people of my generation. Art galleries are very boring and snooty. Everything I hate most about the world is in them. And the private ones are the worst; the ones which are only interested in you if you have a pile of money to spend.'

With a café on the ground floor selling tea and pies to market traders, it would be impossible anyway to launch a gallery which sold art in the old, exclusive way. Hedge had to invent a new way. 'We are not a community gallery, but we have the community in mind with the exhibitions we do. We are in no-man's-land and are accessible to all sorts of people, yet we are a very successful commercial gallery. People come here from all over the world to buy our work; we sell an enormous amount, and to some very high-profile people. We sold Tomoko Takahashi's work to Charles Saatchi. Collectors don't find it a problem that we are in Deptford High Street. They find it charming and intriguing that we have a café full of ordinary people upstairs, including those who aren't the slightest bit interested in art.'

However, they might be. There is more than a soupçon of zeal in Paul Hedge's large frame. 'I definitely am a missionary. Creating something where there is nothing. In his missionary journals of the 1780s John Wesley said this area was a barren wilderness that would blossom as a rose. That has always stuck in my mind. And the arts could be part of it. When we started work on the building, there were a lot of derelict buildings round here. And just by saying we were going to open a gallery and a café serving really nice food was a missionary-type statement. Many people thought we were completely mad. It was the middle of a recession. But I felt it was the right thing to be doing. We had the support of the local church, interestingly enough, who owned this building.'

The gallery tripled its turnover last year. Rather than show a range of young artists who pass through and out onto bigger things (Sarah Jones, the Chapmans), it now has its own stable: Takahashi, Jonathan Cowan, Jonathan

The matriarch of a new market: Angela Flowers at Flowers Central.

Callan whose punched books are becoming something of a cult. And Neville Gabie, a South African artist whose photographs of goalposts across the world were a huge hit. 'After that work I had a phone call from Fila. They want to do a project with him. Anything he wants. A few years ago that sort of approach would have been unheard of,' says Hedge. 'They would have had a budget and asked for something quite specific. Now they are handing out money and saying, "Do what you like." He is dead keen.'

I bet he is. Hedge smiles and sips his tea contentedly. He has seized the chance to spot the future in the present. 'Change is blowing through art galleries. They are having to respond to galleries like us. There is a huge difference in the way people see us now, compared with the way in which they were looking at us three, four years ago. People with money are now coming along and saying, "Do you want some of it? I want to be part of what you are doing."'

His illustration puts those City bonuses into perspective. 'People who come to us are lawyers or bankers. People who are doing stressful jobs that are essentially a bit dull. They want a bit of something that is a bit sexy. Whether the art world is or not I don't know. But the perception is that it is this sexy extravagant world which is slightly wild.'

The next night I am having dinner at Flowers East, a huge East End gallery. Socializing is part of the deal for the dealers and around me are all sorts of extravagant and sexy people. Former BBC Director General John Birt; the film star Mary Elizabeth Mastrantonio; and all those empty lawyers and bankers.

Flowers East and its sister gallery London Fields are run by Angela Flowers and her son Matthew. They are part of an empire which stretches from Hackney to Los Angeles, via Ireland and Cork Street in central London. Flowers started her business in 1970 and has weathered four recessions to reach, last year, a turnover of nearly £3 million. According to her, the market for contemporary art has never been so strong. 'People are buying so much more art. We are selling twice as much as we used to. There is so much more money around.'

Flowers' artists and clients are different from those who frequent Sadie Coles HQ or White Cube; she is the first to admit she is not dealing with the

THE GALLERISTS

cutting edge. However, one of the key reasons why the art market is so strong is that it has outlets for an astonishingly wide range of takers. Flowers has cannily defined – some would say invented – a market for mid-priced easel paintings, prints and sculptures which are elegant, witty and aesthetically pleasing. Unsurprisingly this formula sells all over the world. Patrick Hughes's glorious reverse perspective landscapes do a roaring trade from Korea to Toronto; Peter Howson and John Keane have both made the headlines as war artists in Bosnia and the Gulf; and Lucy Jones's faux-naïve paintings are as newly neurotic as anything you might find at the Saatchi Gallery. Tony Blair is said to have commissioned a work from sculptor Nicola Hicks.

'Someone once asked me what I called myself,' says Flowers. 'I have always seen myself as an impresario. Dealing is going to someone's country house and seeing something and taking it away. Old-style dealers do that. I have a gallery. A place where artists can exhibit and make a living by selling their work.'

And a place for the impresario to put on shows, dinners, dances, songs and anything which exudes the feeling in Flowers East, West, or Central of an event. 'Small dinner parties are just such a good way of getting the work seen. Forty per cent of our work gets sold that way. It's posh and it makes people feel good.'

This approach is seeping through the private sector which, formerly, for anyone other than a major collector, would promote the masochistic mantra: Enter Gallery, Be Ignored, Leave. Suddenly the gallerists are attending Charm School. Everyone is at it. No one told Will Ramsay of Will's Art Warehouse, which sells paintings for under £1,000 to Sloaney types in South London, that it might be a good idea to blare Capital Radio throughout the gallery and hang the art as if it were clobber in Top Shop. He just did it, and it worked. No one told Victoria Miro that it might be a groovy idea to promote her new gallery even before it had been refurbished by having a Sunday brunch the day before Tate Modern opened; but she did it, and it worked. In fact, everyone does Sunday brunches now.

You can even get clothes in galleries these days. Or at The Approach you can. The Approach is such an unscary, feel-good space. It is so lovely that after

wheeling round its stripped floorboards and white-walled, big-windowed gallery you just feel like running up and hugging its proprietor Jake Miller. The Approach is above The Approach pub. On Approach Road in Bow. So it's easy to find. Which is just as well, because to get in you have to march through the pub and up a tiny staircase. This is not the ordeal it might be, however, because Jake's family owns the pub. Which is partly, but not the whole reason why he is there.

'When I started I wanted to be connected to somewhere like a pub. After all the private views I always went to, everyone went off to the nearest pub and drank. Rather than welcome the extra weeknight income the publican and staff often looked horrified when we all turned up unexpectedly. So I thought a good way to fund a gallery might be if I could use all this money being spent in the pub to be fed back into the exhibitions that were generating the crowds,' he explains nicely.

We wander round. The one-room Approach is full of some pretty surreal work by Los Angeles artist Dave Muller, who identifies himself as a DIY exhibition organizer, freelance publicist, musician and conscientious host. The show is called '"I Can Live With That"/A Three Day Weekend'. The idea is as much a social event as an exhibition. Dave is part of the event, too; after looking at his art you can have a drink with him downstairs. One of the pieces is a clothes rail full of tops. The idea is that you take off your own T-shirt and swap it. I exchange mine for one which says 'Tate Modern' in the official Tate font above a drawing of Carl Andre's nationally reviled bricks. According to Dave, this shirt is an illegal creation, a Tate bootleg, which in itself is an interesting concept.

Miller tells me how he began. 'At the same time that I started the gallery I was working as assistant for Michael Craig-Martin, who often gave me good advice. The first show I put on was of three artists who made little sense being shown together. But the place was mobbed, from day one. And it gave the feeling of the way the gallery would go.' After five or six shows, Miller was running the gallery on his own, and had a breakthrough.

'I put on a solo show by the painter Peter Davies, which generated a great amount of interest. The show attracted the likes of Nicholas Serota who reserved

a painting for Tate. Paintings were also bought by Charles Saatchi, the Arts Council and the Southampton City Art Gallery. Suddenly I had sold four paintings to great collections. This success made me think I could make a living out of this. And so far so good. Nick Serota still drops by.'

One of Miller's discoveries was Michael Raedecker, nominated for the 2000 Turner Prize. Paradoxically, because Miller is not obsessed with going nuclear, he is doing very well. 'I always wanted to show artists that weren't necessarily commercially successful, but who people would find interesting. I just choose work that I like, and balance it out.'

Miller is sweetly modest about his approach for The Approach, although by popular consensus he has chosen an ambitious stable of artists. 'I came along at a very good time. For me the whole kind of interest in the art world, both in the media and in the money, was growing when I was growing. I have a good working relationship with the pub. The opening night crowds keep my rent to a minimum and I have nominal staff. I do OK.'

It's a very measured attitude, and Miller suspects it is why other galleries allow their artists to show with him occasionally. 'There are galleries where it wouldn't be right. Here it seems the right thing to do. But it would be awful to think that artists and gallerists forgot about what is good or bad art and were just thinking, "Is this cool or not?" I like to think the real reason the whole thing rolls along at The Approach is that I show some very good artists. I can't tell you why the artists work. They just do. So I guess I must have a good eye in some way or another.'

Then he says something very interesting. 'Plenty of galleries have good ears. But a good eye is more important. If you see something you like, trust your eye, believe in what you show and install it well. You will be OK. Simple, eh?'

Selling is obviously part of what this clutch of leading commercial galleries do, but they also have a public service ethos; an interest in breaking new artists; an interest in the notion of hanging a coherent show rather than just selling individual pieces of work; and a sociability which has allowed them to be something more than mere shops for art.

# CHAPTER EIGHT
# THE PUBLIC SERVANTS
getting down to business

But is taking your shirt off at The Approach a replacement for, or an addition to, the public sector? Neither. At least not in some places. Public galleries have moved on a bit. Well, some have.

I am upstairs at the Institute of Contemporary Art in the beautiful Brandon rooms with their perfect Georgian ceiling mouldings and huge sash windows. The ICA started off in the late 1940s as a very alert place with people like the poet and modernist Herbert Read and the collector Roland Penrose putting on experimental art. Sadly over the years the light had to a certain extent gone elsewhere, leaving the ICA fumbling about somewhat with Very WORTHY but rather dull bits of performance art. This evening, though, I am to receive a masterclass in how the ICA has repositioned itself.

In one of the rooms, people are milling around drinking vodka. In the other, they are sitting down on sofas, beneath two huge blank pieces of brown paper stuck on the walls. Each piece of paper has a message at the top. One says, 'What Do You Want To Do?' The other says, 'What Have You Done?' Down on the floor, beside the original Nash skirting boards, are pads of Post-It notes and

biros. On the opposite wall is an arty film showing goings-on at the Winter Palace in St Petersburg. This has been produced by the design company Tomato. Chilled ambient music is playing. People in Miu Miu kitten heels, with velvet bows around their necks, are lounging on the big orange sofas. 'Move up,' says one of them. 'There's loads of room.' And there is. Welcome to the ICA Cultural Entrepreneurs Club.

On my way in I am given a guest list, which is good, and a name badge, which is a bit squirmy but everyone else is wearing theirs, so I put mine on. I eagerly scan the guest list. There are architects, artists, designers, musicians, digital film makers, e-commerce gurus, club managers, 'lifestyle website' people, artists and venture capitalists. It's a blueprint of the sort of person the ICA has been trying to woo over the last couple of years with a newly eclectic programme of architecture, digital art and product design exhibitions alongside the 'formal' art.

The aim of The Club is, however, to network. Yes, that key Nineties phrase redolent of the now-defunct First Tuesday evenings, where fat cats met penniless kittens with Good Ideas; of the Match:Unmatch nights in London's Match bars where participants wear wristbands, hear uplifting speeches from captains of industry and experience on-line art from britart.com. Now the idea has come to the ICA. Funky companies like FAT, el ultimo grito, Cake Media, turn up to meet their potential godfathers, Barclays, Absolut Vodka, Channel 4, Bloomberg, even the Foreign Office.

That the ICA is doing this sort of thing raises two points. Firstly, it's a publicly funded body, and secondly, it represents a traditionally high-brow artistic arena. Everyone expects networking to go on in the City, but you don't normally expect digital whizz kids and bankers hungry for ideas to hotfoot it along to the ICA. At least, not until Philip Dodd arrived.

Philip Dodd is Director of the ICA. He is the sort of man one imagines would have fitted in well at Bloomberg. Or at Credit Suisse First Boston, or some new IT venture. But he started off with Alan Yentob working on BBC arts programmes, and such public service culture credentials don't drop from people's

A cultural entrepreneur: Philip Dodd at The Club, ICA.

epaulettes all that easily. So instead of going off to be an entrepreneur, Dodd stayed public but brought the entrepreneurs in. The resulting hybrid, he insists, is the future.

'The people at The Club represent arts businesses which the Institute of Directors don't understand to be business, and which the arts community don't understand to be arts. They fall between. They are young multimedia companies. They are design, fashion, music, film, architecture companies. They are usually begun by two people and a dog. One of them, Deep End, is a digital design company which now employs 156 people in four cities across the world. My view is that they are the future of culture. They are not cult art. And they are not business. The truth is that they are both. On a monthly basis we bring them together to allow them to develop ideas. Not on the First Tuesday principle, which is, "Give us some money," but on the creativity principle.'

According to Dodd, young creatives these days don't want to work for television companies, or big corporations in any form. They would rather go it alone. They can't be bothered with public funding, not from some arcane spirit of pride, but because the private sector is theirs to take. 'This generation is Thatcher's generation. They didn't come through public institutions. They set up their own institutions. So they were entrepreneurial from the very beginning. Everybody, for good or bad, inhabits the market. They are in this hybrid world which nobody owns. As a social phenomenon, it is fascinating.'

I look at the 'What Have You Done?' sheet of paper. Some Post-It notes have started going up. 'Cut a tree down in my parents' garden', 'Streamed media solutions to open an interactive TV station in Shoreditch' are a couple. There are also some notes up on the 'What Do You Want To Do?' wall. 'Work with interesting architects,' reads one. 'Link fashion retailers to digital designers,' reads another. 'Make boys hard and girls moist,' reads a third. This last has drawn a small clutch of admirers. 'What great PR,' says one awestruck Clubber. I imagine The Club is exactly what Philip Dodd wants for the ICA. Liberal but fashionably realistic. It's idealistic (art is important) yet oriented towards deliberate gain (how can it be marketed).

'A lot more than the Berlin Wall has collapsed since 1989,' says Dodd. 'The landscape that you and I were brought up with – where there was subsidized art here and commercial art there, where art was one place and rock and roll was another place, and film was something else – has collapsed. We live after an earthquake, which was the collapse of all those categories. They collapsed because finally they bore next to no relation to the life that most of us live.'

He realized that no one was turning up to see the roster of art films that the ICA was diligently programming on a weekly basis. So he brought in another sort of club – Little Stabs of Happiness nights, invented and run by Vivienne Gaskin – where arthouse films are shown within a club context. You wander in and out of the cinema; you can sit anywhere; you can drink; you can smoke. After screenings of three separate films, there's a disco which is usually DJ'd by Mark Webber from Pulp.

It's no surprise to learn that the innovative Gaskin, who at first was brought in just to run the ICA membership applications, was a former assistant to the late Joshua Compston. Under his banner 'Factual Nonsense', Compston brought in the notion of art as event, art as mediated experience, of art in conjunction with everyday life. 'He would walk around Hackney and point to advertisements or tenement blocks and argue as to whether they were art. For me they weren't but for him they were.'

Gaskin goes on. 'You stop thinking about codes. The black box versus the white cube. Why keep those as realities? They don't have to be. My interest wasn't in the art world, it was in the club world. But the ICA isn't a club. Yet events with a DJ at the core are very accessible. And if someone wants to come down to Little Stabs to see if Jarvis Cocker is in, and they also take in two or three very difficult films for which there would traditionally only be twenty people watching, then it's worked. That is the experiment.'

Gaskin's ideas at first went down reasonably badly. 'People said you are here to do Membership. Get on and do it.' Her critics have since left; Gaskin (who has herself now moved to become Head of Artistic Programme and Education at the Centre for Contemporary Art in Glasgow) was given the

ICA's Live Art programme. With a radically different culture. 'I believe in Entertainment before Art. Art is mediated through entertainment, but entertainment is the principle and the overall experience. Ten years ago, this idea was anathema. Even today when I talk about art being part of the leisure industry, people hate it. They absolutely hate it. It's like you are taking away from part of the mythology. But why not? You can go to the swimming pool, see football, have a pint and come here and see a show.'

Philip Dodd admits the results have been extraordinary. 'How is it that when Mark Webber presents a film he will get 300 people watching it sitting on the hard floor, whereas if I showed it in the cinema I would only get fifty people? It's because the context in which people want to see things is different.' It's access, but a different animal from the government's much-vaunted ambition to get disaffected teenagers flocking into the Opera House auditorium. 'The tragedy of the Labour government is that they want access to the same bloody things,' says Dodd. 'My view is that you will only get new audiences with new cultural forms.'

At this point, hear the cries of 'Dumbing Down' from the purists, the Buñuel specialists, the experts on *La Nouvelle Vague*. This is sacrilege! Showing *Clockwork Orange* in a nightclub context where people are chatting and smoking and sitting on the floor!

Dodd simply won't have any of this. 'The notion that once upon a time art was this little refined thing is made by historical illiterates. The history of culture is partly the history of access to that culture. The people who hate Tate Modern are those who, in my view, used to own the Tate. It was their playground, and they didn't like a lot of vulgarians getting in. There are dangers of hype, of course. But being a best seller is far better than only selling 300 copies of your first novel. Look at Dickens! After he wrote *The Old Curiosity Shop* he sailed to America. On his arrival crowds of people on the harbour surrounded him shouting, "Is Little Nell dead?" He was a celebrity. He was a vulgarian. He went out and did readings. Orson Welles did coffee ads. How vulgar! It didn't stop him from being the greatest director cinema has ever produced. Culture isn't

dumbing down. Culture is simply being wrested from the control of a small body of people. And,' he continues, warming to his theme, 'these are the sort of people who wouldn't know a good film if they saw one.'

Philip Dodd wants the ICA to be promiscuous. And it is. Since arriving in 1997, he has got into bed with all sorts of people, from Sun Microsystems (a £2 million, three-year deal for digital equipment) to Beck's Beer (a new arts prize). 'The notion that we are some purified sector has gone. I want to work with the people who are the most energetic and intellectual. Sometimes you work with corporations, or freelance curators, or you work with the public sector. We are in a pick and mix world. The defining line between commerce and culture is difficult to read. So you can move and swim like a fish amongst them.'

Which is all very well, but how does it work on his Arts Council grant application form? 'Dear Gerry Robinson, I would like my annual grant, but I also want to move and swim like a fish with the private sector. Yours sincerely, Philip Dodd, Director, ICA.'

'The Arts Council has outlived its useful purpose. It was set up in 1947 when rock and roll and popular film was just becoming important, as a bulwark against these things,' says the remorseless director. 'The notion that this group of people have got the knowledge, competence and expertise to determine what is happening now in the cultural world is just a joke. I would rather give Channel 4 the money and let them distribute the money for two years. And then give it to somebody else. The ICA is now 65% self-funded. So my view towards the Arts Council is, "I don't want any more bother from you and you are just a minority stake holder. A valued one, but a minority one."

He gives me one final line. 'If you want the old world you can go into a library and read it. If you want the new world it needs to be noisy and it needs to break eggs. And I have broken some. Alright?'

I go off in search of Andrew Weaver, CEO of consultancy company Cap Gemini who sponsor The Cultural Entrepreneurs Club. Helpfully he is wearing his Club name badge on an easily seen lapel. Mr Weaver is clearly a veritable *grand fromage*. So how big exactly is your cheese, if you don't mind me asking?

'It's the largest management consultancy and systems business in the world. It's worth £900 million. I run about £400 million of it,' he says genially.

Fine. So why link up with the ICA? 'If I want to have the best company and have the best customers in the world, I have to make it exciting,' says Weaver. 'I also have to head hunt. To attract talent we want to make our company exciting for our employees. We could sponsor football, but art gives a better lifestyle statement.' It's not just lifestyle, but another valuable commodity. Ideas. 'The ICA is a cultural incubator. The things that go on the walls are almost incidental to the ideas that are being discussed within the building. Money isn't really the point. Leverage is the point. And the leverage of The Club is very high. Ideas happen here, new ways of thinking, new ways of business. And that is an opportunity for us. So if there is a breakthrough here, an invention in the way business is done, then maybe people will share it with us. Looking back is interesting but, as a consultant, the only reason for us to exist is to be at the front.'

Which is great for the ICA, where Philip Dodd has instigated a fluid culture of ideas above a rigid programme of exhibitions. Yet where does this leave institutions which don't have 'incidental' art on the walls? When you have a permanent collection things are more difficult. Old Masters are very beautiful but they are not going to give you 'leverage' over modern-day business problems. And sponsorship of shows is vital: in 2000, private support given to museums and galleries was worth over £35 million.

Remarkably, some publicly funded institutions which might appear ill-suited to answer the needs of the modern-day sponsor, have risen to the challenge. Look at the 'themed' hang at Tate Modern, or the advent of the 'concept exhibition', most brilliantly executed at the National Gallery. From the 'Making and Meaning' series, through to 'Seeing Salvation', which meditated on how art has depicted Christ, these 'concept' displays, devised by the National Gallery's director Neil MacGregor, have brilliantly used theme to readdress the permanent collection.

Presenting art, even a thirteenth-century diptych, in a manner which analyses philosophical concepts rather than historical facts also pushes up the

ratings. People don't care about mulling over dates. They want ideas. 'The old economy of sponsorship was all about control and ownership,' says Cap Gemini's Andrew Weaver. 'The new economy is about the implementation of ideas. What people want is creativity. Creativity gives one the chance to be different, and truly meaningful.'

Public funders are aware of the way institutions are thinking. But they are swamped with bureaucracy and hideous devolution, resulting in their more ambitious clients scenting the current wind of economic prosperity and going elsewhere to get their money. Indeed, they are rewarded for doing so. Down in Peckham at the South London Gallery its then-director David Thorpe got access to a valuable Stabilisation fund from the Arts Council precisely because the gallery had linked up with private funders.

'I arrived to find no programme in place and no professional direction. The status quo was uninspiring and uneventful,' says Thorpe. 'It was utter stagnation. There was no money, and no possibility of receiving any more revenue funds. The only way we could run an exhibitions programme and develop new audiences was to look at the possibility of collaboration, mainly in the private sector.' The local council of Southwark, which funds the gallery, was keen for him to do anything to get it back on track. 'Back then they didn't consciously know how hip art was. There was just a belief that the arts were A Good Thing.'

Thorpe went about repositioning the gallery with the élan of a showbiz entrepreneur. He brought in Gilbert and George, and their friends. He won a sponsorship deal from Beck's Beer who gave him money in 1995 to put on 'Minky Manky', a 'shocking' exhibition which attracted national headlines. All at once the South London Gallery was on the map. Who was in 'Minky Manky'? He recites the names like a mantra. 'Damien Hirst, Tracey Emin, Mat Collishaw, Sarah Lucas, Gilbert and George, Stephen Pippin. Mustn't leave anyone out. Gary Hume. It was the best attended show we had.'

Thorpe thrived from being left alone. 'The local authority was interested in audiences getting value for money, and a high profile in the press. If we got that, and didn't exhibit some dreadful neo-Nazi thing and weren't gratuitously

exploitative, it left us alone. That freedom has given me the opportunity to go for it. Which...' he laughs, '... is what I have done.'

So goodbye to the old South London Gallery with its quaint exhibitions of local paintings, and hello to a brave new world of wacky scientific performance art, international artists such as Leon Golub and Julian Schnabel, and chic contemporary British art by the likes of Gavin Turk and Marc Quinn, both of whose exhibitions were mounted with the assistance of Jay Jopling and his gallery White Cube. 'The link with the private sector enabled us to do a number of shows that we couldn't otherwise do,' says Thorpe.

I suggest that the only potential problem is that the beneficiary isn't, of course, just the publicly funded South London Gallery. It's also White Cube, which gets a nice big space and an instant audience to show off its stable. He sighs. 'There is a fuss about curatorial integrity and compromise, but we don't compromise. We show what we want to show. And the dealers help us to do that. I don't see that there is a problem.'

Moreover, without a commercial bottom line, Thorpe is free to show artists with a less obviously high price point alongside the YBA alumni. 'The biggest danger is that if the dealers and the market control what is exhibited, the public is not in a position to evaluate things properly because they do not have an unlimited choice about what to see. Which is where the power of the curator lies. It is something the curators have to look at and consider, and if you look at the programmes we have had over the last eight years they have been remark-ably diverse. We have artists on the periphery of the mainstream. Nobody remembers that two years ago we had a show from two artists, one from Guyana, one from Jamaica, or the two exhibitions of Indian artists we have done, because those things don't get high profile. However, because the gallery itself now has profile, people come along anyway just to see what is on.'

Having driven the gallery from scout hall which attracted 4,000 visitors a year to international hanging space with 60,000 visitors a year, Thorpe is determined that it should now stand alone. 'We wish to be independent from the local council, with salaries and budgets to help us run this place properly.

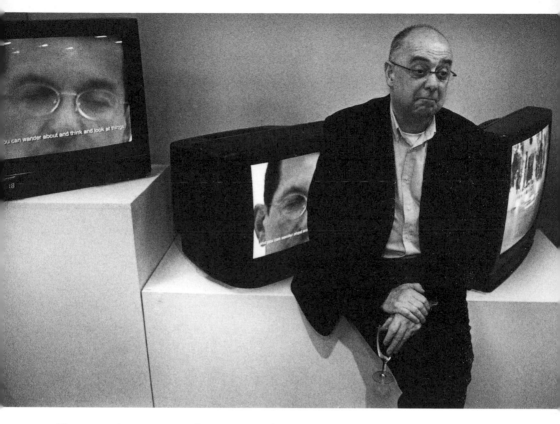

The man who encouraged 60,000 people a year to visit the South London
Gallery: David Thorpe.

Southwark Council has supported this institution which is now ready to be launched into the big wide world. It has done its bit. If we have independent status, we will be released from bureaucracy. We will be more flexible for fundraising. We can employ permanent staff. A marketing officer. A head of education. A director of exhibitions.'

It seems as if Thorpe will have his way, having been admitted to the Arts Council's Stabilisation Programme, which is set up for arts organizations wishing to undergo a major change. The grant is worth £1.5 million over three years; it should provide stability for the South London Gallery for five. 'We are the only stand-alone contemporary gallery admitted onto this scheme. The Museum of Modern Art in Oxford was turned down. The Arnolfini in Bristol was turned down. I find that very encouraging. It's an endorsement of our approach, because we have acted in a more entrepreneurial way, and more flexibly than others. We haven't just held out our hands and said, "Give us more money."'

After running the gallery for eight years, Thorpe left in 2001 to sort out the Henry Moore Foundation. A single director turning round a single public space; yet even in the big public institutions, change is on the way. The art critic David Sylvester has recently suggested that the most important people in the cultural world are not the artists but the curators: 'the true brokers of the art world'. Contemporary art shows are events and artists the stars not only because the art is popular, but also because the shows are put on in a far more self-conscious, overtly curated manner than before.

The innovative and influential Iwona Blazwick, who left her position as Senior Curator at Tate Modern to run the Whitechapel Art Gallery in the spring of 2001, is one of these 'super curators'. It was Blazwick's uncompromising adventurousness that steered the original non-chronological iconoclastic hang at Tate Modern, and the riveting multi-disciplinary style of its first big exhibition, 'Century City'.

In obligatory black top and not so obligatory gold sequinned skirt, Blazwick stands on the great bridge which crosses the Turbine Hall at Tate Modern. It's the opening night of 'Century City' and the gallery is packed with

artists, collectors, patrons and colleagues who have helped her pull off this vast exhibition. How does she feel about the title of 'super curator'?

'They always had power but before they were protected by the mantle of the institution,' she says. 'Now at least people are coming forward, saying, "This is my decision. I take responsibility for this." And I think that is more transparent. I think it is a positive thing, a political thing. And at least one knows who to blame!'

We talk about the phenomenon of galleries beginning to mark their presence not by an acknowledged history but by the style of the current curator. 'Because you are not saying that these are neutral spaces, that the work suddenly emerges and naturally on the walls,' says Blazwick. 'Somebody made a decision, somebody decided what to include and what to exclude. On the other hand I don't think that any of us want to have a completely idiosyncratic vision. We are working in a public arena and we want to welcome a whole diversity of artistic activity. We don't want our personal tastes and our peccadilloes to get in the way of that.'

'Century City' was a show which not only rejected the usual criteria for the highlights of twentieth-century art history, but also hammered home the extraordinary multiplicity of creativity which occurs in these urban 'flashpoints'. The show revealed artists as film makers, fashion designers, sculptors and poets, and suggested that to be a fully realized catalyst for invention and acclaim, urban culture must, and does, cross-fertilize. The London section, as with each city chosen in the show, revelled in its creative connections. Blazwick suggests the eclectic, electric cross-fertilization of contemporary British culture has even influenced the way formal galleries are structured.

'Being a curator is no longer an establishment position. It is much more diverse. There are many many more women curators, for example. Artists have become curators. I came out of an art school background. Artists can claim to be curators for a moment and then step back. Damien Hirst is a great example of that. He curated "Freeze". We are all doing lots of things. And the demarcations are just breaking down.'

# CHAPTER NINE

# YES PLEASE

the survival of beauty, truth and the one-off

A brief and truly random selection of press invitations. On a large piece of stiff card: 'The Rt Hon Chris Smith MP, Secretary of State for Culture, Media and Sport, and Chairman of the Millennium Commission, together with his fellow Millennium Commissioners, invites you to a celebration of the outstanding achievements of the many diverse projects the Commission has supported. To be held in the Turbine Hall at Tate Modern*. Dress: Lounge Suits. *The Turbine Hall is unheated. The Millennium Commission is proud to have supported the development of Tate Modern with a grant of £50 million.'

What else? More stiffs. Monday: the Globe Gallery is having an off-the-peg sale of painting, pottery, print, porcelain, etc. Tuesday: the photographic Proud Gallery is selling books, prints and membership with a guarantee of future 'celebrity-laden opening nights'. Meanwhile on Wednesday there is a show at The Nunnery, Bow Road. Thursday is award night, with an evening to 'celebrate the launch of an important new art prize' at Pizza Express (Charlotte Street branch). Also, a glamorous 'celebrity' opening of a furniture store. And then, on Friday, the launch of a new book by design guru Stephen Bayley.

What does this little pile say? It tells us that the government is delighted to be associated with Tate Modern, as much as it was horrified to be linked to the

Dome. Also, while Tate Modern is obviously establishment (viz. the recent knighthood of its director), the government still considers it a somewhat radical cultural addition. Note the invitation's shocked delight in 'The Turbine Hall is unheated'.

The invitations also indicate that nowadays it's not just furniture shops that model themselves on galleries. High street pizza chains are part of the zeitgeist. Now joining awards from the chic ranks of UBS Bank, Tate, Beck's Beer and the John Moores Foundation, the art world welcomes the Pizza Express Art Prize. Please come along to celebrate its *launch*? It's rather like being invited to the sending off of a mailing list. Meanwhile, contemporary galleries need no hype. Let the government tell you how to arrive and what to wear. The Nunnery, a set of East London studios with a gallery attached, merely indicates the date of its new show and people will turn up. Oh yes, and Stephen Bayley has another book out.

I go and see the Prophet Bayley at his secret hideaway studio in fashionable workaday Kennington. I call him the Prophet for it was Bayley, was it not, who first identified the Dome as a big pile of rubbish, and got out while the going was good?

This morning the design leader is wearing a fantastically sharp, chalk-striped suit. He greets me in the hall of his house which appears to have been stealthily transformed into a bespoke coffee shop, complete with zinc-topped counter, chrome stools, proper coffee cups and a cappuccino machine. A single branch of foliage leans artistically out of a vase, Zen-style, whilst two feet away, on the other side of the window, the mid-morning traffic streams down Kennington High Street. 'This used to be a pharmacy,' says Bayley, gesturing nonchalantly around what I now realize is actually a small shop interior. 'Oldest in South London.'

Humbled by this historical nugget, I follow him inside. The shop opens out into a perfect book-lined study with nice leather chairs and halogen low-lights, leading to a walled garden complete with a piece of abstract modernism: what looks like a sort of Ellsworth Kelly steel sculpture on the back wall. 'My own

Ellsworth Kelly,' says Bayley, pointing to the sculpture upon which a fountain of water is playing. 'Got the local steelsmith to knock it up.' I don't really know what to say. What with his real cappuccino and his veritably antique pharmacy and his fake modernist sculptures, Bayley is an odd paradox of high art and high street. And nowadays he thinks he is redundant.

'I have done myself out of a job. There is no reason to campaign for anything any more. When I started to write about design it was very difficult to persuade newspapers to publish articles about it. If anything did go in, it was as a tiny paragraph on the Women's Page, next to a recipe for scones. But now it is part of everyone's agenda. No one would even think of selling something which is not well designed. You don't need to argue the case for design any more. The everyday object has been completely aestheticized. People today learn more about beauty from motor cars than from modern art. In fact, beauty has left the galleries and taken up with ordinary things.'

Well, it was Bayley, Director of the Boilerhouse project at the V&A and then the Design Museum, who asked us to see the excellence in a Philippe Starck lemon squeezer. It was Bayley who revealed to us the beauty of a David Mellor spoon. He waves his coffee cup at me. 'The opening exhibition at the Design Museum in 1989 was called "Commerce and Culture". It made the point that the museum and the department store emerged in Europe at the same time, around the 1850s. And that they are the expression of the same idea in the European mind. That we must collect the whole world, categorize it and put it on display. Then the modernists, the avant-garde, went away from commerce and reinvented the idea of the obscure, suffering artist. Now they are coming back together. It's one of the absurdities of the Design Museum. I spent eleven years building it but now we are not a million miles from the Conran Shop.' Or Selfridges, which, as we know, has deliberately repositioned itself by a huge emphasis on visual seduction; not for selling's sake, but for aesthetic's sake.

Bayley agrees. 'That is where beauty resides now. The high street. Tracey Emin is hugely talented but her work is not about beauty. Whereas the work of the guy designing the next Ford Mondeo is very much about beauty.' He is none

It may not be a real Ellsworth Kelly on the back wall, but it's just as beautiful.
Design critic Stephen Bayley.

too keen on our heroes of modern art, and calls their central award, the Turner, a 'crown of synthetic outrage or lazy effect'. He considers them self-obsessed 'pranksters', more concerned with ego than elegance. 'They have a genius for outrage but they are not practitioners of beauty. Tracey Emin and Gavin Turk are determined to cling to this notion that the artist is an individual who creates autonomous acts and puts them in one place, but for me art always has something to do with beauty. So in a sense, Tom Dixon at Habitat is more of an artist. People who care about beauty don't want to put soiled beds on display. Art is a fugitive thing. And at the moment, it has gone elsewhere.'

So why the huge audiences? If beauty has left the galleries for the high street in 'the hands of architects, film makers, industrial designers and photographers', then what are people getting when they go to the Serpentine, the Whitechapel, the Ikon, Tate Modern, et al?

At this point, Stephen Bayley starts swivelling around in his chair getting very excited. 'I am still struggling to understand Tate Modern. The great power and effect of it is not its art, but the event which makes it exist in itself. It's actually quite difficult to find the art in there. It's a phenomenon which has been going on ever since the extension to the National Gallery in Washington. Or the Guggenheim in Bilbao. I mean does *anyone* know what paintings there are in Bilbao? Of course they don't. There are very few paintings of any interest in there. In Tate Modern, the architects have spent most of their creative effort in making a dramatic and beautiful space.'

A cathedral to modern art, many have called it. Is this what Bayley means? Indeed it is. 'My view is that the more wired we get, the more electronic, the more people crave the preciousness and authenticity which art gives. People want to be in touch with something which is not shimmering and electronic. They want contact with humanity. They want something real. And that is part of the extraordinary success of Tate Modern. It is a temple. People are going there for that quasi-religious contact with something special and physical. Very few people like Joseph Beuys. But he is clearly not a fraud. And although people may not like Beuys they sense he is saying something worthwhile.'

Bayley's phone, a black and silver shiny design *thing*, starts to ring. 'Excuse me,' he says, and leaps over to claim it. 'Reggie!' he shouts delightedly down the receiver, and then over to me in a stage whisper, 'Reggie Nadelson!' (American critic). 'How are you darling?... Are you coming to my book launch?'

All this talk about religiosity is fascinating, not least because just before, I had been standing outside Stephen Bayley's workspace wondering if I was at the right place. While considering the conundrum of how a man never seen without cufflinks and a pristine shirt could possibly function within what looked like a derelict building, I was hailed by Mark Wallinger, whose most famous work is a sculpture of Jesus Christ.

Mark Wallinger is a bit of a hero. He's serious enough to have been given a 'mid-career' retrospective at Tate Liverpool, and the charge of representing Britain at the 2001 Venice Biennale. He put a piece of modern art in the middle of Trafalgar Square – on the Fourth Plinth, a pedestal empty since it appeared in 1841 – and got away with it. Apparently the popular choice was to have the plinth ornamented with the Queen Mother on Red Rum, or a sobbing Gazza, but due to the insistence of the Royal Society of Arts (and, in an extraordinary crossover, the society cook Prue Leith), three contemporary artists were chosen to create temporary pieces. Wallinger's was the first to go up. His statue, *Ecce Homo*, was a standing figure of Christ immediately prior to the Crucifixion.

It was a daring deed. Outside the National Gallery, home to hundreds of Christian icons dating from 1200 onwards, here was an icon for today, if you so wished. *Ecce Homo*, wearing only a loincloth and a crown of thorns, life-size in white marble-resin, was dwarfed against the Technicolor, high decibel torrent of traffic, pigeons, fountains and Admiral Nelson. However, the statue immediately found favour with the public; the same public we are asked to believe only wants ersatz, sentimental art.

I meet up with Wallinger at Tate Liverpool. We sit in a large open-plan office on the ground floor where the bright blue of the Albert Dock swishes up against its terracotta arched parade. Against the candle shops and the pasta restaurants the Tate makes a grand proposal for leisure.

For someone who has had his photograph taken in a football crowd at Wembley waving a huge Union Jack with his name stitched on, Wallinger is surprisingly reticent. 'Yes, I am a shy person really. I am confident about my work, but then I want to run and hide. I'm not confident about the idea of having a public role.' Hardly the stereotype of the brazen contemporary artist, but then Wallinger has been careful to position himself outside the circle of the YBAs.

We talk a bit about *Ecce Homo* and a previous work, *A Real Work Of Art*, in which he raced a thoroughbred in the 1994 flat season as a living statue, much in the same way as Marcel Duchamp famously exhibited a urinal as a work of art. 'Yeah, well,' he says, and looks over to where the Mersey meets the city, 'I have made a few pieces down the years as a commentary on Duchampian inheritance. It's now rather lazily assumed that anyone can plonk anything down in a gallery you have found on the street, rather than use the urinal as Duchamp did. With both *Ecce Homo* and *A Real Work of Art*, I was trying to see how far one could nominate a creature within which it's very hard to pick apart what is natural and what is cultural. Someone once argued that Jesus Christ himself was a found object. In the Duchampian sense. A man and divine at the same time.'

Wallinger is obviously very attached to the sculpture, and clearly wishes it could return permanently to the square. Sometimes he even addresses it on personal terms. 'I've just showed a cast of the figure in a big, top-lit gallery at Secession in Vienna. Because I knew his life-size nature, I thought he could hold his own away from Trafalgar Square. And it was pleasing to see that he did. I care very much about *Ecce Homo*. After the three sculptures have been up it's been proposed that maybe the public might vote for one to stay there for ever. Which is quite appealing. If you know it's temporary, it's a bit like a stunt. I like the permanence statuary can stand for. And it was such a terrific opportunity to have an impact on a public that wasn't filtered through institutions or curators.'

Wallinger's work has long been focused on such ambivalent yet moral commentary, with popular imagery as its conduit, whether in the figure of Christ or the culture of racing, art or Irish politics. Putting on *The Importance of Being Ernest* in Esperanto. Designing the Union Jack in the green, white and orange of

Mark Wallinger contemplating real works of art at home on his sofa.

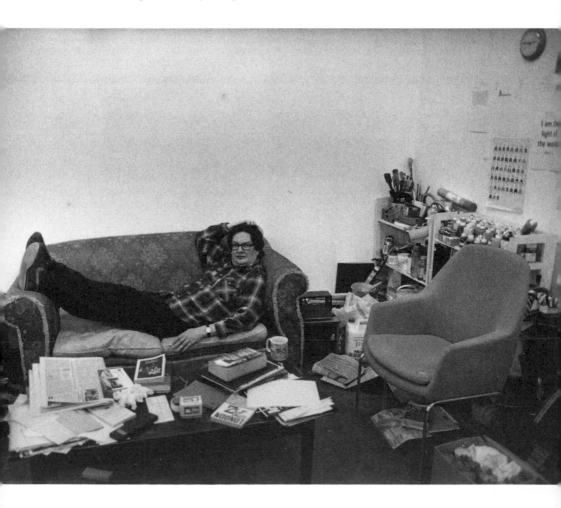

the Irish tricolour and raising it on a South London roof. Painting his friends as homeless people sitting in the porticoes of City buildings. Filming a dead fly with tributes in the style of a television obituary. Reciting children's poetry after inhaling helium. Wallinger's artwork – carefully arranged rearrangements of everyday life – is designed to startle the mind into thought.

In one of his most celebrated works, the video piece *Angel*, we see Wallinger as a blind man in dark glasses with a white stick. He has learnt the first five verses of St John's Gospel. Backwards. While reciting them he is also walking backwards at the bottom of the escalator at Angel tube station in North London. The whole video is then itself screened backwards. The result is an extraordinary, David Lynch-style performance of the disguised Wallinger making almost-but not quite sense, walking forward while everyone else is flying past him. At the end of the speech he stops walking and is himself carried up to the top of the escalator while Handel's *Zadok the Priest* blares out around him. It's comical, chilling, mechanical and human. In one seven-minute tape.

'I like to do work which doesn't reveal my intentions or politics, so the viewer finds themselves implicated in how to interpret certain works,' says Wallinger. 'But also in a way that finds beauty in certain structures. I hope my work isn't all concept. Beauty is definitely a by-product. *Angel* was a good example of such a structure. I had to find phonetic noises which, when run backwards, would come out as words. The bonus was to see how everyone moved, and to see how beautiful that was. Not only were they moving backwards, but because everyone was on an escalator, they were being swept along by something else and moving much faster than the actual gestures they were describing.' If he had chosen to film himself alone on the escalator, the overall feeling would have been much more sinister; as it is, it's beautiful and elegiac. To make your point, there is no need to scare the audience away.

'It's important to be playful. And it's important to be exuberant. Exuberance is truth,' says artist Cerith Wyn Evans, former film maker with Derek Jarman, now one of White Cube's leading lights. 'That is what William Blake said.' Wyn Evans should know.

Altogether an amusing, playful sort of person himself, Wyn Evans translated the entire works of Blake into Morse code and set it up to be flashed out of Tate Britain over three months. He looks like a film star from the 1940s, with his long, lean frame and dashing moustache. He sounds like a cross between Richard Burton and an extra from Pobol y Cwm, and says that Welsh television companies are always on the phone, begging him to be in documentaries. 'Because I am a Welsh speaker, you see. It's my first language.'

Wyn Evans's work, like Wallinger's, rambles over the entire spectrum of artistic expression. It's not so much the medium is the message as the message selects the medium. Even if the idea requires taking a bit of Tate Britain down. 'I was asked to submit an idea for the front of Tate Britain to celebrate its relaunch,' says Wyn Evans. (In the end the commission was won by Martin Creed.) 'My suggestion was to remove one of the columns from the front of the building, and replace it with an acroprop, which is a bit of metal to keep the thing up. They thought it was very amusing and not to be taken seriously, although one of the engineers took me to one side afterwards and whispered, "It is possible, you know..."'

Wyn Evans giggles and selects a fresh cherry from a large bowl of fruit which is on the floor beside him. We are in his voluminous flat which seems to have no furniture, bar a couple of chairs, and no decorations bar a huge photograph of the artist Sarah Lucas sitting in sunshine astride a large bit of rock.

'So after the Tate turned down that idea I was then having a think and realized Blake would have lived opposite the Tate on the south bank of the river. So I thought about something passing over the river, a reverberation. Then I thought about MI6, and a piece I'd read about Morse code being decommissioned and I thought, "Perfect! We will send the complete works of Blake across to MI6."' There is no limit to the ambition of art. Morse code; Christ in Trafalgar Square; every bell in San Gimignano; tiger shark in formaldehyde? No problem.

'It's about 7.5 million characters. It's everything. The complete poetry. It's thousands and thousands of pages. I downloaded it from the Internet. Thank God it was already there. The computer reads it like a random juke box.'

The piece is set up within Tate Britain in the contemporary space Art Now. The light flashes on and off a huge glitter ball in the centre of the gallery. Twinkling lights spin around the white walls. The overall effect is dizzying and vast; the concept of such a communication too large to even whimsically contemplate. 'It could take a thousand years to read everything,' says Wyn Evans. 'Have another cherry.'

At this point it's probably worth mentioning that if you like having your mind exercised by such a huge concept you should go right down the Thames at Woolwich. There, in a lighthouse opposite the Dome, artist Jem Finer has created a work which will take exactly one thousand years to complete. *Longplayer* is a musical composition made from a recording of the chiming of small pots which has been digitally interlaid on six tracks in a computer programme. The tracks are moving in speeds relative to one another. They started their journey on 1 January 2000 and will return to their starting point, which is also the finishing point, on 31 December 2999. It's mind-boggling and terrifying.

Back to the cherries. Cerith Wyn Evans is talking about a piece he has in The British Art Show 5, a gold-plated crowd control barrier. On the day I went to the show, which was then at the Birmingham Museum and Art Gallery, an official cheerily explained that Wyn Evans's piece was something of a stumbling block. Being positioned right across the entrance. 'Oh yes,' she said. 'Lots of people think we're shut. I have to tell them it's a Work of Art. There's a sign up to say it is.' Wyn Evans explains how the piece was originally made in the heady summer of 1997. 'I was looking for a ready-made vehicle. And I saw all these crowd control barriers everywhere. Diana had just died and they were *everywhere*, especially in the West End, because there was such a massive influx of people taking part in the commemoration and funeral. You couldn't cross the road without going right round the block because of these barriers everywhere. I thought how amusing to have a long chain with one which had sort of won the lottery because it was made out of gold. You can see it as a political metaphor, but it is also kind of absurd. When I explained it to a critic, I said, "It's made of gold and it divides people."' He laughs.

Is this the hand-crafted, individual gesture we are going to Tate Modern in our millions to find? It could be. Since seismic shifts in manufacturing have ensured you can now get the arty look from Heal's or Habitat or Selfridges, even from that nightmare otherwise known as the IKEA shopping experience, artists have had to go elsewhere. It's a bit like when the camera arrived onto the open market. Why bother doing a still life when you could take a photograph? Artists didn't want to do perfect representations of reality any more. They didn't need to. So they went away, cut up reality and invented Cubism.

Artists today might have abandoned a superficial search for aestheticism but a) if the High Street is full of it, and b) if you can replace it with an original statement about life, our life now, then it doesn't seem too much of a loss. Particularly when beauty is still, as Mark Wallinger points out, 'a by-product'.

I visit the studio of painter Dan Hayes. A couple of years ago, he won the £20,000 John Moores painting prize. His pictures are very beautiful. Taking hugely enlarged, scanned, computerized images, he paints and shades each pixelated square. He turns a computer screen into a marbled passage of paint. At the moment he is painting an enlarged photograph of an American landscape he has downloaded from the Internet. Of course, there is a twist. He is happy to use the most banal of images for inspiration – much of his work springs from impersonal sources such as mail-order catalogues – but with the American landscapes he has used the photographic work of another Dan Hayes, father and all-round Yankee good guy who lives somewhere in Colorado.

'I simply logged my name in and came across a site for another Dan Hayes. He had a gallery of images: video stills from around his home landscape. When I contacted him to ask if I could use them, he was quite excited. To hear from another Dan Hayes. He was into the joke. There is a sort of family thing. I am always using other people's pictures. I don't feel any problem lifting them for my own purposes. But it is different with this Dan. He's like my brother in the States. It's quite scary. He has these images of his kids and wife on the site. Opening Christmas presents, that sort of thing. But there is no photo of him. I have this awful feeling that if I ever clicked onto it, it would be me in a baseball

YES PLEASE

131

cap. It is really creepy. Then eyestorm.com reviewed one of my paintings of his picture, and put a link onto his site. So there has become a sort of circle.'

I look at the London-based Dan's painting. It's a big chocolate box cover-type shot of an American lake with some trees by the shoreline. The photograph has been blown up and is pinned on the side of the big canvas. Hayes has taken apart each square and oval of the scanned photograph and is giving them the painterly treatment in aquamarine and grey and green and white. It's a bit like a Chuck Close portrait. It is very beautiful. 'My study is the study of visual seduction. I want to paint images which draw people in visually. And use a subject matter which is quite low – low, culturally. Like mail-order catalogue images or these web images. I want to invest them with a sense of mystery, so they can transcend something.'

Looking at the picture you can't help thinking of all the imagery speeding around the world, the zillions of computerized shots, all the photographs in all the photo labs, the pure visual 'stuff' bombing around on daytime television, the cable films, the thousands of landscapes and millions of portraits currently in the atmosphere on digital, analogue, live, tape. 'There are more images than people in the world to paint them. And they are passed over so quickly. I want to linger over them. I will spend about six weeks painting them.' He suggests this picture will sell for about £10,000.

We need people to make sense of the things in the modern world. Our football teams, our politics, our millennium, our spirit, our passion for communication, the speed, frenzy and ease of the Internet. These are the things about which the chattering classes chatter. They are also the things in which artists are interested. With amusement, intelligence, humanity and no small sense of the aesthetic. No wonder there's a strong market for the stuff.

# CHAPTER TEN

# NO THANKS

## where have all the critics gone?

It's early autumn. I am at a fantastically lavish party thrown by the financial communications company Bloomberg in the Turbine Hall, Tate Modern. Bloomberg is one of the corporate sponsors who have paid for the liberty of entertaining in the nation's most famous power station. It has in fact sponsored the gallery's portable information handsets, which is why the invitations are replicas of a Tate handset.

Funnily enough, the one detail the invitation does not go into is that the Turbine Hall is unheated. We arty lot are supposed to know that already. In any case there are probably enough candles alight to heat the entire building. There must be twenty-five huge, branched candelabra alone on the bridge which runs over the hall. A band is playing world music. Legions of catering staff stand in serried ranks along the bridge, holding out champagne for the guests as they arrive up the stairs. The flutes contain small, solid plastic fish which gyrate alongside the bubbles. Waiters walk around with piles of sushi on mirrors decorated with velvet and ivy.

Who are the guests? Not clients, but the artists sponsored by Bloomberg. Bankrolled, funded, supported. Call it what you will, Bloomberg has aligned itself with everyone who is fashionable and modern: the Royal Court, Tate, the

Serpentine, White Cube, The Museum Of..., Artangel, etc, etc. Places which trade on looking forward, rather like Bloomberg itself. Hence the connection. 'Other people do Sport. We do Art,' says the company's feisty UK boss, a man clearly inspired by a certain flick featuring Michael Douglas in red braces. He even has a hot Hollywood name: Lex Fenwick. With Bloomberg sponsorship the budgets are unlimited and the scope is huge. Everyone gets directly involved, including staff on all levels. These days sponsors don't just send a cheque and expect to see their name on a leaflet.

As a little 'thank you', Bloomberg has decided to give the artists a party. Lots of people have turned up. Artists like Fiona Banner, Mark Wallinger, Tim Noble and Sue Webster ('We're still duckin' and divin'. We're like the Artful Dodger, us,' says Webster.) Sally Greene, who runs the Old Vic. Mark Francis of fig-1 fame. Loads of critics and PR people. After drinks we all ascend to the seventh floor for supper. There is a huge buffet with weird but fashionable things like rhubarb and couscous. The tables are decorated with shortbread served on pieces of slate. Through the massive windows, dominating the other side of the river in silent splendour, is St Paul's Cathedral – white, huge and carved in the cool night air.

Inside the Tate Cathedral, Lex Fenwick is holding court. I bump into Karen Wright, editor of *Modern Painters*. She sniffs and looks down the line of artists, arts administrators and PR people. 'What are we all doing here? I mean, why are we here? Is this for Lex to say, "I am all-powerful"?' It probably is, and Karen Wright was possibly the only person questioning the validity of the event. Because all that sort of political questioning is just not done any more. All that delineation of Us and Them has gone completely. Sue Webster sums it up rather neatly. 'The artists of the '80s. They were all about Line and Form. And Weight. Whereas we have a laugh.'

She is right. Previous work was heavy with resonance: it might have been worthy but it was also willing to be difficult. Previous artists' favoured social stance was one of pissing into the tent from the outside. That was the line. It now seems hopelessly dated. Some of the artists eating and drinking courtesy of

Mike Bloomberg might protest, and say that they, too, enjoy waving their tackle about. But if so, it's definitely on the inside. And with an empty bladder.

If you look at the work of someone from a previous generation, the change in political voice is remarkable. Take the sculptor David Mach. Mach might seem to be a forerunner of Hirst, Emin, Quinn and co., with his use of commonplace 'found' objects and their reworking in the space of a gallery. However, his art is rarely without a critical social engagement, an engagement wholly lacking in the tangled sheets, booze and condoms of Emin's bed or the rubbery fin of Damien's shark.

It's clear in a piece such as *Lie Back and Think of England*, Mach's red, white and blue flag made up of hundreds of empty, coloured bottles. The bottles outline a Union Jack, alongside the figure of a spread-eagled archetypal male. It functions as critique of neo-fascism, understanding of the hooligan's sexual allure, reference to the hurled bottle, and acknowledgment of da Vinci in one swift blow.

However, if the hand offering the money is as liberal and interested as the hand of Bloomberg, artists might not feel the need for principled refusal. Artists have the attention of the moment; they know it, and so do the image-conscious corporations. Yet with so much company money swishing around, Lex Fenwick and his kind have removed a certain rigour.

It's influenced the media as well. Art critics used to hate contemporary art. But as Michael Craig-Martin comments, 'You had to stop people looking at art as though you had Michelangelo and Leonardo and Rembrandt hanging alongside it, and then asking, "Is this stuff any good? This stuff? Next to Rembrandt this stuff is terrible!" That was a ludicrous approach. Or, looking at work done by someone who was thirty years old, and saying, "Is this going to last?" Well, that was an insane question. It was not an interesting question. It was a stupid question. Because we don't know and it doesn't matter. *It does not matter.* Culture is not simply made out of the pinnacles of world culture, of which there are only thirty every hundred years,' says Craig-Martin. 'There is no sense in reading the books on the Booker shortlist and then saying, "Well, they are not as good as

Jane Austen, so why bother?" That is not a reason why they are not important. As we don't know what will last and what won't, and our judgments might be right and the future judgments might be wrong, who cares? It is not an interesting question. *I find it completely uninteresting.*'

Indeed, most critics are currently very happy to carry on eating the canapés. In his book *High Art Lite,* Julian Stallabrass deplores what he calls the 'decline and fall of art criticism'. He paints a picture of a world where the power of the galleries has overtaken that of the journalists so much that they practically buy space in the art magazines. 'The result is that critics are rarely critical and there is a small and impoverished market for the criticism that is.'

He tells an extraordinary story about the artist and critic Michael Maloney daring to suggest in the art magazine *Flash Art* that Jake and Dinos Chapman were making sensationalist art for the sake of it. Maloney writes, 'I look at the work of Jake and Dinos Chapman and I feel deep embarrassment and utter boredom. Embarrassed not because it is sex or kids or dicks or cunts or arseholes, but because it is second-rate art with a pretence to being something grander, profound and endurable.' The Chapmans were so incensed by this that they took out a full-page ad in the next issue of *Flash Art* in which they ridiculed Maloney and took him thoroughly to task. As Stallabrass comments, 'It was a register of the power of successful artists that they could simply buy the space to reply.'

With the mainstream press, who are unlikely to worry much about what the Chapmans think, it's a more intriguing tale. Obviously the celebrity and popular shock-value of the new artists was worth responding to, as their galleries had hoped. Perhaps also because the press was hostile to contemporary art for so long, a positive position was a more sensational one to maintain. It was so radical for *The Sun* to approve of Tate Modern that it was newsworthy. For whatever reason, it has become thoroughly unfashionable to slam contemporary art in the old style. John Humphrys gets away with it on the *Today* programme, but that is only because we all know who he is. Brian Sewell in the London *Evening Standard* gets away with it, but that is his long-defined, highly eloquent position.

The dearth of a critical voice in the papers may be one thing. The dearth of a critical voice in the exhibitions is another. In his foreword to the catalogue of The British Art Show 5, curator Matthew Higgs comments on the 1990s: 'Critical dissent – whether by action or by words – was for most of the decade a deeply unfashionable position to avow. Voices of dissent – whether oriented by gender, race, sexual preference, intention or political allegiances – were silenced by their marginalization.' According to Higgs it is this lack of critique which is the most significant legacy of the YBAs.

Matthew Higgs is a good example of the new hybrid of artist and curator. He is also one of the four new associate directors of the ICA (the other three are based in Amsterdam, Helsinki and Glasgow). Last year Higgs was on a list of 'most influential people' in the *Evening Standard*. Indeed, lots of people want to use his ideas. There doesn't seem to be a group show or contemporary art institution which doesn't have a Higgs Connection.

'The culture of artists and a corporate desire to become implicated with them has become fully realized,' says Higgs. (Most of his sentences are like this, fully formed phrases which appear to have sprung straight from academic art lectures. This is just the way Higgs is.) He continues. 'The complicity between artists, institutions, government and the corporate culture has become so fully realized that it doesn't raise a mutter of dissent any more. It's just taken as the status quo. For politicized artists who have been around since the late 1960s, corporate culture was a thing to be addressed. But for artists perhaps born in the 1970s or after, it had become such an orthodoxy that it wasn't a thing they had to be aware of, or had any desire to be aware of.'

One feels that Higgs is rather weary of artists who traffic in, as he puts it, 'pickled sharks, bloodied heads and dishevelled beds'. He feels it has all become a bit unambitious. 'If you look at the mythic example of "Freeze", it was clear what was going to happen,' he says. 'Especially if you look at the catalogue, which I still have and which is not in wide circulation. The final page gives a list of the sponsors for the exhibition. It includes the Docklands Corporation, and Saatchi and Saatchi advertising. At the time, of course, we were in a high

Thatcherite period. It has been mythologized that "Freeze" was somehow this radical gesture against the system and the orthodoxy of the system. But in fact it was the opposite. It was hyper-orthodoxy. The lumpen British art scene of the 1980s was so set in its ways that it wouldn't have even anticipated embracing corporate culture in such a way.'

Such an embrace gave the YBAs the perfect springboard for global command. Now, says Higgs, it has become a stranglehold. 'There hasn't been a generational resistance from artists in their mid-20s. Because of the mediation of British art in the popular press and the way it is held up as a lifestyle item, ultimately artists now want to be involved in what they can see to be the orthodoxy. But that orthodoxy has now been established for five, ten years. In the current benign climate, artists don't realize that in order to establish their own generation, which is what the artists in "Freeze" did, they have to work against what they are presented with. The resistance to the current condition is nonexistent. Which is incredibly short-termist. If something is so fully realized in the public eye, that is its final moment. Once something becomes widely visible, that is its moment of collapse. Tate Modern is actually the curtain call for British art. They should rethink their strategies.'

Some have. At The British Art Show 5 (co-curator, Matthew Higgs), there is quite a lot of dissent flying around. From Graham Fagen, for example. Fagen hit the art scene a couple of years ago with the necessary combination of cheek, smut and jokey conceptualism which is so in vogue. He admits his first London solo show, the installation *Peek-A-Jobby*, at the wonderful Matt's Gallery in East London was a carefully planned event designed to make larger institutions like the Lisson, where he had showed in a group capacity, sit up and take notice. It worked. After the extraordinary *Peek-A-Jobby*, where people read through an increasingly scatalogical script and then witnessed a related stage set, he was commissioned for The British Art Show.

*Nothank* is Fagen's installation. Chairs are arranged on a piece of carpet, around a table and a television set. On the table are books, files of paper, and a half-eaten tube of Extra Strong Mints. (The arrangement is so shambolically

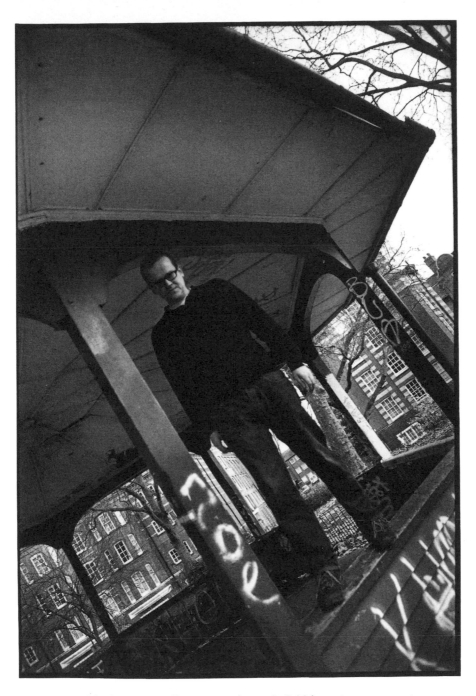

Possibly the most well-connected man in British contemporary art:
Matthew Higgs.

lifelike that during the exhibition some children took the mints from the display and ate them. Fagen thinks that they were set up by a pushy parent anxious for the attendant news coverage, but I think this is overly cynical. The whole thing is utterly realistic.) On the TV a cod documentary is being screened: *Nothank*, about an eponymous council estate in Scotland.

A bouffant-haired male presenter appears on a roadside. He leads us through the story of Nothank, using the phoney hand movements, insincere head nodding and sanctimonious enthusiasm associated with modern television reporting. He is joined by a dour, young architect wearing a sharp suit. Together, they present Nothank as a paragon of civic excellence; a ring-roaded, grassily-landscaped paradise for Glasgow families to enjoy lives of newly-awakened bliss. However, these two are edited against whirling traffic and interviews with dis-illusioned Nothank residents. The place is, of course, a barren wilderness of tarmac and underpasses, of 'No Ball Games' and a dearth of community. The yawning chasm between idealism and reality could provide heavy-handed comedy, yet in Fagen's hands it's a grim sketch from *The Fast Show*.

The idea itself is not radically new, but Fagen's withering edge is gripping. Nothank is clearly ghastly, which is itself awkwardly entertaining, but the film also has wider targets, notably the professionals who parachute down in their black roll-neck jumpers, devise urban plans, wave microphones around and patronise so-called 'ordinary' people.

It's not even wholly fictional. 'Nothank exists,' explains Fagen. 'It's Castle Park, the estate where I grew up in Irvine, a new town outside Glasgow. In the programme the questions I ask are the ones I asked myself after I had left there. Simple things.' The notion of 'overspill' families, policies of social control, the bland smug language of television reporting, the difference between reported truth and actual truth. Artists have, of course, often dealt with these issues. It's just that not many have done so, recently. 'More people are going to galleries than ever before. They see them as places for entertainment,' says Fagen. 'I wanted to entice people to spend a bit of time thinking, which is why I put chairs out, and used a television. People know how to function with a television.'

Around *Nothank* Fagen has made some pictures which, from a distance, look like classically photographed *objets d'art*. When you get close you realize they are of childish weapons: blowpipes made from Bic biros, flame throwers made out of bottles, thumb catapults with elastic bands and tacks. 'Like any industry, art goes through fads and fashions,' the artist says. 'There are lots of pretty pictures around at the moment and artists known for their name rather than what they are saying. What I am interested in is work with a social edge. At the moment artists are pretty much an uncritical part of the institution. They are interested in making their careers. Sure, you need the institutions but at the same time you need to be aware of their politics.'

Also in The British Art Show 5 is a piece designed to answer all of us sad-dos who read *Wallpaper\** and go to Tate Modern and put arty things around so we can seem contemporary. It's a plain, white vase by Grayson Perry entitled *Video Installation*, on which is inscribed a cringingly recognizable decalogue.

1. Video installation with home-made sound track
2. Broken kinetic sculpture
3. Series of large ironic paintings
4. Vitrine with kitsch model
5. Found objects arranged in a pattern
6. Fibreglass figure
7. Simple elemental form
8. Neon sign
9. Everyday item transformed in a witty way
10. Seemingly casual photographs.

Another ceramic, *Boring Cool People*, ridicules those who have probably burnt a large hole in their pockets acquiring the above ten accoutrements. Here they are, drawn onto a vase. They lounge about as if they have just been flipping through the latest edition of *Tate Magazine*. Grayson Perry knows the type very well. His is a sort of Trojan Horse technique, by which I mean he is a guest at his enemy's table.

Owning a Grayson Perry vase is now a very fashionable thing to do, even if you are being slaughtered on its perfectly glazed surface. Particularly as Charles Saatchi has apparently bought a score.

I first meet the artist at the party after The British Art Show 5 opening in Birmingham. Martin Creed's band is playing very loudly in the corner. Matthew Higgs is dancing like a dervish. Perry is hanging out by the bar. In come three local girls, who flock around Perry. 'You're gorgeous, you are. You really are. Do you know you look like a blond Paul Nicholas?' Perry chokes on his pint.

Everyone seems to have a Grayson story. Cerith Wyn Evans tells me they share a birthday and used to share a squat in Camden Town. 'Grayson joined a pottery class thinking it was the maddest thing he could ever do. And the first thing he made was a plate for me which had "Gay Sir Cerith" written on it. And that was my birthday present! He is an extraordinary person. He is an outsider. He is incredibly critical of the art world. That is one of his strengths.'

Doing pottery was one of the signifiers. 'It's a double whammy,' says Wyn Evans. 'It's not only decorative but it's also craft. Within which is this encrypted matrix of perversion which lurks on the surface. And its illustration. He has found all the areas where you are not meant to be, if you want to be a profound and true artist.'

I go and see Perry in his North London home where he lives with his wife and daughter. His wife is a psychoanalyst, which doesn't surprise me at all. You feel that Perry has spent a lot of his time analysing his own fiefdom. 'Being aware of being a contemporary artist is very much part of being a contemporary artist. We are not mad. We are not child artists. We don't just splurge it all out,' he says. 'You need to be aware that you are making stuff in this cultural institution that is Contemporary Art. I can second-guess how my art will be read by my audience. Which is art collectors, museums and the media. I know the jaded filter they are viewing it through. I have to constantly look for ways to prick them in the eye. It might be sex, but that is very, very tired. It's about ways of looking at what is coming up the back half of the circle of fashion. And what is most interesting is the art which is least like contemporary art.'

Grayson Perry, wondering what caustic phrase of apt social critique would work best on his new vase.

Hence pottery, and needlework. 'I chose to utilize a more feminine language. So I went to evening classes and did pottery. It was the same with embroidery. I found out that a) I could do it, and b) it had a pleasing effect on me. One of the things that attracted me was that it was regarded as second class. I had low self-esteem, therefore I chose a medium which had low self-esteem. It was the path of low resistance. My other thought was that here is an area which is loaded. And very Non-U. My experience is that art has to be about rebellion. To be kicked around and beg for more. Pottery was this double bluff I could play. Because I am making real pottery, not sculptures of pottery.'

His vases are real vases, confounded by elegant designs which seek to ridicule and criticize the predominant value system. 'I feel like a content provider in a world which is over-provided,' he says. 'In the past, the art world had a huge amount of quality going into a small amount of stuff. Now it is the other way round. It's a bit like *Harry Potter*. A pretty mediocre novel spread over a huge area, spawning an entire industry.'

He attacks taste but, like all Tastemakers, knows which buttons to press so that his message will be taken up and digested. His work is imbued with such delight you don't care how bitter the pill is. Who could mind being called a pretentious wanker when it's done so elegantly? This might be a problem for Perry, but if it is, he is not letting on.

'I had such a weird experience at the weekend. I felt like one of my vases.' He leaps up, rushes out of the room and returns clasping a huge ball dress in a large plastic bag. I forgot to mention. Grayson Perry is also a transvestite. His alter ego is a woman called Claire. Claire is 'a lower-middle-class Avon lady who attends art events', as well as regular transvestite functions. Perry shows me a postcard of her holding a placard reading 'NO MORE ART' outside Tate Britain. She is wearing a black printed dress and black hat. Her expression is one of politely disguised embarrassment, as if she was just given the placard to hold for a minute by someone who then disappeared.

'I went to a tranny weekend in Eastbourne. Where women could come along too,' says Perry. He hangs the plastic bag on the back of the door and

unzips it. The dress is all flowers and flouncy net and buttons and bows. 'It works in the same way that my vases work. Look! There is all this decoration. But these little flowers are little penis flowers and these roundels are made up of penises. What happens is that people are so seduced by the work and the frock that even though people might have noticed penises on it, they sort of didn't notice. Only one woman came up to me and she was like, "Oh! Cool! Penises!" But she was American and more into the art scene.'

He holds the dress out, proudly fluffing up its net and silk skirts. 'From across the room, it looks innocent. Like an ice cream confection. But come nearer, and the darker it gets. That way of couching things is what interests me. It's almost like starting a conversation with a compliment and then saying something really nasty. People don't take it so badly. It hasn't got the context of a black and white newspaper photograph or a documentary.'

It's not just about saucy stunts, though, with Perry. 'I feel my role is to attack society. Things like pollution. Parenting. Violence. I want to make pieces about the issues of the day,' he says. It's true, his vases are not just full of Islington media types, but also gun-wielding babies, people with knives, multiple dismemberments. All in the best possible taste, with delightful pieces of silver and sprightly sprigs of pottery foliage dancing around the designs.

This is one way. Others, however, decided that to really piss into the tent you have to be much further away. The art collective Bank made its name and reputation for a continuously scathing approach during a series of shows from 1991 to 1999, although former member John Russell admits that it was impossible to really assume the role of outsider for long.

'It is always suspect, since it is as much a commodifiable position as being inside. We played it as always being aware of what was going on. That was the point of the press releases. You had to be critical and at the same time part of it.' Bank 'corrected' gallery publicity and faxed it back to the respective gallery, pointing out hype, art jargon and meaningless cultural mannerisms. 'We felt we were the only voice, I guess. And we kind of romanticized about it,' admits Russell, although in the tight circles of the market this approach was a risky one.

Bank's monthly tabloid newspaper *The Bank*, which specialized in hilariously screaming headlines – 'Ad Man You're a Bad Man!', 'Galleries All Owned By Rich People!', 'White Cube Of Shame', 'Nicholas Stoat-Ghoster' – was never going to win many favours. 'We tried to pick on people who could defend themselves. Nick Serota. Charles Saatchi. But they were also the people who could help us.' No wonder Saatchi never added Bank's work to his collection, even though he was approached by someone on their behalf. A glossy biography, *Bank*, admits sales of the newspaper never made much money, but the group considered it a worthwhile practice since it achieved such a high profile. They held launch parties with a deliberately 'pointless atmosphere', like so many art openings; they constantly poked at the lunatic media frenzy which was building up; and they caricatured the self-importance of the art press. Yet, in the end, the energy and ideas tailed away.

John Russell implies the current was simply too strong to continue swimming against. In 'Bank', a retrospective catalogue, the opening editorial attests, 'Over NINE YEARS, we systematically RIPPED through every option to make SOMETHING HAPPEN; and when we saw options running out, we changed course ... or STOPPED.'

Russell goes a bit further. 'The critical position became kind of tedious. And you need to sell things in order to make money in order to carry on. And you need to be producing saleable work to achieve some kind of celebrity. What we were competing against was the alchemy which money can create.' He sounds rather sad. 'If someone is famous their work is worth a lot and they get talked about. It is a magical effect. And it is impossible to compete against.'

There was another enemy. Real estate. The artist-run spaces which briefly flourished during the property slump of the early 1990s, and which provided a base for the likes of Bank, started to disappear as the market perked up. Property developers conquered the East End zones, and the artists' groups who inhabited them either evaporated or got equally ambitious. Artists started to envisage their careers as independent entities, to be operated by large blue-chip 'agencies', not in collectives. 'A lot of the artists I meet now are expecting to be picked up and

put in a studio and paid money,' says Simon Hedges of artist-run space 21 Underwood Street. 'I don't see the old edginess around now. That sort of DIY mentality. It's gone. It's nothing like it used to be.'

21 Underwood Street, where Bank ran its Gallerie Poo-Poo, is perhaps the last truly artist-run space in Shoreditch. Although about 25 still exist in London, including The Nunnery and Chapman FineARTS in the East, Delfina, Milch and Sali Gia in the South, Cubitt in the North and Tablet in the West. 'These things aren't permanent, anyway. They will go, and everyone will turn round and say, "Oh dear, what happened?" And they won't be able to do anything about it by then,' says Hedges.

He's right. There is now a wave of distinct nostalgia for the artists' collectives and co-operatives; the truly awkward squad who gave the phenomenon a crucial hint of danger and daring.

# CHAPTER ELEVEN

# CURATING
# THE REAL

## worlds of their own

Of course if you don't like the current world, you can always make up your own. Paul Noble, one of the six people behind the late and legendary artist-run gallery City Racing, is currently submerged in an exclusive world of his own devising. People are so excited about this world that in 2000 it won him a £20,000 Paul Hamlyn award, and exhibitions all over the place, including at Maureen Paley's. On a rainy day I go and see Noble at his South London studio. I can see why he is happy with a parallel universe. In reality, half of his studio has a leaking roof so fundamental it's like a power shower.

Noble is the creator and administrator of Nobson Newtown, an entire community with urban elements ranging from the Nobslums to the Lidonob, by way of the Nobpark. The environment is designed around an alphabet created by Noble with its own special computerized font, Nobson. Written in block capitals, the letters of the alphabet themselves delineate the buildings. The word 'Mall' is the shopping mall; the slums, in their pit of raw sewage, are little buildings which spell out the word 'Nobslums'. The Nobspital looks more like an oil derrick. The centre of town is a smashed-up wasteland.

'Words are really no different to drawings.'
Paul Noble

'The project started off with a story about living in the city. The way you looked at the story was through words which looked like buildings,' says Noble, who has thought about Nobson Newtown so much he has even invented an archaeological history for it. There's a guide book, *Introduction to Nobson Newtown*, and photographs of installations to represent fictional places. But it's really the intricate, huge, pencil drawings which carry the idea. 'My work is all about the space between words and meaning. Words are really no different to drawings. They are simply 26 shapes out of which we can construct an infinite amount of communicable thoughts. The only difference is that there is an order to the written line, as opposed to the drawn line.'

It's painstaking work. Each drawing takes six months. Noble estimates it will take seven years to finish his ambition of twenty Nobson drawings, selling as he goes. He's been doing it for five years already. Nobson Newtown is now scattered in pieces across the world, although he hopes to 'persuade some big space to show it all together', once the town is finished. They are very much hand-crafted pieces, and I can see why they sell. They are the sort of works that people who go to Tate Modern searching for human creativity hanker after. Stephen Bayley would probably love them.

'I had a straightforward ambition just to present work that is fuck off,' says Noble chattily. 'Work should be fuck off if it's any good. Something that can be looked at. That deserves to be looked at.' Then he says something which is probably on the mind of every artist working in the heated environment of contemporary art. 'It's quite straightforward. I didn't want to do a cheap version of something that deserves to be in an advert or an interior.'

Nobson is a tyrannical world, where choice and freedom have been replaced by a formal system wielded by Noble (living in The Architect's House, or Paul's Palace). But the idea of three-dimensional buildings visually defined by written characters is really all about art and the hierarchy of culture. 'I am concerned that art not be considered the stupid cousin of all the cultural practices. Literature occupies the highest step. Subconsciously, you think that controlled expression is better housed in the written word. The meanings are more anchored.'

This could equally be applied to Emma Kay, whose work is fundamentally text-based, although she puts this down to a lack of ability. 'Although I went to art school, I knew I couldn't be a person who could paint or make a beautiful object,' says Kay. 'I have never been able to do it. I turned to what I know. I was going to do an English degree, and then rebelled and went to art school. So it's no coincidence my work is writing.'

Kay is another one of those people whose name comes up a lot. She's also fascinated with creating a written universe. This time, however, the inspiration is grounded in Planet Earth. 'Or my subjective view of the world,' she says, 'rather than a representation of something else. I try and shape the words, or the view of the world, into something which is as beautiful as I can make it. It was always my idea that if I presented something highly subjective in an authoritative enough way, people could always measure their experiences against mine. And that is how the work I have made functions.'

Emma Kay's working day goes something like this. She sits down at a big white desk. She thinks of a universal cultural product. She writes down everything she knows about it. The things she chooses are the stuff of *Desert Island Discs* without the music. The Bible, the complete works of Shakespeare. And, of course, the history of the world. The only twist is that there are no reference books at hand: Kay does the whole thing from memory. What we are thus presented with is Kay's version of the Bible, her version of *Romeo and Juliet*, her version of the Wars of the Roses, or the Great Wall of China, or the First World War.

'I just sat down here and rewrote my version of the Bible in longhand,' she says. 'I didn't have a religious upbringing. I never went to church. Although I did RE at school. The work is pretty slim. My Bible is about 7,000 words long, which is pretty short for both the Old and New Testaments,' she confesses.

It might not be Authorized, but it's an interesting version all the same. Here's a clip. 'The disciples were Matthew, Mark, Luke, John "The Baptist", Peter "The Rock", Paul, Simon, James, and three others.' See what I mean? Or 'ritual total immersion in water was the method used to welcome people in the faith.

Emma Kay, who remembered the future and wrote it down.

This was called baptism. The disciple called John did most of this baptism, for which he was known as John the Baptist.' You have to admit it's pretty succinct. And impressive enough for an edition to go off to the Tate.

'Most of what I recalled did not come from knowing the Bible,' says Kay. 'It came from advertising, theatre, and films, lots of films. I knew the story of Joseph because we did *Joseph and his Technicolour Dreamcoat* at school. And then there are the phrases that are in common use, that people use in everyday speech. Biblical references. If they come into your head and you trace them back they have come from the Bible. I had a vague recollection that Elijah was fed by ravens. I had absolutely no idea why or how or where it fitted in, but it had to go in somehow.'

Her work is a revealing commentary of what we carry in our brains. We are told that these works are an essential part of Western culture, but how much of that culture do we actually know? How much of the Bible? How much Shakespeare? In Emma's case, certainly not the Complete Works. 'I left out about ten plays and I inadvertently made one up, *Edward II*. Which I now know is by Marlowe.'

What about *Worldview*, the Kay history of the world? The Big Bang through Jurassic Park via the Ottoman Empire and the reign of William and Mary, to the Vietnam War? 'I didn't bother with dates,' says Kay of her 80,000-word epic. 'Unless they just popped into my head. I just vaguely did it in centuries. It's by definition a complete failure. But it was the best I could do, which is the point. My idea was that everyone walks around with an idea that they know enough about the world to have a sense that they know where we have got to and where we came from. And I just thought I would see how adequate or inadequate that was. By trying to write it down. I found it to be pretty inadequate. But obviously it is adequate enough.'

Particularly if you do it with conviction. She has written the 'Future From Memory', which was shown in her solo exhibition at the Chisenhale in the spring of 2001. This sounds impossible but somehow when she explains it, it's not. 'The more I thought about it the more I realized I could approach the future

in the same way as I had approached the past. I knew enough about it, hypothetically, in the same way. And if I sounded authoritative I could make it into a piece of work.'

She may not be able to draw much ('all my work at art school made people laugh'), but she knows her position as an artist. 'It is not the purpose of the artist to make something beautiful. It is the purpose of the artist to make something that makes people think ... that is intellectually provocative.' The World According to Emma Kay. Her efforts have given her an important position from which to provoke. Her gallery is the highly-rated Approach.

'These attempts to re-situate the world as a found text discover the author evacuating the position of the artist in order to become a curator of the real,' says Steve Beard of Book Works, which has published Kay's *Worldview* as a book.

Curating the real. It's what these artists do. Buoyed up by private money, credited with the confidence of public acclaim, given regular media platforms and handed cultural dominance, artists are not satisfied with reflecting the world. They want to re-create it. 'I feel powerful in an odd way,' says Emma Kay. 'I guess you could say that of the other artists. It's as if we have some licence to rearrange structures and represent them.'

It's an idea also presented by artists like Cornelia Parker, who has long focused on a readjustment of reality, whether by depicting maps of London after fictional meteorites have dropped on it, or in *Pornographic Drawings* which take oddly anthropomorphic ink blots from pornographic video tapes. Parker took rearrangement to an extraordinary level with her sculpture *Cold Dark Matter: An Exploded View*. She blew up a garden shed and everything in it, and then painstakingly repositioned every little shard and splinter to appear as it might have done at the moment of explosion.

Or Marcus Harvey, who produced a huge reproduction of the famous picture of Myra Hindley, as seen in countless newspaper articles. Nothing new there, except Harvey gave it a shocking newness by delineating Hindley's stony face with thousands of children's hand prints. And in his sculpture *Dead Dad*, Ron Mueck updated the funerary tradition of death masks and cask-side visits by

casting a model of his deceased naked father in miniature. Coincidentally, both pieces were on show at the Royal Academy's 1997 exhibition 'Sensation', where they enabled visitors to sense the rare vibration not only of life, but also of lifeless cliché being summarily dismantled and repositioned.

No wonder that contemporary artists are fascinated by facts, lists and archive. Works like Douglas Gordon's list of everyone he has ever met. Done again and again, each time from memory, the list with its hundreds of names mutates with each successive production as people are born or die, are left out or forgotten. Self-confessed list fanatic Matthew Higgs gathered together suggestions for the alternative Seven Wonders of the World; Fiona Banner penned film scripts; Tacita Dean recounted the last days of elusive yachtsman Donald Crowhurst through newspaper archive and family accounts; Matthew Thompson's *Works Not To Be Shown* was a slide projection presentation of eighty small things he once made but never intended to show. No detail is too small. The sound artist Scanner hired the Royal Festival Hall to read out urbane entries from his diary.

Others simply use information, as experimental ensemble Forced Entertainment do in their show, Quizoola. Tim Etchells from Forced Entertainment explains. 'The idea is to ask all the questions in the world. It's a test on the idea of the infinity of knowledge. It's a catalogue show. Anything that is a question can be in this show.' Sometimes they have guests asking or answering the questions; sometimes they have members of the audience. Sessions can go on for hours. According to Etchells, the idea is not about being witty but about taking risks. 'Knowing you can ask whatever. Many people say they can't perform. But they would like to take part in a quiz.'

Forced Entertainment are performing a marathon, twelve-hour edition of Quizoola at The Museum Of... on London's South Bank. I go along. The show is taking place on the top floor of an abandoned warehouse adjacent to the museum. Two men are sitting on chairs under *Mastermind*-style lights. About thirty people are watching. 'Have you ever burnt a house down?' asks the questioner. 'No.' 'Have you ever committed arson of any kind?' 'No.' 'What is the

CURATING THE REAL

name for the piece of skin between my thumb and forefinger?' And so it goes on, for hours and hours.

Their other gig is one in which they tell every story in the world. 'No story is ever allowed to finish,' says Etchells. 'We use film plots, novels, made-up stories. The idea is that there is this inexhaustible catalogue.' The narrator gets a certain amount of time to talk, depending on the interest of the listener. 'Sometimes people get ten minutes, sometimes they are told to stop straight away. The stories that get retold a lot are Nativity stories, but the trick is to tell a well-known story in a different way so it is obscured. Once we went on for six hours in a performance in Beirut.'

Gillian Wearing is interested in restaging the real, as shown in her extraordinary photograph, *Homage to the woman with the bandaged face who I saw yesterday down Walworth Road* (1995). Wearing saw the woman and followed suit, wrapping hospital bandage over her whole face, leaving a haunted white mask fretted by strands of her long, black hair. The result is the viewer's unsteady mental zigzag from the picture of Wearing to an imagined image of an unknown woman with a bandaged face.

Jeremy Deller is another curator of the real. And he's another one who admits he can't draw. I quite like this mood of disingenuous abandonment of any attempt to appear talented. In the past, artists who seemed dangerously modern were always explained away with a 'Well, of course, he/she draws like an angel. It's just that he/she doesn't choose to.' Picasso, although obviously a brilliant drawer, was for some odd reason usually cited as the chief practitioner of this double bluff. These days, however, artists say they can't draw but that doesn't matter. They are artists because they say they are.

'I try and work with music, but I am not musical,' says Deller. 'I can't draw or paint either so I have to rely on people who can do it. I didn't even do O-Level Art. I wasn't allowed to. My art teacher was so anally retentive he just thought you should draw and paint like a photograph. We had to do these tiny drawings of plant roots. He loved things like *Gray's Anatomy*. It killed any creativity. So I can't draw or paint but that's fine. I can do other things.'

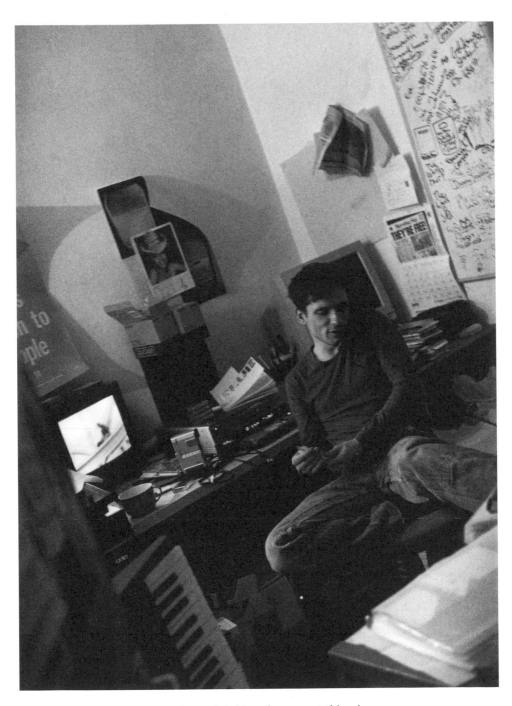

'It's more of a social thing than an art thing.'
Jeremy Deller

He too has done a History of the World, but his History links various cultural movements to one another by mapping them out. This provoked his invention of Acid Brass, a hybrid of brass band and rave music which he has developed with the Stockport-based Williams-Fairey Brass Band. Deller and the band have performed acid house anthems all over the place, notably at the huge opening party for Tate Modern in May 2000. 'I'm interested in folk music and the social aspects of brass bands. It's about family and a way of life. What the band did at the Tate was similar to what they do anyway, and people just got into the music. It wasn't that different; it wasn't conceptual art or anything. At the end of the day it was just a brass band which people enjoyed, and that is great.'

He's interested in difficult, unfashionable reality. His video piece *Current Research* (1988–ongoing) captures London as a theatre in which various allegorical experiences are staged; the culture of dissent, for example, where Remembrance Day celebrations at the Cenotaph are juxtaposed with shots of anti-capitalism riots in the City. Deller documents the naff side of popular culture. His installation with Alan Kane at Tate Britain's 'Intelligence' exhibition, *An Introduction to Folk Archive*, included pictures of things the Tate wouldn't usually dream of exhibiting. Huge dummies dressed as Jimmy Savile. Cheap-looking mugs. Tattoos. Glossy air-brushed portraits of Princess Diana. And not done with irony, either.

'There is a lot of irony around,' says Deller. 'It's in every lad's mag, with Chris Evans and all these DJs being ironic. My work is just not ironic. I did a show last year in Cardiff called "Unconvention", which was based on the artistic social concerns and tastes of the Manic Street Preachers. It sounds odd but we had work from Picasso, de Kooning, Warhol, Francis Bacon and the Situationists all in the show. We had an opening weekend where local groups pitched up around trestle tables. We had people of all ages there. A male voice choir turned up. Arthur Scargill gave a talk. It was all about connections between art and people. It was trying to get back to art and music as a meeting point. Something that irony tried to kill.'

Irony is not the point. Reality is. 'I'm attracted to the wide world. *The* world. Rather than the art world. You have to work with the art world, because that's what they are there for, but I hope the work will bypass the art world and become something outside it. Like this Artangel thing. It's more of a social thing than an art thing.'

For the summer of 2001 the company Artangel has commissioned Deller to reconstruct, as accurately as possible, a major riot which took place during the miners' strike in Orgreave, Yorkshire. 'With all 10,000 people in the actual place. The colliery and the coking plant have disappeared. There's nothing left apart from the field where the riot happened.' Deller pauses to take in the enormity of his plan. 'It's like the real-time reconstruction of a crime, showing what happened to the miners that summer day. The police charged on horseback, beating their shields. The miners were all topless because it was so hot. It was the day the Labour movement died. It was a set piece for Margaret Thatcher. This huge force descended on these people, to teach them a lesson and destroy them. I hope we'll do it in conjunction with English Heritage,' says Deller.

English Heritage? Trusted preserver of Stonehenge, Avebury and the Albert Memorial? It seems an unlikely collaboration but perhaps English Heritage wants to be on the inside, too. 'Every weekend, battles are reconstructed around Britain,' says Deller. 'This is just a way of updating it to the last big civil war. That's what it might be called. "The English Civil War."'

And so we reach Michael Landy, who has pulled off probably the ultimate alteration of reality, unless you count body artist Orlan, who has rebuilt her face with plastic surgery, or her fellow 'carnal artists' such as Franko B, who tattoo and wound their bodies for strangely moving visceral effect.

Michael Landy has taken reorganization of his personal goods and chattels to the extreme, by destroying them. Again with the assistance of Artangel, Landy proceeded to make an inventory of everything he owned, took it all apart and then ground it down to dust. Talk about de-junking your life.

He whetted people's appetites for this at The British Art Show 5, where across several intricate drawings he explained what was going to happen.

Everything disappears down a conveyor belt into a compactor. It's utterly mesmerizing. There goes his Casio calculator! There go the Timberland boots! And the basin, and his duvet, his bed, a pair of scissors, 900 milk crates, a coin found on the streets of Dublin, a Japanese crisp packet, a hospital trolley.

Drawing it, however, was not enough. He wanted to do it for real. So in February 2001, Artangel, with additional sponsorship from *The Times*, enabled him to hire the old C&A department store on Oxford Street, in which a real-life conveyor belt and compactor were rigged up. 'All I will have left is a written record of what I possessed,' Landy told me before the event. 'I have categorized seven or eight different areas of my things. E is for Electrical. So E11 is an Olympus 35mm camera. It is put in a labelled bag. It gets weighed in. It gets logged onto the PC and the inventory list and enters into a roller conveyor circuit 100 metres long. It's like a giant Scalectrix.' What next? 'Then it gets taken off the conveyor belt and broken up into its constituent parts. Those parts get weighed and logged onto the PC. Once it is broken down it goes back onto the belt and what happens is I will have a platform with people standing and identifying all the different materials. They go down chutes into large bins and those either go into shredders or granulators. So in the end all I will be left with is powder.'

I tell him he is a modern day Francis of Assisi (who destroyed all his worldly goods before turning to religious contemplation). 'Hmm,' says Landy. 'I think I saw it more as a way of questioning consumerism and the motivation behind it. I have been working on the idea for three years.'

It's also a meditation on self, on possessions and on memory. Landy said the hardest thing to watch going into the shredder would be a sheepskin coat which belonged to his father in the 1970s. He bought it when he was 37. It was so expensive he had to pay it off in installments. Soon after, he had a serious accident at work and the coat was too heavy for him to wear. It took Michael's mother twelve months to finish the payments for it.

One of the key things, oddly enough, that Landy is concerned about is the embarrassment factor. When you log all your possessions in public, they

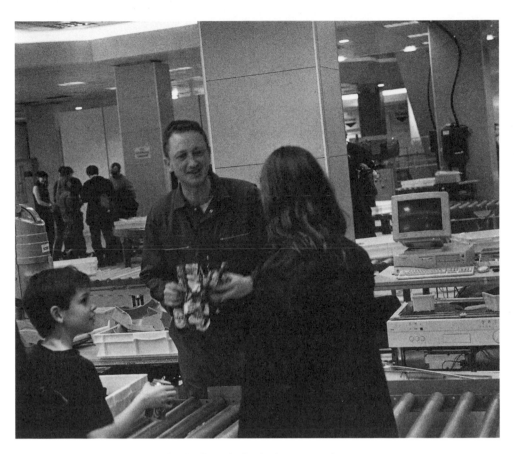

You don't think I'll junk the lot? Just watch me.
Michael Landy at Break Down.

might not seem fashionable enough. 'There are things that aren't the latest model. I think it is quite interesting that I feel like that, because we all feel inferior. We all have this thing about what we own and whether it is the latest thing or not.'

Landy's Saab 900, taken apart by a (presumably heartbroken) Saab specialist, the heated blanket his mum gave him, his photographs, books, faxes from his girlfriend Gillian Wearing, his No Bite mosquito killer device which the inventory states as never used. He'll never use it now. His bed. Not that that really matters, since he actually lives with Wearing, which sort of wrecks the headline a bit, but still everything in *his* flat has been condemned to the list. Sorted, categorized and then: vamoosh! 'It's an anti-consumerist thing,' says Landy. 'It's not a moral thing. But doing it in Oxford Street, there is a message. All these things are replaceable. I am examining consumerism, and my own consumerism. I mean I am not Elton John. But I have a lot of things.' (In December 2000 Elton John famously sold for charity 16,000 items of clothing and accessories which he had acquired over only two years.) Whereas the likes of Tracey Emin and Damien Hirst pitch their work to the outside world, Landy is stripping away from within, removing every outer covering until he stands alone in his boilersuit and underwear.

Landy, who doesn't have a dealer, is not the only one shrugging off the bands of a refined, confined, white space. For if you are playing around with reality, why not do it in the real world? Landy in Oxford Street. Deller in a Yorkshire field. The artist Darren Almond may be represented by White Cube, but his latest project is an electromagnetic clock set to GMT which he has set to sail around the world backwards through time. 'I feel I am in a self-educative career,' says Almond. 'I feel I can go everywhere I would like to and need to. I think it's got something to do with my grandfather who was a coal miner from Wigan.' Meanwhile, Wolfgang Tillmans, winner of the Turner Prize 2000, spreads his work across magazines, exhibitions, postcards, posters and the *Big Issue*. The dealers may stay inside their white spaces, but the artists are gambolling across the big wide world.

# THE LABORATORIES

## goodbye to the traditional gallery

It's clear that there are now quite a few instances in which galleries simply won't do. They aren't big enough, or small enough. You need a large field. You need C&A on Oxford Street. You need somebody's bedroom. You need the MI. Artists have got vision and ambition. And formal art spaces can't always contain them. Enter the Laboratories – innovative spaces which have appeared in order to do the artist's bidding.

As its name suggests, Artangel is something of a facilitator for art's wilder dreams. Over the last ten years, Michael Morris and James Lingwood have been responsible for more than thirty cultural highpoints around the country, ranging from Rachel Whiteread's *House* to Michael Landy's *Break Down*. Essentially, if you want to produce a bit of art down in a disused tube line, a storage space in Wembley or the middle of Soho Square, Artangel is your port of call.

With the sort of brilliance that comes from true invention, i.e. giving people something they wanted that they didn't know they wanted, Morris and Lingwood have responded to both the increasing scope of the artist and the public desire to participate in a pilgrimage to a modern-day spectacle. Art has become transformed into an event, a one-off, truly astonishing, public, visceral, humming happening you will talk about for months. The artist comes up with

the idea; Artangel provides the mechanics. 'Even the journey there provides a sense of adventure,' says Michael Morris. 'No matter how exciting the show is that night at the National Theatre, when you are in the foyer, the experience is the same as it was last time.'

Morris is a big bundle of enthusiasm and intelligence, the sort of person who rushes through foyers embracing everyone, but NOT the sort who then looks over your shoulder to see if there is anyone more interesting on the way in. So, a nice guy as well as a creative genius.

'Ten years ago James and I were at the ICA. I was Director of Performing Arts. I looked at my programme for 1986 and discovered half of it wasn't in the ICA theatre at all. My interest in a 160-seat black box theatre had diminished. I had enough faith to think there was a much bigger audience for these artists, and there are all kinds of spaces that they can work in.'

Artangel work with a different artist every time. And in a way which makes the Planning and Steering committees of your average arts institution seem like something out of Tsarist Russia. 'When we started out, artists were becoming estranged from institutions. Institutions were spending so much time fund-raising, scratching their heads wondering whether they had to restructure or not, and all that kind of nonsense, that artists felt totally alienated,' says Morris. 'They needed an organization like Artangel. Although at that time "organization" was a ridiculous word. The office was so small James and I couldn't both work there at the same time. But we were able to maximize the time we spent with artists. That was our day. Sitting down and talking to artists.' It was the perfect time. Artists were coming up with wildly ambitious projects. Audiences were looking for something different. Artangel, with its 'no boundaries' approach and experience of theatrical production, could deliver both.

'The turning point was *House*, which put us on the map. And Michael Clark performing at King's Cross Depot. We realized afterwards that if no one had turned up to it, we would have gone bust. It was a huge risk but it was absolutely packed out. Even if it started half an hour late every evening because no one could find the warehouse.'

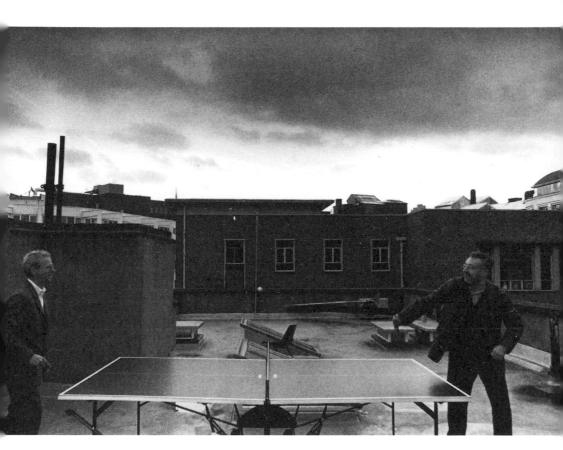

They put art in wild places; they play table tennis on the roof.
James Lingwood and Michael Morris from Artangel.

Because Morris is the sort of producer who credits the artist with the bulk of the idea, he might suggest that Artangel was simply providing a venue for what was bound to happen anyway. Yet I suspect that without his and Lingwood's daring, John Berger and Simon McBurney would never have led one hundred disorientated people into the utter darkness of the tube track at Temple Underground, or Michael Landy ever realized his pictorial notion of destroying his worldly goods. All Morris will say is that the company has been 'pivotal' for the artists.

He spends a lot of time weighing up rival attractions. He says theatre is dead, but there are other things jostling for attention: restaurants, multiplex cinemas, reawakened bars, even hotel foyers. With all this in mind, Artangel's invention of a temporary, 'special' location for art is a brainwave. 'Artangel audiences come from different walks of life. Some people feel the National Theatre is not for them, or the National Portrait Gallery is not for them. But when you are working in a Baptist chapel on the Goldhawk Road doing a Susan Hiller project about UFOs, then it's no one's project. And the audience can feel an ownership of that place. They feel they have discovered it themselves.'

Even in formal spaces, enterprising directors are bringing radical practitioners in. Artist Keith Khan, one half of the design company Moti Roti, which he runs with Ali Zaidi, has triumphantly engineered cross-boundary, multi-skilled projects in a variety of spaces from the Theatre Royal Stratford East to the Albert Hall and the Dome. 'There is this problem that everything can happen the way it has before, but everything has changed. Contemporary art now goes across all the boundaries. Artists who have successfully negotiated that are the most interesting.' Khan needs firstly space, and secondly people. What follows is a riot of imaginative visual theatre.

He designed the visuals for the critically acclaimed Dome show and the opening ceremony on New Year's Eve 1999. 'That was a bit of a nightmare. We had to dress all the celebrities. To symbolize the next century there was no black tie. I took the entire ENO and the orchestra out of dinner jackets. I dressed all the opera singers. Willard White, Bryn Terfel. There was a slightly abbreviated

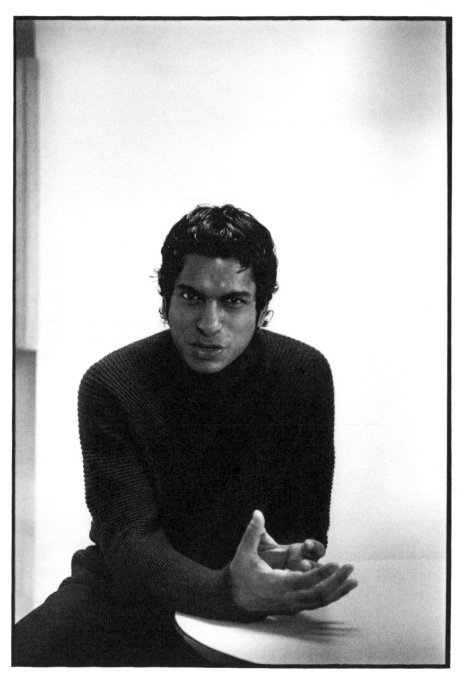

'Contemporary art now goes across all the boundaries.'
Keith Khan

conversation about the Queen, I recall, who I couldn't dress. Mick Hucknall insisted on wearing a dinner jacket and looked really bizarre, because he was the only one wearing one.'

Khan shows me a selection of photos from 'Coming of Age', a subsequent Moti Roti experience at the South Bank Centre. It is stunning. Fabulous lights. Dancers. Music. The entire concrete space illuminated with abstract colour and choreographed performers. 'There was nothing overtly there, but over the course of the evening the whole centre came alive with Indian dancers,' says Khan. 'All the windows, all the platforms.' Moti Roti has now been booked for the Manchester Commonwealth Games in 2002 and by the British Museum for 2003. It is both theatre and abstract art, much in the same way as the Notting Hill Carnival is (on which Khan worked for ten years). His is a gorgeously flamboyant and highly decorative street style which is now being enfolded into formal celebrations across the country, no matter what the scope. 'Nothing is too big or too small for us,' says Khan.

Audiences love big events but people, being what the marketeers call 'cash rich and time poor', don't always have the time for long ones. While this may present a problem for rival attractions, particularly ones by Richard Wagner, it is no problem for visual culture, which can come in nuggets rather than three acts. How about a single piece of art? For only seven days at a time in a strange little room in Soho? You still have the idea of a special event that you yourself own. But it's quick.

Fig-1 came out of the same frustration that produced the freewheeling likes of Artangel and Moti Roti. 'The idea is to respond to culture in a much more spontaneous way than formal galleries can,' says its director Mark Francis. 'We do a different project each week and we don't plan more than six weeks ahead. So if we see something new, we can do something about it rather than saying, "Oh, that sounds interesting. Come back in two years' time."'

Fig-1 was an offshoot of White Cube, who commissioned it throughout 2000. It was sponsored by Bloomberg and Beck's Beer. So far, so typical. Yet fig-1 was a small revolution. It's already over in London (although not in New York),

but will cast a long shadow of influence. Flexibility. Variation. Brevity. Communication via e-mail. Clubs do it. Why not art events? 'You couldn't possibly have a mailing list and send out to everyone on it,' says Francis. 'The only way was on e-mail. New technology was critical. As was private money. Public funders simply can't respond quickly enough. And they don't have pools of spending money for something experimental. Working like we did was liberation into the free world.'

Fig-1 was an utterly blank page. The name was an arty reference to Marcel Broodthaers, an artist of the 1970s who used to attach the term to various objects. But you didn't have to know that. You just had to wander along every week for an ever-changing injection of current culture. Will Self writing a book. An installation by milliner Philip Treacy. Work by fashion guru Hussein Chalayan. A film by Patti Smith. And the visual artists: Michael Craig-Martin, Bridget Riley, the Chapmans.

It was a tiny but brilliant distillation of the modern cultural centre, a place where fashion and writing and music coalesced. 'We needed to reinvent the old ways,' says Francis. 'The barriers are much less evident between these contingent worlds of fashion and film and performance and video.'

I am at fig-1 for the start of Harland Miller's week. Miller, author of the hilarious, dank, nauseating, urbane and cultish novel *Slow Down Arthur, Stick To Thirty*, has produced an installation. And *Vogue* has just dubbed him 'the most stylish man in London'. Indeed, he appears all the time in photographs of society events. Sam Taylor-Wood took the photograph on the front of his book. He's best known for his novel, but Jay Jopling is his dealer. Miller has momentarily left the party to change his suit.

His piece is a short story about a woman with Compulsive Obsessive Disorder who can only go to work if she takes Polaroids of the front of her gas oven with her, showing that all the knobs are turned off. The story is pinned up along one wall. On the opposite wall are all the photographs of the gas oven. It's nice. You come in and see sixty or so Polaroids of the front of an oven, then you turn to the other wall and read the story. Book Works have published it as a

little text. People are buying copies, and drinking Beck's beer. Jarvis Cocker pops in briefly (he wrote a paean of delight on the front of Miller's novel) and, eventually, Miller himself appears, looking fabulously sharp.

The gallery is packed, so we sit in the tiny fig-1 office. Miller is a bit nervous about having so many people look at his work all at once. 'It's not ideal,' he says. 'This audience. I prefer the idea of the reader being on their own in a semi-lit room. It could go wrong here.'

We are disturbed by a commotion outside in the corridor. A burly man is bumbling out of the gallery. 'You don't come all this way to see a bunch of Polaroids,' he shouts. 'Where is the artist?' I look at Miller. Miller looks at me. 'That is a good example of why it could go wrong,' he says in a low voice. 'When you've read something, your feelings should be contained for a while. You don't immediately talk about it. That's what people do at openings. They immediately have an opinion. I just write and hope that people will be moved by it. Not like *that*, but you know...'

A lot of people then put their heads round the door and say how much they liked the show. Miller and I chat about how he trained as a painter at Chelsea College of Art and then travelled around the world, and how, when he turned thirty, he went back home and started writing about growing up in York, which is the substance of his novel. It's been published across the world and he's turning it into a screenplay. 'It's only been optioned, you know,' he says.

Fig-1 is an attempt to get back to something of the unplanned spirit of the artist-run spaces. I go and see Hans Ulrich Obrist, a curator at the Musée d'Art Moderne de la Ville de Paris. His 1996 show 'Life/Live' was an attempt to catalogue these spaces. We meet at a Starbucks in Bloomsbury which is apparently where he conducts his London meetings. I come with a bag containing Jake and Dinos Chapman's £400 ties and a couple of others on loan from the tie exhibition, because I'm talking about them on the radio in a few hours' time.

'It is very important that no one forgets what has happened... This incredible moment in Britain,' says Obrist. 'When I came to London at the beginning of the 1990s I was struck by these exhibitions which were put on by the artists

Hans Ulrich Obrist, negotiating the early morning London zeitgeist.

Darling, darling, darling.
Style Queen Jibby Beane at the Royal Academy.

themselves. They set free an incredible energy. This whole professionalism of art, of it getting bigger and bigger, is very positive. But we must not forget also that we need these small spaces, these laboratories. Where you can make mistakes and experiment and have no pressure. When I lived here, that's what we achieved in Salon 3. At the Elephant and Castle.'

He ponders the subject a little. 'The first city where real estate killed off art was Manhattan. Five years ago artists could no longer afford to pay the rent in Manhattan, apart from the few famous ones. Now the university professors can't afford it either. New York used to be a centre where people from all disciplines met. It used to be. London could go the same way. I looked in *Time Out* the other day to see whether any of the spaces I listed in "Life/Live" still existed. Hardly any did.'

Obrist's big idea is to insert laboratories back into the institutions. In Paris, he has introduced 'Migrateurs', places for new artists which 'wander' around the Musée, from café to roof to the second floor. The spaces are intended to pop up in different places, avoiding predictability.

I say goodbye to Obrist and take my leave. I also take my leave of the bag containing £1600 worth of neckwear. Fifteen minutes later I am charging back in a blaze of panic. Have the ties been stolen? They both do and do not exist. It's a sort of Schrödinger's Cat scenario. I remember this being deployed with total brilliance in a Laboratory moment two years ago at the South London Gallery by an artist who sat for a whole weekend in a black box utterly sealed from sound, light and food. I get back to Starbucks. The ties are still there.

Of course, you could simply stay at home. In the 1950s, there was Kettle's Yard in Cambridge; in the 1980s, there was Maureen Paley's Interim Art in East London. And from there, the idea has taken off. Perhaps domestic spaces are the obvious progression from the Temporary Autonomous Zone, since you don't need a commercial space. You can just use your living room.

Jibby Beane, platinum-haired model, muse, art hostess and all-round cultural goddess, started to show art in her house about ten years ago; she is famous for running a salon and championing art events from her fantastically

chic apartment with its huge white spaces, walk-in wardrobe, plasma telly and truly mesmerizing City views.

Mary-Jane Aladren's Nylon Gallery also began in her house, in this case a one-bedroom flat. As its name implies, Nylon focuses on a symbiotic relationship between artists in New York and artists in London. After a career at Estée Lauder's New York HQ, the British-born Aladren realized she had an eye for emerging artists, and started selling prints and paintings to smart Americans who had begun to demand a bit of culture in their lives. She arrived in London with a similar aim. She has a stable of artists, but also about a hundred in 'flat files' (works on paper): although the art is challenging, her brief is one of inclusivity and understanding. Although a practical necessity, her front room gallery was a perfect way to encourage new buyers. For if the art boom is indeed a boom, then enthusiastic introductions making nervous newcomers feel at ease must be part of the deal.

'What I am trying to do at Nylon is present the work in a way which isn't intimidating,' says Aladren. 'There is a degree of domestic hospitality going on, which really works. I can say this with certainty, having had three hundred people at opening parties, all of whom were eventually trekking off to use my bathroom which has all my memorabilia and photos of my mum in it.'

However, no one has pulled off the combination of gallery and salon with such consistent brilliance as Laura Godfrey-Isaacs and her 'home'. A functioning house for Laura, husband Glen and young daughter Tallulah, home also boasts six-month hanging exhibitions over all four floors and monthly live salons with audiences of forty. The South London house has hosted normal family breakfasts alongside a Volkswagen van in the sitting room, a woman rolling around in paint in the attic, a mermaid in the bathroom and someone performing Andrew Lloyd Webber in the bedroom. Even the iconoclastic Bobby Baker has been At Home, at home.

'A domestic place should also be one where art can be experienced,' says Laura Godfrey-Isaacs, an artist who opted to work from home after the birth of her daughter. 'It doesn't have to be this pure thing that you only see in a white

space. Modernism denied the whole subject of the domestic. It was seen as bourgeois and feminine. But over the last ten years, the domestic in art has re-emerged. As an artistic concern as well as a site. It can have decorative functions, or it can be this ephemeral, live, entertaining thing. And you come together with other people to experience it, so there is a social context. It's the very antithesis of the smart white gallery in Cork Street. The integration of art and craft is unique, and the fact that it is a functioning family house with the presence of a child changes things.'

'Dear Rosie, I am writing to confirm your booking for Salon 6, An Evening With John Carson "Just for you", on November 10. Please arrive promptly as drinks will be served before the performance...'

I am sitting on a cushion in Godfrey-Isaacs's dining room. It's a large, open-plan space leading off the kitchen, which is just as well since there is a huge crowd of people. Our hostess is popping about, offering crisps and wine. After everyone settles down, John Carson appears and takes his position beside a piano. The head of Central St Martin's art school and a long-time live per-former, Carson is a tiny Elvis Costello lookalike. Tonight he is wearing black tie, which is only slightly undermined by his leopard-skin brothel creepers.

The idea behind 'Just for You' is that we, the audience, choose what John will sing for us. To this end we have all sent in requests, from which John will attempt a selection. This concept was apparently inspired by Carson's youthful experience as night porter at the Coast Road Hotel, Carrickfergus, which used to hold such musical evenings. One of his duties was to sweep up the little request cards for specific songs, from which he would imagine the night's entertain-ment. I sit on my cushion, fervently hoping that John isn't hoping to exhume the Carrickfergus favourites tonight. Particularly as I have discovered the man sitting next to me has requested the Sex Pistols' *Anarchy in the UK*. We laugh together at the absurd notion that this could be one of the songs.

A woman comes and sits down at the piano. John begins his first number, *When Irish Eyes Are Smiling*. It's wildly off-key, and I don't think it's ironic. John can't sing. Never mind. He doesn't care, so we don't care. He ploughs on with

Laura Godfrey-Isaacs (standing), her daughter Tallulah and artist Masha
Chuykova, plus installation from the Alive Foodstuff Series at home.

devastating effect through *Fly Me to The Moon*, the Everly Brothers' *Dream*, and *Great Balls of Fire*. At one point he dons a bright orange curly wig for Laura Godfrey-Isaacs's personal request, *Oh, What a Wonderful Morning*. He bounces about the room, doing strange knee extensions. Nothing seems to phase him. Nothing is beyond him: *Mack The Knife, Walk on the Wild Side*; he even attempts *La Donna e Mobile*. The singing doesn't get any better, but the atmosphere is fabulous. We are all on John's side. It is a thoroughly group experience. Halfway through, he hands out photocopied papers. Great! We are all going to sing. It's *Anarchy in the UK*. Fabulous! At one point John asks, 'What would you say to an Irish a cappella?' and launches into an unaccompanied folk love song. Amazingly, it's brilliant; spot on, note perfect. After over twenty songs, he wraps up with *Yeah Yeah* and *Irene Goodnight*.

People mingle. I meet Angela Hodgson, a consultant doctor from Greenwich Hospital who is also an art student. 'I bring performance art into high-level meetings,' says Dr Hodgson. 'My latest one's called *Cleanse*, in which I squirt people's hands with liquid soap. It's all about evoking memories. I do it on my fellow consultants. Not one questioned whether this was art. They all watch the Turner Prize. Art is now a fashionable medical accessory.'

For home audiences who want more than the crooning Carson, there is more. Russian performer Marina Perchikhina wrapping her naked body in packaging tape; artist Helen Goldwater washing her hair in the bath; a destruction of a toy landscape by Stelios Stylianou; and an exhibition by body artist Franko B. According to Laura Godfrey-Isaacs, home 'references back to a nostalgic idea that people would get together in people's houses and play games, sing songs or entertain one another. They would experience something which would provoke discussion. Established galleries don't interest me. It would be hard to do this sort of work in a conventional gallery, because in a domestic space you can get away with being eclectic and taking risks.'

The performances are all broadcast on the Web, meaning people in other homes can access Godfrey-Isaacs's home. 'The Internet has opened up people's houses,' she says. 'Lots of people now work from home. It's a pre-industrial

THE LABORATORIES

society situation coming back into play, where home and work were closely linked. You can still be professional even though at home.' Entertainment via the Web is a truly terrifying trend for anyone involved with live shows, but rather than ignoring the advances of technology, visual art practices are exploiting them. Artangel, fig-1 and home all have Internet link-ups.

Home is now so overwhelming that Godfrey-Isaacs is considering another venue. Yet this will be tricky. To continue, the idea needs another 'social place where all sorts of art and performance can be shown, which will also have a concern with design and interiors and food. It's where people spend a lot of time, and cook, and collect objects. It's where they have art and decoration. It's where they socialize and have parties and listen to music.'

Her criteria make up the blueprint for the sort of function that directors, curators and artists across the country are now programming with gusto. You can see it in the ideas behind The Club at the ICA, the one-off events at Sadie Coles's, those dinner parties at Interim and Flowers East, and late night openings at Tate Modern with its concurrent restaurant opening hours. Even the British Museum and its new Great Court, in which you can eat, drink and meet while also picking up a bit of culture, has got the message. If the Laboratories can prove anything, it's that audiences aren't always going to make the effort for a lonely old exhibition, concert or traditional play. They want a holistic cultural experience. They want a pilgrimage. They want spectacle, and design, and some drinks, and community. Whether by giving out beer bottles, hosting a salon, invading a strange location, handing round bowls of crisps, or all these things together, the Laboratories have defined a new venue for art.

CHAPTER THIRTEEN

# THE MONEY

who pays and why

Without which nothing much can happen. Where does it come from? Of course, the traditional sources are still there. Collectors, of whom there aren't many in the UK. The main one is obviously Charles Saatchi, who never gives interviews so we don't actually know a huge amount. He owns around 2,500 works. A lot of people consider him to be nearer the definition of a dealer rather than a collector. He is reported to have made some $43 million profit in deals, and has been known to offload whole rafts of art at a rather alarming rate. Yet he is also concerned to share his collection with the public; since it opened in 1985 his Boundary Road gallery, with its mouldbreaking 30,000 square feet of pure white space, has been something of a standard for contemporary art shows.

I once met his older brother, the sculptor David, at his home in the Hamptons. Charles might be frighteningly private but, according to David, he has a keen sense of public duty. I think this is a fair comment; he exhibits, promotes and curates. He lends work out; he generates entire exhibitions, and not just at Boundary Road. He has allowed one of the most terrifying and beautiful works of art in recent years – the huge lake of sump oil which is Richard Wilson's 20:50 – to remain on permanent display. And his buying and exhibiting habit has quickened and sustained a generation of artists.

Then there is the public purse. The Lottery, of course, has been vital. Anything which gives around £200 million per annum to myriad arty building projects and new funding schemes is bound to be. That the arts has managed to maintain its Good Cause status and cling onto the lottery cash cow is a miracle if you flick through the Opera House press cuttings. However, it has, and via the Lottery dozens of new and rebuilt visual arts buildings have arrived across the country, from the Walsall New Art Gallery to the Dulwich Gallery, the National Portrait Gallery and Tate Modern. The Department of Culture pours a further £228 million into nationally funded (as opposed to locally funded) museums and galleries every year, which it says will have increased to £274.94 million in three years' time. Then there is the Arts Council of England with its £238 million grant in aid which goes up by another £100 million in the next three years. The Council may well be a bureaucratic nightmare but £338 million is, well, £338 million.

The public cash dispensers are, of course, keenly aware of the arrival of a deep private pocket. Keen is the word. Indeed it has been suggested that public money only accounts for 10% of the income of the entire British art market. The public purse is pressurizing its corporate counterpart to join the party; Lottery conditions insist that there is private money topping up the grants; and the Arts Council has introduced a whole portfolio of schemes which are partly, if not wholly, inspired by canny corporate stratagem. There is a lot of new thinking springing from the capitalist grey matter of the Granada chief and Arts Council chairman Gerry Robinson. For an example of this, only look to the financial fillip from the Council to the South London Gallery as a pat on the head for doing business with commerce.

Company cash would probably have found its way there anyway. In 1999–2000, annual corporate sponsorship across the arts was at an all-time high, and valued at £156 million, which is a growth of 11% on 1998–1999. London obviously snatched the largest percentage of that money, with 57% of all business money going to projects in the capital, but in Scotland sponsorship was up by 76%.

A more interesting breakdown is, however, by subject matter. British museums and galleries achieved £38,746,457 in sponsorship over 1999–2000. The visual arts achieved £6,334,209. Add in photography (some £200 thousand) and craft (£100 thousand), and you have some £46 million going towards the visual arts *in one year*. Whereas the combined muscle of opera, theatre and dance could only attract £35 million. That's not chicken feed, but when you consider that opera and ballet were always what attracted the big sponsors, it is something of a switch.

As far as a sponsor is concerned, the visual arts is the ideal running mate. It is fashionable and visible, but cheaper than sport. Its Unique Selling Point is that it is unique. It can be classical but is not perceived to be elitist, in the way that theatre and classical music are. Let's not even discuss the five-letter word that is Opera. In marketing terms, art as a 'product' is perfectly suited to the 'time poor' economy. It is perceived to have other strengths such as value for money and high consumer potential. Think of all those refurbished gallery shops. It can be high-brow but is also closely associated with other sectors of the market, like fashion, where bibles like *Dazed & Confused* have deliberately blurred the boundaries between art and style. Contemporary art is perceived as young, in the way that other art forms are 'old'. Many companies have therefore thrown themselves into close association with the visual art world.

Beck's beer, for example, has become so closely aligned with contemporary visual art that no one was surprised when they commissioned a label from Damien Hirst. (Furthermore, no one was surprised that an artist of Hirst's stature did the label – in essence an advert, but that is another issue.) Via the guiding hand of arts consultant wizard Anthony Fawcett, Beck's is now synonymous with hip arts events where heavy socializing goes along with the package. So at fig-1, Artangel, and ICA premières, which are full of Tastemaking artists, everyone is hanging out drinking (free) bottles of Beck's.

'We are not philanthropic,' admits Maurice Breen, a man who has to grapple daily with the company job title of Brand Director. Breen and I are sitting outside the judging process for the new-ish art prize which Beck's sponsors at

the ICA. This year the judges include Gary Hume and Zadie Smith, two famous people, which is good for Beck's. 'Our sponsorship is about pure marketing. And we are in at the ground floor with art,' announces Breen.

'It is stylish and fashionable and very sociable. Fifteen years ago we wanted to put our bottles into the right hands.' Is Brand Direction really that straightforward? Apparently, yes. 'We wanted to see Art People drinking Beck's. Art People have a style that is leading edge. There is a cool about them. If you can get them to drink the brand, it discriminates it from not so cool brands. For example, Budweiser. I don't think Budweiser would fit with what we are doing here,' Breen says smoothly. He may not be philanthropic, but his Brand Direction propels about half a million pounds in the direction of galleries, shows and art prizes every year.

The other key element is art's affiliation with Social Good. Admittedly, this is not new. Prince Albert and his principled clutch of museums in South Kensington got there 150 years ago. Currently the idea is being pushed in a remarkably subtle yet insistent manner from various cultural peaks such as Tate, the Walsall New Art Gallery, the Serpentine, the National Portrait Gallery and the National Gallery. It was probably never a preconceived piece of propaganda. However, rolled up into a single message, the overall directive is that art equals the unshakeable leader in socially democratic, soul-improving culture (while still being fashionable).

Let's return to Lex Fenwick, last seen at Bloomberg's vast party in Tate Modern. This time he is in his open-plan glass office. The place is strewn with tiger orchids in bark-filled vases, mini televisions sculpted into granite table tops and floors, floating strands of red and blue Perspex, lava lamps, Bruce Nauman-type neon installations and huge aquaria in which swim hundreds of perfectly groomed fish. Whose average length is 2.7 inches. Meanwhile in the fish tank-style office swim hundreds of perfectly groomed staff. Whose average age is 27 years. It's *that* kind of place.

It's Day One of the American election debacle, but Lex doesn't care about such parochial detail. 'Fuck! Fuck! No! Get me these people! Fuck!' he yells

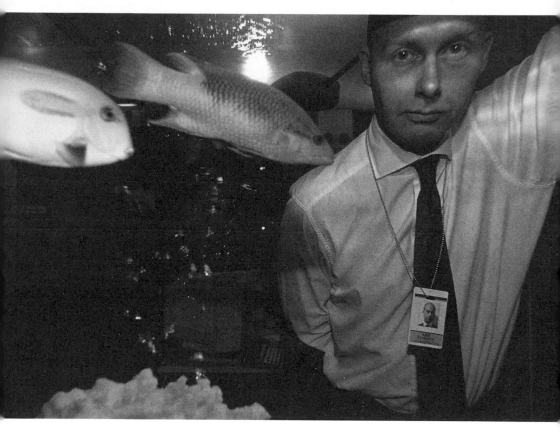

The bucks start here.

Lex Fenwick and his marine accoutrements at Bloomberg.

down the phone. And then slams it down. 'Fuck. Hello. Lex Fenwick,' he says, proffering a perfectly reasonable hand. 'Are you worried about the American election?' I quaver. 'Fuck, no,' he barks. 'No time for that sort of thing.' Meeting Lex Fenwick is akin to entering a play by David Mamet, whose literary style was once memorably described as 'a rainbow of fucks'.

We sit down and Lex explains why he does it. Supports the arts, that is. 'Firstly, we as a company want to be good citizens and support things that clearly need money, and that we think might help better the world.' That's the. moral thing. 'Secondly, the arts have become fashionable. By associating yourself with fashion, some of that rubs off. The more that fashionable people talk about you, the more fashionable you become.' That's the style thing. 'Then there is a payoff.' That's the staff thing. 'Artists offer a different take on life. If we have David Shrigley designing our plates, people having lunch might think, "Wow! These are the strangest plates on earth." And the great hope, of course, is that one of those people will think, "God! That is strange! Maybe I could do my phone calls this afternoon to my clients differently." It sounds silly, but that is what you are trying to encourage.'

I go and find one of the companies who are bringing Art to Lex Fenwick. Claire Catterall and Sarah Gaventa run Scarlet Productions. They are intelligent, perceptive, breathtakingly stylish women with major track records in the design world, acutely honed taste and fantastic contacts. In the olden days they were employed as curators in the public sector. In the olden days they still would be. But private money has come to call.

'It's more of a challenge doing something for a company than an exhibition,' says Catterall. 'It's the real world. We are curators, but also design agents. Our job is to identify things within Bloomberg's offices that we can commission people to work on.' One can just hear Lex. 'Do what you want, but make it arty.' The budgets are unlimited, as is the scope.

Special Girls Claire Catterall and Sarah Gaventa from Scarlet Productions.

Remember when corporate clients were cautious, traditional beasts? It's all changed. Through Scarlet, the Bloomberg meeting rooms are being redesigned by separate squads of design funksters such as el ultimo grito, FAT and Precious McBane. The official Bloomberg cars have been overhauled by design team Bump, with hilarious windscreen stickers updating the KEVIN 4 TRACEY cliché to MARK 4 PENNY. This company deals with money. Of that particular gag, Catterall says, 'We showed it to the American MD. And he kind of went, "Hmm." But Lex said it was absolutely British popular culture; people will love it.'

Gaventa adds, 'Bloomberg benefits from the best of British design. They get seen as young and thrusting and risk-taking, which suits their role of providing financial information. It makes their workers work better. They all go out to trendy City bars after work. Why not be surrounded by the stuff *at* work? At the same time, it gives a platform for young designers. This isn't just silly young ad agencies, or exhibitions. This is the grown-up corporate world.'

Scarlet has traditional clients who are meant to push British design, like the V&A and the British Council. But it's the private sector which really rings their bell. 'We prefer working with unexpected clients like Bloomberg. They are more open,' says Catterall. 'A lot of arts organizations don't have the money. They're also very slow. They want to plan four years ahead. But we are about what is happening now, rather than proposing an exhibition in 2006. It's fantastic to show Lex something. And he says, "Do it."'

Such dynamism! Fenwick doesn't even have to be a huge art fan. In fact, he admits that his taste is more attuned to his children's drawings, which he keeps displayed on his desk. Liking art isn't, however, the point. It's the whole art *thing* that Fenwick relishes. Funky design at work; equally modern social events out of work. It's been done with such force throughout the company that everything has to a certain extent merged into one: on any normal working day, Bloomberg looks like a cross between a Clerkenwell bar, BBC News 24, Tate Liverpool and fig-1, one of Fenwick's particular personal joys.

'The minute Jay told me about it I thought, "Fantastic,"' says Fenwick. 'It appealed to me as someone who, in all fairness, is not the greatest art watcher in the world. It was immensely appealing. I loved the concept of going to just one place, and every single week seeing something different, and spending ten minutes on it with a cup of coffee and then be sort of done. Well, *I'm* done. Without wanting to sound like a Philistine. That's what I like. Not somewhere which is some enormous thing where you feel guilty if you haven't been through Rooms 1 to 8. This is art in fifteen minutes! And it is ever-changing. I think it is one of the greatest things we have ever supported.' It's the sort of approach which would make arts purists squirm, but at least he knows what he wants. And he who pays the piper... 'We are a private company built around flexibility and speed,' says Fenwick. 'We have a culture of making decisions instantly.'

Like all confident institutions Bloomberg is even willing to embrace its enemies. 'I think the outsider view is fantastic,' says Fenwick, who has sponsored anti-corporate artists like Szuper Gallery, who produced a performance in the building. 'The world is getting very dangerous because there are fewer and fewer people with different ways of thinking. If I had an artist outside the building holding up a banner saying "Down with Globalization", I'm not sure that is a good reason for saying, "No, we will not sponsor your work."' And what did you think of Szuper Gallery? 'Any artist standing outside we will encourage to come in. Even homeless people.' Not really an answer, but never mind.

Everyone takes part. 'We try very hard not to just write a cheque,' says the boundless Fenwick. 'We have people in a new play at the Royal Court. We have employees participating in dance at The Place. There are people here who are to some extent doing a relatively basic job. They are trying to sell a product. If you can bring artists and their creativity and imagination into the workplace, and take the workplace to the artist I think you inspire creativity, it rubs off on the human being and they become different people.'

The Bloomberg way is the way of the future. Colin Tweedy at Arts & Business tells me so. It's early evening but he's still in his London Bridge office. He needs to be; things are booming. Not in the old style, mind you. 'The age

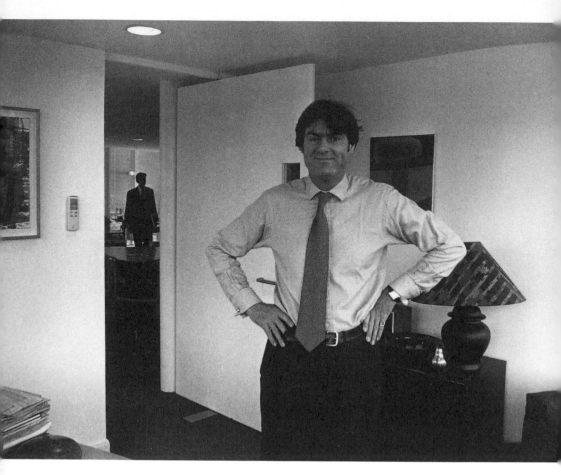

Yes, giving to art can really make you feel good.
Colin Tweedy of Arts & Business.

where Sir Simon Hornby sponsored the Tate and sat in the Opera House every evening is virtually gone. The age of the business sponsor who was incredibly highly educated – Sir Nicholas Goodison of TSB, James Joll of Pearson – all gone. A lot of the business leaders now are in their thirties, or early forties. They go to the gym, not to the opera. They work and work and work. They have fantastic MBAs. They are phenomenally well educated, but the arts don't matter to them. I had to bring the arts into their lives. Whether *physically*, like having an artist in residence, or by building up a corporate art collection.'

His mission has been eased by the essential character of the culture. Art, basically, can be easily finessed into business life. 'I worry that places like the Serpentine and the Tate can take over,' says Tweedy. 'Theatres are at a massive disadvantage, because of course you are sitting in *serried rows* in the dark. And people don't want late nights. I have more and more business people saying, "I do not want speeches at 11.30 pm." I was at a concert the other evening at the Barbican and the speech was at five to midnight. I was at something at ENO and the speech was at *five to one in the morning*. However, if you sponsor an exhibition you can have dinner and a speech and all be home at eleven.'

Yes, but isn't sponsorship booming because business is booming? Ernst & Young can sponsor Monet at the Royal Academy and lay on international flights for its clients to come to the private view. Great. But what happens in the lean years to all that cash currently propping up blockbuster exhibitions, interesting galleries, and fig-1? 'We are deepening the involvement,' says Tweedy. 'We are pushing those companies to really get arts linked into the whole company, because then it becomes *endemic*. Marks & Spencer, for all its travails, is still embedded in the belief that it should support the community and the arts. It's the same with the John Lewis Partnership, who always give its staff free tickets. Companies with Jewish or Quaker roots have arts embedded in the *soul* of the business. But most businesses don't have a soul. They just have a balance sheet.'

Vertically integrated sponsorship could start to be a reality, not least because the company zeitgeist is changing. Even the boss class has begun to realize that too many 18-hour working days result in an unhappy work force. In

which case, enter Tweedy, who has cleverly nipped in with the arts pitch before any of the caring charities could. 'People are working longer and longer hours. But they have no *loyalty,* in the way they used to. And therefore they have to be motivated. And companies are realizing that creativity is not something you learn at business school. It is something which has to be stimulated.'

In response to the pressures on the modern-day salaryman, Tweedy has a word of advice: Engage. With a Project. 'I am saying become a business volunteer. It will look good on your CV but it will also extend your range of management capabilities. Join the board of an arts organization. People often join their first board because it looks good. Then they become captivated by the amazing energy of people in the arts, who have no resources. We now have 1,500 executives on the boards of arts institutions. These are young, intelligent, artistically-orientated business people. In ten years' time they will be running these arts companies.'

Which is all to the good, particularly as most arts groups could apparently benefit from a Square Mile-inspired kick up the arse. 'With the increase of Lottery money what is being revealed is a complete failure of arts management. Take the Royal Armouries in Leeds. It was ridiculous to expect that because lots of Japanese tourists liked seeing armour in the Tower of London they would get on the train and go to Leeds. They wouldn't know where Leeds was. And they have no intention of going there,' splutters Tweedy. 'These institutions have got to be run like businesses. The Tate is a success because it is run like a business. Nick Serota is a genius who can hang a picture like an angel and understands what art is all about, but he also absolutely understands about management.'

So come in, Team Bloomberg. Come in, Clifford Chance, Unilever, Amex. Apply your huge brainpower to the problems of a little gallery or a drama company and, in doing so, change your life.

# THE THEATRE ISSUE

## loud noises off-stage

So how do the fellow diners around culture's round table feel? Pretty cheesed off, I suspect. When he arrived from the States, the artist Michael Craig-Martin observed that it was 'the world of the novel and the theatre which presented the contemporary voice'. Literary events were the things the great and the good turned up to, where new ideas were expounded, at which money was splashed.

Listen to Artangel's Michael Morris, thirty years on. 'Look at the one area of London which has not changed at all. The West End. The theatres look like museum pieces. They're right in the middle of Soho. Soho has changed out of all recognition. Yet when you walk past the theatres, they look like they have always looked. Which is off the map for most people! What are we going to do with them? They aren't even open in the day to pull cappuccinos for people, and make a little line out of that.' That's not all. 'The RSC and the National Theatre. They are over. Why are we sentimental about them? Why is Trevor Nunn at the National? Please. It's embarrassing. He is the last of the generation of theatre directors who has a sense of social duty. Why is the audience there? Probably the same reason. Social duty. Are they having a good time? Probably not.'

Andrew Lloyd Webber, who with his thirteen theatres is the West End's largest single owner, is only too aware that his manor is in a mess. However, although he can't necessarily command blockbusters to order, he has distinct plans. Plans to up the ante in Shaftesbury Avenue. To make the seats more comfy, the sightlines better, the wine a bit less repellent. 'We have got to compete against the subsidized sector, which has much better facilities,' he told me. 'We can't offer people the sort of front-of-house facilities you have in the National, for example, but we have to have a go at doing what we can.'

Other people are trying, too: producers are wooing audiences with star names, 90-minute plays with no intervals (so you can combine a theatre visit with the more fashionable leisure activity of eating out), and audience gimmickry such as immediate response buttons.

Nothing seems to be working, apart from the productions from a clutch of directors in small spaces: the Bush, where a hundred people sit on boxes around the stage, the 250-seat Donmar Warehouse and the 300-seat Almeida. With their intimate auditoria these theatres are perfect for audiences whose tastes have been honed on the close-up worlds of film and television. And the directors have been sagely observing how their cousins in the art world are doing it.

Hence the arrival of The Play as Event. At the Donmar Warehouse, Nicole Kidman taking her clothes off in David Hare's *The Blue Room* was not a piece of theatre, it was a spectacle, a must-see piece of stagery as clever and intoxicating as an Artangel commission. Anything its director Sam Mendes now does at the Donmar is an Event. At least he doesn't mention his Oscar-winning movie *American Beauty* too often, unlike his counterpart and close rival Stephen Daldry at the gorgeously revamped Royal Court. Daldry can't help but attempt to woo in the *Daily Mail* audience by mentioning the Oscar-nominated, BAFTA-winning *Billy Elliot* in the publicity for his shows. Anything to make punters feel they are going to have a special experience.

'In essence, all theatre aspires to be theatre as event,' says Sir Richard Eyre, who led the nation to the National Theatre when he ran it from 1988 to 1997, and who recently led the nation through the history of twentieth-century

theatre in an acclaimed TV series. 'But not very much theatre achieves it. Let's face it, most theatre isn't very good. The only thing which makes the argument for theatre and makes people say, "Yes! I see why people go on about this art form", is because it *is* an event, and because you are sitting there thinking, "Wow! I am here with this group of people seeing something which is unique and happening now." The great problem is how to maintain theatre's quality of event.'

The big blockbuster musicals which have been on in the West End for decades are often credited with keeping Shaftesbury Avenue alive. In Eyre's book, they are deadening it. Who wants a production which has been running in the same theatre for fifteen years? 'That is why Granville Barker – who began the whole idea of having a national theatre – argued for the repertoire system. It was at the heart of his idea. He said you couldn't maintain the event-ness of theatre six nights a week. Which is why the RSC and the National were set up that way. It's sort of dissipated now, but the original idea was that you would run it a bit like opera. Two fabulous performances of something. Then not do it for a few days. Then do it again. So that every time you did it, it was an event.'

Theatre needs to be relaunched, say Mike Bradwell and Tim Fountain at West London's Bush Theatre, itself a stickler for new plays. In a furious counter-blast to *The Guardian*'s theatre critic who suggested that what theatre should do to get back on top was inject more classics into the programmes, they pointed out that in Britain the majority of plays put on in any given week were at least twenty years old, and most over a hundred. Chop down the Cherry Orchard, they said. Barbecue the Seagull. It's tough on Chekhov, but it has to be done. They even suggested banning the classics from state-funded theatre for five years.

Mike Bradwell is the sort of theatre person who is still wearing a duffle-coat and (one suspects) unfashionably left-wing politics. Yet most of his shows are sell-outs. 'Modern contemporary theatre should be as vital as modern contemporary cinema,' he says. 'People do not go to the cinema to see Mike Leigh's radical interpretation of *Chimes at Midnight*. They go to see Mike Leigh's new film. What we have to do is rebrand theatre. To convince people that it is not

about a lot of men in tights shouting. Why do they think that? Look at the Olivier Awards. People turn on the telly to watch and what do they see? Some classic with Dame Judi in it.'

What Bradwell wants is less of the Dames and more of the Damiens. 'Theatre has to be dangerous and offensive, but also popular. There is a big audience for Hirst's work. Which is dangerous and offensive and popular. There needs to be the same seismic leap as with modern art, in which the practitioners completely risked leaving the public behind. And pissing off a whole raft of people who used to frequent art galleries, and who found their work completely offensive and disgusting. But gradually people have caught up with it and taken an interest in it.'

So forget your radical new positioning of *Romeo and Juliet*. Gaining your directorial spurs by doing *The Cherry Orchard* in rap mode, or *King Lear* underwater is NOT the point. 'Trying to nudge it forward in well-meaning ways is part of the problem,' says Bradwell. 'We took *Shangalang* by Catherine Johnson on tour. It was about the Bay City Rollers. We went to the King's Theatre in Glasgow and it took the roof off; the place was packed with forty-year-old women who had been Rollers fans. We took it to the Theatre Royal in Northampton and the staff there tried to persuade members of the audience not to see the show because they thought it was obscene. And the local press said, "This is the kind of thing that prevents Northampton from becoming a city." Now *that* particular theatre had done three productions of *Sleuth* in eight years.'

'You need to lob a hand grenade in there,' says Tim Fountain. 'Which is what Mark Ravenhill did with *Shopping and Fucking*. Suddenly on Shaftesbury Avenue, next to a Coward revival, there was this thing with an obscene title.'

Fountain (who has recently moved from the Bush Theatre to become a freelance writer) has just produced a West End show whose title is similarly candid: *The Puppetry of the Penis*. 'I'm not saying it's great art but it caused a similar stir. There is a frisson of excitement. It's because it was on in the West End, which is far more exciting than if it was on in the Raymond Revue Bar. In which case it would just be two blokes with their knobs out. Put it on in the West End

Enter stage left: Mike Bradwell and Tim Fountain at the Bush Theatre.

'Theatres aren't buildings. They are ideas.'
Jonathan Kent in the Almeida's temporary home, an old bus station.

and people feel they are going to an event which is naughty. You need that frisson. Not the sense that the red curtains are going to rise onto yet another living room with a sofa.'

The Bush has gone into pro-active commissioning; putting playwrights in the 'real context of a given world'. To this end it has sent writers off to gay B&Bs in Blackpool and out and about at Euro 2000 selling bent tickets with touts. 'We want to give people an insight into stuff they didn't know about,' says Bradwell. A slice of dangerous, real life, with all its wrinkles and creases. It's rather like putting an unmade bed into the white space of an art gallery.

The artistic directors at the Almeida Theatre also understand the Emin Principle. Up in North London, Jonathan Kent and Ian McDiarmid have been making a habit of turning out shows which are as relevant, visually arresting and event-driven as any contemporary art experience you care to mention. It was always a bit of a journey out to the Almeida. Now, however, a trip to Almeida Street has become a pilgrimage in more ways than one.

You want famous plays? You'll find new ones from famous playwrights ranging from Edward Albee to Yasmina Reza. You want stars? How about Kevin Spacey, Juliette Binoche and Ralph Fiennes, with a sprinkling of Liam Neeson? (In a nice response, director and actor McDiarmid recently turned up as a Jedi warleader or something in the Star Wars prequel *The Phantom Menace*.)

You want different locations? Simple. The whole company is quite used to packing up and putting on shows from Moscow to Malvern. How about Jonathan Kent's *Hamlet* at the Hackney Empire, or his *Richard II* and *Coriolanus* at Alfred Hitchcock's old stamping ground, the neglected Gainsborough Studios in Shoreditch, which were barren but *so* exciting. What a theatrical experience *that* was. Forget the West End where the toilet facilities and the queues enjoy such perfectly disproportionate sizes. Or the horrid bars where the glasses smell and the fight to buy your G&T lasts exactly the same time as the interval in which you are supposed to consume it.

At the Gainsborough you had Portaloos in droves and a bar area like an aircraft hanger where plentiful staff swiftly doled out fashionable things like

cranberry juice. Once in the auditorium, an echoing brick warehouse, you were not only thrilled by the A-list presence of Ralph Fiennes but, if it was raining, the drips from a leaky roof. And people like Cate Blanchett were in the audience, even on a weekday night. It was a huge hit. Particularly as it wasn't going to last. As with the nearby artists' spaces, the Gainsborough Studios have since been developed into 'chic duplex flats'.

Theatre people have also stolen the phrase 'site specific' from the visual artists. Last year the London International Festival of Theatre produced a show in the windows of Arding & Hobbs in Clapham. This year it is planning to produce one in boats on the Thames. The whole trend conjures up that old musical adage, 'Let's put the show on right here!', except nowadays it's less Rogers and Hammerstein, more Rotherhithe and Hammersmith.

Not content with an aquatic *Tempest* to mark the Almeida's temporary closure for a Lottery-funded rebuild, the entire company decamped early in 2001 to a decrepit coach station in King's Cross which was transformed by designer Rob Howell into a 500-seat theatre. Its opening show was Wedekind's *Lulu*, starring Anna Friel and directed by Jonathan Kent.

'The coach station is in a pretty rough spot,' Kent admits. 'The Blue Danube porn shop on one side and a dodgy-looking healthfood shop on the other. You're probably safer in the Blue Danube.' The parallels with the opening show haven't escaped him; in many ways, it couldn't be a better spot to stage Wedekind's tale of sexual obsession. 'This area has its fair share of Lulus,' says Kent.

Uprooting a theatre from its formal base to a coach station holds no fears for him. 'I never wanted to be confined by the bricks and mortar of the place. Theatres aren't buildings. They are ideas. And people who run them with artistic policies. Our great theatres are neutral at the moment. At the moment there is more excitement about a specific type of theatre, one with a certain flexibility. We are like a maverick guerrilla group. We can steal anyone's clothes. We are not confined by an artistic remit or, like the West End, an economic remit.'

So has the great British theatrical tradition come down to putting stars into converted bus shelters? 'Of course the danger of having celebs or film stars in

the company is that you end up with event theatre,' says Kent. 'And with that, you brutalize the audience. People come out for a look: they do not go to the theatre on a weekly basis. And unless they see a famous film star hanging by his nipples from the ceiling, people don't feel they've been out. People insist on being buttonholed by the plays rather than seeing plays unfold. That is a danger.'

It's not going to stop Kent experimenting. 'I am unrepentant about using the Hackney Empire and Gainsborough Studios. There is more of a contract with the audience when you take them to places like these. When we did *Hamlet* at the Hackney Empire we crossed every racial, class and age barrier. People who thought they would be raped en route got there unscathed and discovered a jewel of a theatre. And there were many first timers to Shakespeare. It was the best audience I have ever had. You just knew it was a great event.'

It's all very well for Kent, with his tiny auditorium and seemingly inexhaustible capacity to reinvent his company, but what happens to those theatres with a formal remit to do plays not in carpet warehouses or bus shelters but in three formally-built auditoria on the South Bank? The National Theatre, as Michael Morris implies, is not having a 'good time'. Yet should it be duty-bound to continue what it was set up to do?

'I went to a seminar on trends in leisure,' says the National's Chief Executive Genista McIntosh. 'It showed us what people are looking for. Fundamentally the research demonstrated that people want to spend money either on something very big, or something very small.' It's the Tate Modern/fig-1 syndrome. A shark in a tank, or a crumpled ball of paper. Ten thousand miners in a field, or a Laura Godfrey-Isaacs-style art work in a bedroom. Art which has transformed itself to take in huge spectacle alongside conceptual introspection. It's a bit more difficult to pull it off when you are hide-bound with Alan Ayckbourn or Noel Coward. But that is what people want. 'They showed how culture was about things getting smaller and smaller in some areas, and bigger and bigger in others.'

Who does she see as the theatre's model? 'Tate Modern. It sets the standard. It's not a theatre, so you can't make direct comparisons. But it has the kind

of atmosphere; the atmosphere you got around the Centre Pompidou when it first opened. The way it seemed to teem, in and out.' Another pause. 'The ground-breaking public buildings now are not theatres, are they? Think of the Guggenheim at Bilbao. Or what the Australians did with the Olympics.'

Which would certainly stop foyers looking like 'an assembly point for a Saga holiday', as the bracing Bracewell puts it, referring to the entire West End.

Supposing, however, that this is what you want to do, how do you do it in a ready-made theatre? 'This building was purpose-built and is supposed to stand for the National Theatre,' says McIntosh. 'But now what we are driven by is concepts, not buildings. So you have to intervene in the building. I think one of the problems with the National is that the building tends to lead, and the artist has to follow. Part of what I am looking at is the necessity of changing that. We will think of how to do it, but were we to do it, it would be about changing one of the performance spaces quite significantly.'

It's a pretty radical idea. Not only is the National listed, but it is, well, it is the National. Never mind. McIntosh has an eye for change. She is focusing, in particular, on the Lyttleton, the middle-scale auditorium. 'It's very difficult to do anything permanent with it. But I am interested in emptying it of its content.'

So. Will we see the Lyttleton as a place where you might flop down on a sofa and watch an art house movie? 'Yes, you could see that. Whether it was films, or cabaret. Or very, very new writing which was only on for a few days. Maybe circus artists. Maybe music. Theatre people live in a number of different worlds. All I know is that work will never develop into something that will go on in the Lyttleton, as it currently is.'

Go on. Would you have club nights there? Lounge music? 'I only have a sense of what might be possible,' says McIntosh. She looks out of the window across the Thames, possibly sensing a brave new audience of lounging clubbers ready to stream across the bridge and into a reborn arena. 'I just think we have to knock a few holes in the place. My hunch is that you have to be able to move flexibly.' Aha. She's been having lunch with Jonathan Kent. 'And I bet we will start seeing it in the West End. They will start knocking the theatres about.'

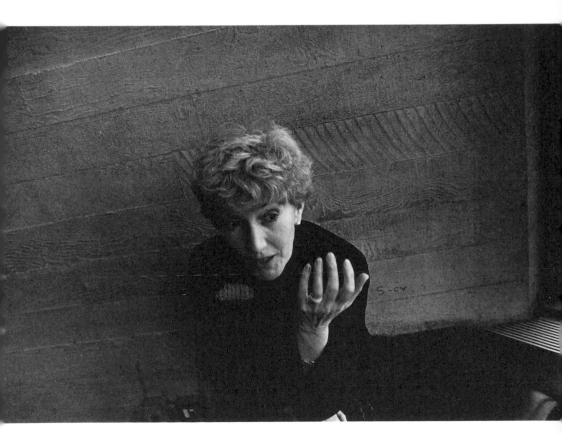

Genista McIntosh, determined to change things at the Royal National Theatre.

CHAPTER FIFTEEN

# THE GRUMPFEST

fear and loathing from the outsiders

There is, of course, a reasonably large constituency which isn't buying into any of this. Not Tate Modern's admission figures, not Emin's bed, not Creed's crumples; not even fig-1.

They fall, largely speaking, into two camps. There are the grumpy traditionalists, and there are the grumpy radicals. The first lot look back to a misty past of classical music concerts and paintings which stayed on the easel. The second simply feel left out.

The traditionalists recently marked out their battle lines with an adrenaline rush of books about the State of the Art. John Tusa, Managing Director of the Barbican Centre, published a bundle of wailing essays. According to Tusa, British cultural life is over because polite people can't often hear Shostakovich in concert halls due to the din of digital art. 'Our existence,' he writes, 'is under threat.' Meaning, of course, that what he likes is under threat.

He worries that Culture has been debased; that a word which used to only signify Art can now also mean Lifestyle and Film and – horrors! – something he calls Clubbing. According to Tusa, the widening of the picture is nothing but a coarsening; the spirit of social inclusion, a quick slide down the rubbish chute named Access.

Let's hear a spirited riposte from Colin Tweedy. 'The fact is that if nobody hears about your art, if no one listens to Schoenberg or Stockhausen, then there is no point in it being there. If you believe in it, you should get others to come and hear it. And why not kids out of housing estates? If we believe it is magical for us middle-class white males and females, it should be magical for everyone.'

Tusa suggests that the problem with the present is that we don't spend enough time looking at the past. 'What is under increasing threat is devotion to, respect for, and teaching of the centuries of artistic achievement which underpin all art forms,' he writes. Although that hardly explains the thousands of people who have willingly gone again and again to the New Art Gallery in Walsall, where the Garman Ryan collection is now installed, with its Corots, its Gauguins and its thirteenth-century Indian sandstones.

Tusa seems to dislike the fact that things have shifted, that state funding is no longer the beginning and end of the scenario, and that the Arts Council's wallet is not the only one on the table. According to him, the funding of the BBC's orchestras is 'the bell-weather of serious cultural commitment'. Commitment to whom? His book is peppered with references to Wagner, Britten and Schiller, as if these names are echoes from a long distant past, while he gazes upon a barren future led by the likes of the Bush ('no classics') Theatre. Tusa paints a picture of tomorrow's culture as a place where everyone buys *The Jungle Book* on video (apparently the No. 1 purchase), there are no arts centres left, and you can't get to see a good production of *The Cherry Orchard* for love or money.

Tusa puts up an old-fashioned view and, at the same time, slams the media for supposedly promoting that view. He suggests that the press coverage of the evening performance at Sadler's Wells, after it had been announced that the institution would receive some £30 million in Lottery funding, was skewed towards trying to find elitist nobs in dinner jackets, rather than the true scene. Which apparently was 'the young and the black, casually dressed, coolly drinking beer from the bottle'. Tusa wants it both ways. He paints the arts scene as full of horrid ideas like Access, but also as a place full of endangered, minority arts lovers – 'the young and the black', drinking 'beer from the bottle' – with an

attendant media idiotically supportive of the first, and dangerously prejudiced against the second.

In his book *The New Elites*, the former Conservative MP George Walden puts up an eloquently lofty and ferocious attack against anyone who dares to like what is going on, or who 'pretends that the '90s were the '60s, that Oasis are the Beatles, that Stephen Fry is Oscar Wilde, that Ken Livingstone is John Wilkes, that Margaret Thatcher is Winston Churchill, that Damien Hirst is Duchamp ... just as we persuade ourselves that a modest terraced house in London is worth a million dollars.' Surely a million *pounds*, George, by now.

He reserves special bile for what he calls Britart: 'the most powerful symbol of our culture of pretence. Britart is a rusted bomb, retrieved long after the war is over, buffed up and placed on display to give us a retrospective *frisson*. It looks like the genuine thing but is perfectly safe to handle: the explosive has been removed and the bomb prudently defused some decades ago.'

According to Walden, contemporary art is simply another example of the kitsch, meaningless marketing which has invaded culture. But look at the facts. A huge new audience was indeed wooed into the South London Gallery by the scandal and attendant column inches of a group show involving Tracey Emin, Gilbert and George, and the rest, but the gallery has since prided itself on keeping that audience and offering it a varied diet of exhibitions.

Three hundred thousand paying customers went to see 'Sensation' at the unsupported Royal Academy. Eighty per cent were under thirty. Was this not a good thing? If only for the Academy to sort out its finances after a horrendous fraud, and for people like Walden to see that people under pensionable age can quite easily find their way in past that statue of Joshua Reynolds. One million people went to Tate Modern in its first six weeks. Yes, they were probably going for the spectacular building. No, they were not going for the 'rusted bomb' which is 'Britart'. As many critics have pointed out, there isn't all that much 'Britart' in Tate Modern. There is, however, quite a lot of difficult, academic modernism.

Walden also seems stuck with the idea that contemporary art must be revolutionary in spirit and, because it is not, it has failed. Why? Quite apart from

the difficult shimmy that would have been necessitated from the likes of Tate Modern, the National Portrait Gallery, the Serpentine and all the rest who have had huge rebuilds thanks to Lottery money in order to 'challenge the system' (which effectively paid for their new bricks and mortar), there is not necessarily a need for art to encourage its audience to start bearing arms. If it gives people enjoyment and pleasure, then what is the problem? No one is saying that the delicately threaded paintings of Michael Raedecker are a clarion call to social critique, but then when has art ever convincingly led what Walden calls 'a new and probably inexperienced public' into battle?

One expects the old guard to be like this. If you were at the Edinburgh Festival in 1950 you might well hate the Islington Art Fair in 2001. But there is also the other half of the equation. The artists who promote Another Way. Correctly identifying the so-called avant-garde as nothing of the sort, the artists' group called the Stuckists has appointed itself to fill the gap. Blatantly ignored by critics, black-balled by *Time Out*, without dealers, collectors or any major fan base, the Stuckists have nevertheless got remarkable sticking power.

On the day of the Turner Prize, there they are outside Tate Britain prancing about in clown costume. On the eve of Tracey Emin's Groucho Club dinner there they are with a champagne opening for their own show, 'The Real Turner Prize'. They suggest they are a valid alternative to the current art orthodoxy, but their very name comes from an eminently quotable quotation by Emin, viz. 'Your paintings are stuck. You are stuck. Stuck, stuck, stuck,' which critique was levelled at founder member and former Emin partner Billy Childish.

I meet up with Childish and the group's co-founder and chief spokesperson Charles Thomson at the Dover Street Arts Club, where I am tutored in the aims of Stuckism. These appear to be about replacing the cynicism and sensationalism of the YBAs with wholly creative expression. Thomson hands me a glossy brochure which is the Stuckist Manifesto: 'Remodernism: Towards a new spirituality in art'. According to the manifesto, spiritual art is not about 'fairyland' or religion. It is about a 'spiritual renaissance'. Today's art is 'anti-art', which makes Stuckism 'anti-anti-art'.

Putting a brave face on it.
Billy Childish and Charles Thomson, aka the Stuckists.

'We really believe in it,' says Thomson. He has a high, pinched voice, as if stifling a laugh. 'In order to get attention you have to do stunts. I wouldn't bother doing all this if I didn't have something serious underneath it. We are advocating a radical art which reclaims some of the values which are being lost. Art has become a manipulation of materials rather than an expression of humanity's vision. We advocate a return to painting because it is still the most flexible, expressive and subtle medium. The work that is being promoted is not second- or third-rate. It is fifth-rate. It is tired and empty and selling people short financially and spiritually.'

Billy Childish is sitting on the sofa beside me. His name, coined in the 1970s, comes from the rather endearing tendency for punk musicians to re-christen one another in the style of a Restoration comedy. He is wearing a sailor's hat, navy trousers and a navy pea-coat under which, he assures me, is a heavily tattooed body. I've got to say it, Childish is also heavy on charisma. I can see why Emin went for him.

'A lot of people are outraged that we have the effrontery to be artists, and have a different opinion, and say it.' Since 1977 when he quit his first and only job in a Chatham dockyard, Childish has been a prodigious creator, with eighty albums, thirty books of poetry, four novels and nearly 2,000 paintings under his belt. However, critical and commercial success have so far eluded him. He has never had a manager, agent or gallery. To the present day, his lasting claim to fame in Britain is that he was for a long time Emin's other half. They met in 1982 at the Medway College of Art and Design.

'If you are in America people know who I am, and not who she is,' he maintains. 'A BBC documentary interviewed me about Tracey and they told me she wanted to be a household name. "What?" I said. "Like Harpic?" Apparently when she saw that she went wild and insisted it was edited out.' He roars with laughter. Although Emin's rise has left her former partner far behind, he has a remarkable lack of bitterness, possibly because he believes he started off the Emin style. 'Sometimes I do sit down by the fireplace and say, "God forgive me, I have created a monster." Ha ha ha. If I didn't exist, a lot of the YBA stuff

wouldn't. My style of writing, my style of work is all traceable in Tracey's work. She is being me. But I had an excuse for doing that sort of stuff then, because I was young and stupid. Ha ha ha.'

They were friends until about a year ago when, according to Childish, 'she pressurized me into not talking to the papers. She feels I have betrayed her, so she doesn't speak to me any more. After nineteen years.' His name is the most prominent one stitched into Emin's famous tent. 'I don't mind having my name in the tent. Very nice. Although I think the work is useless. I wouldn't want what she has. I had a few opportunities offered to me, but it didn't agree with my beliefs,' he says. 'I am not interested in the delusion. I never ring up papers and give my views. Fame – any sort of fame – brings more problems than being anonymous. As soon as you get into all this glitzy rubbish when you believe your own importance, you are in trouble.'

I notice Thomson shifting. 'Can I have a word at this stage?' he squawks. 'Because we have heard quite a lot about you already, and I am here, too.' Childish doesn't seem to mind being ticked off like this. 'Could I say,' Thomson continues, 'one reason we are not bitter about Tracey Emin and everything is because we are doing really well. We are the only other group with a national reputation. We have tons of shows. We have supporters. We have fellow groups starting up over the world. Two in America, one in Germany, one in Australia.'

'Yeah, the Melbourne Stuckists,' says Childish, interrupting. 'They can get information from us, but we don't censor anybody. Or anyone in our group. We have no policy. The group has never even met in full. Most people only probably like one or two things, apart from Charlie who likes all of it.' Thomson smiles apologetically. Childish shrugs his shoulders. 'Everything I do is outside the art world, yet I have had 21 one-man shows. I think my stuff is mainstream. And they are the outsiders, with a silly adolescent viewpoint. Which is fine for teenagers, but boring with thirty-year-olds. Our main critique is how boring the YBA art is. And how unindependent.'

What they lack in critical status the Stuckists certainly make up for in verve. 'In ten years' time we will have a substantial position,' says Thomson. 'A

Stuckist will have won the Turner Prize. We have been hugely successful. We only got our first mention in the paper a year and a half ago. Now this year in *The Guardian*, the headline was "Turner Winner Riles the Stuckists". We were mentioned on *Have I Got News For You*. There is a need for an alternative, and I got on with it. It will happen. It's like Impressionism.' What? Stuckism? 'When it first started, Impressionism had very little impact. It was laughed at and scorned. But now look at its value against French academic painting of the end of the nineteenth century.'

On my way out of the Arts Club I flick through the Remodernism catalogue. It's like thrift store art. Weird women with black eyes, smoking, or holding string puppets. Dogs. Skeletons. Quasi-Munch women. That's Stuckism. Then I go and see John Keane.

Keane is an interesting artist; he professes to be utterly outside the orthodoxy, yet is Artist in Residence at the *Independent on Sunday* and was War Artist during the Gulf conflict. Anyway, he's written enough rude things about the Turner Prize, Nick Serota, Charles Saatchi, Damien Hirst et al. to be out in the cold for the next few millennia. He has just got back from a trip up the Amazon with Greenpeace and is working on a series of vast canvases dripping with reflective water, butterflies and huge trees. I tell him I went to see the Stuckists.

'They are just another media creation,' says Keane. 'Their work is such a pile of crap. They just want to rant and draw attention to themselves, too. There is this notion that there is the avant-garde and there are the fuddy duddies and if you are not with the avant-garde you are either a fuddy duddy or a Stuckist. Do us a favour! And the avant-garde is the establishment anyway. Where is the dissent? Where are the mavericks? I am generally just filled with dismay by the whole situation.'

He walks about his studio. Four large timber circles are leaning up against the wall. They are from an illegally felled tree Greenpeace hauled back from the rainforest. Keane is intending to use them for paintings. 'Let's have art which deals with real things,' he says. 'That is the problem with being an artist today, because of the tiresome Traceys and the dreadful Damiens. All doing art about

art. For God's sake, it is so boring. Let's cut through all that crap that the media lap up and regurgitate. What an artist should be doing, which is the business of responding to the world, gets sidelined with all this tiresome trivia. And shock-value stuff which is not really shocking anyway. And that is all so boring. You could argue it is good that people are interested. But I think the end result is detrimental. People could be drawn in deeper by the headlines. That is possible. But I hate and despise the trendiness of it. And the whole thing is open to manipulation. There is a totalitarianism about it which is exemplified by Tate Modern, and the fact we have no broad base of collectors. The power is held by a small number of people, who say, "These are the people who are important. And if you don't feel as we do, then tough."'

The next day I am standing in front of a huge John Keane painting which is on sale at the Flowers East stand at the Islington Art Fair, otherwise known as Art 2001. With me is the critic David Lee, one of the few people who dare to criticize the current art scene. Lee has what might be called a 'bluff Northern style', i.e. he can be very rude at times. He was once memorably caught on camera at the 1999 Turner Prize, crossly stalking around the iron railings outside Tate Britain like a huge Siberian tiger. It's a position he's worked hard to create. He quite likes Keane's work. 'I don't think he's produced a key work yet but there is the potential there for him to produce something which warrants being in the Tate and which will be in there for centuries.' Not if he carries on writing rude articles in the paper about the status quo, he won't.

According to Lee, the status quo is currently immutable. 'People say taste in art is cyclical, but the avant-garde hasn't had the imprimatur of the state behind it before. It now has a PR machine headed by Tate and the Arts Council shoving it further and further along. There is no opposition. I honestly don't think that there are sufficient numbers of newsworthy artists who can capture public imagination in the same way that the artists of the last ten years have.'

We leave the stands and go over to the café. Lee considers what opposition there is. 'The Stuckists? The Stuckists are dead in the water. I went to their exhibition and, with the best will in the world, their painting is shit.' Well, he is

It's not funny, it's stupid. Or it's a conspiracy.
John Keane in his studio.

a critic. 'There was one person there called Charles Thomson who looked as if he might be able to paint if he kept at it long enough, but the rest was just clamouring for attention. One wanted it to be good, in order to provide an alternative, but in the end they have fallen into the same trap as the artists they purport to oppose. They are more interested in promoting themselves than they are in producing work of profundity and sustained quality. You cannot look at a single painting by Billy Childish and say, "This is an opposition." It isn't.'

It's not what Tate does, but the way that it does it which gets Lee foaming at the mouth. 'My grouse about how contemporary art is presented is that it is unrepresentative of the diversity of contemporary art. You only have to look around Art 2001 to realize there are very many styles and ways of reflecting what life is like now. But work is not recognized if it is by people who are considered by the State Authorities as the wrong type of artist.'

Surely it's good to have a firm curating line? You don't want all exhibitions to look like Art 2001. Or the crazily democratic jumble that is the Royal Academy's Summer Exhibition. Do you? Nick Serota is pretty hot on this. 'By running a gallery consistently you become known for doing things a certain way and doing a particular kind of show,' he says. 'You reinforce what the gallery is and why it's doing it. That then helps to build a public. I believe in building a public by making it clear what we are trying to do. You can't be all things to all people. Galleries which try to do everything end up doing nothing.'

'The duty of the director of a national museum is to identify excellence wherever it alights, and whether or not he likes it, and to purchase it for the national collection,' insists Lee. 'I think it is wrong that we spend a great deal of time promoting the endeavours of some artists to the exclusion of others. A good example of the distortion is about Sarah Raphael, who died last week aged 41. In the last few days she has been called by four broadsheets "one of the most important figurative painters in Britain". Yet unless you are in the swim of art lovers, you will never have heard of Sarah Raphael. And yet artists who are ten years younger than her – the qualities of whose works are debatable – have retrospectives and are toured around the Arts Council galleries ad nauseam. I am not

saying that Gillian Wearing, for example, is bad, good or indifferent.' He pauses, then goes for it in classic Lee style. 'I think that some of her work is interesting. But the vast majority of it is pretty awful. But then I could say that about most artists that I come across. I am only interested in exposing the partiality of the State Academy of Contemporary Art, as I call it, in order that other artists may benefit. There is room for both. The art market is not Charles Saatchi paying a million quid for a blown-up model. The art market is what you and I buy for our homes. And that is conventional painting.'

Lee hands me a sheaf of pamphlets, the latest few editions of *Jackdaw*, his 'Newsletter for the Visual Arts'. It's typical Lee stuff. On the front cover of the current issue is a picture of Nick Serota as Frankenstein's monster and the headline 'SEROTA: Dangerous Dictator?' Inside are various regular columns (Gravy Train, Lisson Spotting, Stunts), in which he fires off at his favourite targets (the Arts Council, the Lisson Gallery, the art critic Richard Cork from *The Times*). It's all rather bracing and jolly. Lee, who admits he earns £2000 out of comment and critique at every Turner Prize, is obviously as much part of the scene as those against whom he fires his scathing essays. As are most of the other grumps. Unless of course Stuckism becomes the new Impressionism.

CHAPTER SIXTEEN

# THE MISSIONARIES
the provinces fight back

There's another distinct point. All these people, Michael Craig-Martin and Michael Morris, Simon Hedges and Paul Hedge, Mark Francis and Mark Wallinger... They may not have started out London-based, but they are by now. In many ways the buzz about British art is confined to the capital.

Tate Modern may well have been mostly funded by the National Lottery but it competes on an international pitch. Its key cultural rivals have to use a passport to get to Southwark. Curators from the Centre Pompidou and Parisian journalists alike took great pleasure in sniffily sniffing around Tate Modern. THE Modern (i.e. the Museum of Modern Art) in New York was said to be somewhat nervous about Serota's giant baby. In the end its curators graciously conceded it was a triumph and left it to the chief art critic at the *New York Times* to dub it a 'temple to vanity'. Anyway MOMA is no doubt content to keep its powder dry until its own new extension opens, with anticipated global ballyhoo, in five years' time.

Which leaves the rest of the UK where? As a state of ungalleried, unmitigated Philistines? Hardly. Although museum director Peter Jenkinson has a great joke about how people took the new gallery he was opening in Walsall to be in *Warsaw*. Because no one had ever heard of Walsall.

Aaahh. Peter Jenkinson. Everyone loves him. He's got it all. Bionic drive, passion for his subject, an utter lack of metropolitan snobbery and a lightning enthusiasm which shames those who consider that anything exterior to London should be, by definition, inferior.

The £21 million New Art Gallery, which opened in Walsall in May 2000, is startlingly superior. Gorgeous galleries. Huge windows. Terracotta brick. Leather banisters. A stunning rooftop restaurant with real linen and proper cutlery. It's won all sorts of things: the RIBA West Midlands Award, the Interpret Britain Award, the Gallery of the Year, a nomination for the Stirling Prize. The old gallery above the library had 40,000 visitors a year. In its first year, the New Art Gallery had over 210,000. Of which 88 were the first Japanese tourists ever seen in the area. Do I need to go on? It has created over seventy new jobs. Local shops have reported an overall £4,000 increase in takings *per day*. The gallery now has something like 3,400 press cuttings from the media around the world.

I pay the great man a visit. White tie, sharp suit, mobile phone on the hip like a pistol in a holster, long legs leaping around the place. You just can't help but get swept up in the delighted atmosphere that is Peter Jenkinson. Five minutes in his company and you, too, are jumping up and down about the lift announcements, which are by Slade leader, ironic style champion and local boy Noddy Holder. Ten minutes in his company, and you think the Turner Prize should relocate to Walsall. Fifteen minutes and you think the family should relocate to Walsall.

'Right,' says Jenkinson. 'This is the first thing you come to. Absolutely deliberately so.' We are on the ground floor, in the Discovery Gallery, which is centred around children's activities. 'In most British galleries the so-called activity areas are in the basement. With lights which burn your hair off and second-rate furniture which is hosed down all the time because they think children are smelly and dirty. And it is an entirely second-class experience.'

At the New Art Gallery, no one is second-rate. 'Champagne for all is our motto,' says Jenkinson firmly. We walk into a large space artfully painted in pastels. 'Why do children always get rooms designed in primary colours? We had

a brief. "No Primary Colours." I think there is a lot that London can learn from here. Children's activities in London galleries are sort of seen as uncool.' The floor is painted with the legend 1 + 1 = 2. 'That is also our motto. We want the whole gallery to be focused. And pristine. And correct.'

Jenkinson's socialism is perhaps very unfashionable, but it was a stroke of genius to give it the uppermost position in a winning formula which also includes hard business sense and artistic validity. Why did Jeremy Isaacs not have a Walsall lunch with Jenkinson before launching the farrago that was the Opera Lottery Bid? The biggest mistake Covent Garden ever made was to fail to push the democratic button, with the result that the whole project collapsed in its stumbling progress from the top down. Whereas with Jenkinson's utter commitment to public inclusion, the New Art Gallery has spectacularly risen from the bottom up.

'I know we are seen in the art world as happy-clappy, but we are doing it like this anyway,' says Jenkinson, who launched his lottery bid in Walsall Town Hall with people passing the application from person to person until it reached someone dressed as Postman Pat who drove it in his van all the way to London Town. Postman Pat! What sort of antic is that for a cool art person?

Cool art people rather like Jenkinson. The Discovery Gallery includes original work by Yinka Shonibare, Richard Wentworth and Nicky Hoberman, and a huge Damien Hirst spin painting, high up on the wall, called *Beautiful babies optical parson's nose trembling camera weird shutter release artistic eye exploding pig chainsaw sex painting with two small pink splashes made in 1996*. Beneath it is a computer terminal. 'Here you can make your own spin painting,' says Jenkinson. 'And here on this screen, you can see Damien making it. And if you are a baby you can still make it on felt, here, with Velcro. If you talk of Access, people always think you are dumbing down. But that's just not the case. This gallery has real work by decent artists.'

We go up to the first floor library and workspace. Peter tells me it took two and a half years of 'protocol' to get HRH to open the gallery. 'The Mistress of the Queen's Bedchamber is one of our patrons. Very handy. This is a very poor area.

Peter Jenkinson, of the New Art Gallery, Walsall, who insisted that money and effort be spent elsewhere than in the capital.

In this region one job in five is in the creative industries, but I can guarantee kids around here won't even consider that sort of future. So we will work with careers advisers and young people in this space here.' Careers, unprivileged youth, an inferred reluctance from the Queen to come to the Black Country. Is there nothing he can't transform?

'This has been a long dream for Walsall. The first plan for a major art gallery was in 1903. I first arrived here in 1989.' For two and a half years, Jenkinson worked on plans for a gallery on the other side of the town. 'Then the poll tax hit and it was cancelled. So this grew out of that. What we have always tried to do is connect it to the place. It is not just a spaceship thrown down for people to get on with. We did an Arts Council booklet about public involvement. I read it now and feel exhausted to see what we did to get the sense of public ownership. Questionnaires went out to every household. Eighty-five per cent of the returns supported the idea of having a new gallery. On postcode analysis most of the "yes" replies came from the poorest areas.'

The main galleries hold the Garman Ryan collection, a huge assembly of paintings, sculptures and drawings which was gifted to Walsall in 1974 and used to hang in the old gallery above the library. It was the personal collection of Jacob Epstein's wife Kathleen Garman, who came from the area, and his pupil, the sculptor Sally Ryan. It encompasses work by Epstein, Monet, Rembrandt and Constable, as well as sculptures from Africa and Asia and work from the Epstein circle of Augustus John, Modigliani and Gaudier-Brzeska. It's now housed across two floors of blond wood and glass which, as Jenkinson points out, has been designed to look like a domestic house. 'This is the front hall. Then you go off into all the rooms. There is even a Romeo and Juliet balcony up there. We are launching a special Singles night on Valentine's Day. It's a great place to go on the pull. And it's all themed. Forget Tate Modern. We've been thematic since 1983. Look at this fantastic Lucian Freud.'

One gets the sensation that Jenkinson is still amazed he's pulled it off. 'Look at this wood. This leather handrail. Do you know, we have had no graffiti anywhere,' he muses. Then, with feeling, he suddenly comes out with it. 'The

arts scene in London needed to be shown this could happen elsewhere. The idea that "if it was outside London it wasn't worth it" got my blood boiling. People across the regions are talking about the Walsall Effect. It's a cheesy thing to say, but then I always say cheesy things. This building is supposed to give people a bit of respect. Look how wide this door is!' He rushes up to the doorway as if he has never seen it before.

'There is a sense nowadays that our public spaces are all a bit squeezed and controlled. But here people can stretch out and think, "This is for me." Local people have been found crying in the gallery. Choked up. It sounds very Luvvy in Tights, but that really gets me.'

It's the same delight in the democratizing nature of art as felt by Nicholas Serota. Serota says sincerely that the time when Tate Modern really hit home was not when he welcomed in the Queen, or even the Prime Minister, but when the doors opened on that first morning and the general public came rushing in.

'People here have learnt to accept second or third best,' continues Jenkinson. 'The last building of this nature was the Town Hall, built at the end of the Victorian period. Everything since then in Walsall has been decrepit. But the Town Hall declared lasting values and civic dignity. And that is our mission.'

It's not come without a personal price for Jenkinson, long-partnered with the former director of the Ikon Gallery down the road in Birmingham, Liz-Ann Macgregor. They were a formidable presence, Jenkinson creating Walsall and Macgregor driving the Ikon through a huge, Lottery-funded relocation. But then she was offered the directorship of the National Gallery of Modern Art, Sydney, and that was that.

Adam Caruso, of architects Caruso St John, says it was Jenkinson's doggedly inclusive approach that sealed Walsall's success. 'Whether the building was a gallery or not is irrelevant. We approached it as a public building which the public own. The building became insinuated into the fabric of the place; it got under its skin.'

Getting the gallery to click with the town wasn't just about the wisdom of having questionnaires and tours and asking people to help choose the menu.

Caruso St John designed it that way. 'We built it in brick, to connect to the tradition of those really hard brick Midlands buildings. Brick in the Midlands looks harder than anywhere else in the world. In Rome or Siena it looks soapy and rounded. But around Walsall, the factories have this incredible tautness and a sense that they were built to last. And we responded to that.'

It may be a cultural factory for the area, but its ambition goes further afield. Jenkinson has created a partnership with the Tate over the next three years. It will be the first of a series of 'new relationships between us and the national collections'. He clearly thinks the gallery is on a level with its big siblings down South. 'I once asked someone at the Tate whether Nick Serota would know what his loo roll dispensers were like, and I knew the answer would be yes. He is like that, and I am like that. At least people now know we are not the capital of Poland.'

He's a one-off but he is not alone. Up the road from Walsall there is the huge enterprise which is Baltic. I used to live opposite the vast brick warehouse on the River Tyne in Gateshead. It was part of Joseph Rank's baking empire. His flour mills, scattered across the country, were each named after a body of water: Solent Mill, Atlantic Mill, Ocean Mill. This one, probably because it faced the chilly Scandinavian coast, was called the Baltic Mill.

When I lived in Newcastle, the building was a lonely monolith, offering nothing but the urban myth that inside was a European Community sugar mountain. Then the Lottery came along, coupled with the event that was Tate Modern, and suddenly the Baltic's fate was changed. It was to become an arts centre, part of the £250 million Gateshead regeneration scheme. A flagship for culture on the south bank of the Tyne, historically the great river gateway to the heaviest of heavy industries.

This transformation was the confirmation – if confirmation were needed – of culture as the replacement for shipbuilding. The particular culture which was chosen for the Baltic was never in any question. It was to become a huge contemporary art space, housing over 3,000 square metres of galleries, studios, two cinemas, the obligatory shop and rooftop restaurant.

Gateshead had already manoeuvered Antony Gormley's *Angel of the North* onto a grassy knoll beside the A1 with huge success; Baltic was the next step towards the transformation of the area – the Tate Modern of the North. It even sounds a bit like Tate Modern, having dropped the defining 'the' from its name.

On a chilly spring day I go and see the director, Sune Nordgren. He has just confirmed that Baltic will now formally open on 9 March 2002. This is at least six months after the original date, but Nordgren is unfussed about the delay. 'It's fine for me. We can move into a finished building, with the quality I wanted. There have been places that have opened too fast, and it's always difficult to correct things after you have moved in. This gives us a lot of time.' It also gives him time to organize someone appropriate to open it. 'I want the most important person in the world to do the job. Who do you think that might be?' he asks, with what I can only term Swedish inscrutability. Nordgren always, always dresses in black. It's become a bit of a joke with his staff. He was a former TV anchor for a Swedish arts show. He's clearly a bit of a personality. I shrug my shoulders. 'Kofi Annan, of course. He should open Baltic.' Of course.

Baltic has been given £33.4 million in Lottery money by the Arts Council of England, and achieved the matching £12.3 million with contributions by the local council, the European Development Fund, English Partnerships and Northern Arts. No private money has been put into it. It has also received revenue funding, to the tune of £1.5 million a year, for the first five years of operation, and was the first Lottery project to do so. Clearly no one wants Baltic to run aground.

Nor should it; although Gateshead is a different picture altogether from Walsall. There's no permanent collection, for one thing. When Nordgren arrived from Stockholm, where he was running the International Artists Studio Programme, all he inherited was the Baltic building, criss-crossed inside with a honeycomb of silos, each 100 foot tall. He had no staff. There was just the architect, Dominic Williams of Ellis Williams, preparing to remove the 148 concrete silos and hastily put up a counter-balancing scaffold which would stop the building from toppling into the Tyne.

'I had the opportunity to build something from scratch,' says Nordgren, 'and I was determined that Baltic would be different.' The plan is to have not so much an art gallery as an art factory. Nordgren aims to fill Baltic with artists, perhaps five in residence at any one time, 'taking possession', as he puts it, of the building. There will be collaborations with international galleries and commercial galleries to host shows, but a lot of the work will be produced on site. Nordgren has started as he means to go on, commissioning Anish Kapoor's *Tarantara*, a gigantic, red tube of material which sat in the hollowed-out edifice from July to September 1999.

Unlike Tate Modern with its huge central hall, Baltic is detailed and compartmentalized on the bottom, then opens up as you climb the building, until you reach two galleries which run the length of the whole structure. I travel in a tiny red cage to the top. In time, people will be performing this feat in three cozy glass elevators shooting 140 feet up the side of the building, where it's blustery and wild. On the opposite bank of the Tyne, Newcastle bustles vertiginously. Past the tiny dot that is my old flat, I can see out to the old Walker shipworks. We walk delicately over metal tubes, plasterboard and scaffolding. Hundreds of men in hard hats are working on the building. It's as if a new ship is being created. But can culture ever be as galvanizing a force as the multifarious connections of industry?

Naturally, Nordgren believes it can. He talks of giving people a focus, of connecting with local industries. In Gateshead he can lay his hands on everything, from glass to reinforced steel. 'I believe this will be the place with the best facilities. Artists will enjoy doing a residency and preparing exhibitions here. There is nothing like it across Europe.' Who will he invite? Damien? Tracey? Antony? Why not? He has a little trick with a world map which he used to play when he was Director of the Konstall Gallery in Malmö. Under Nordgren, the Konstall showed an eclectic range of contemporary artists ranging from Barbara Kruger to Cindy Sherman. If any were commissioned to work on site, and felt a bit wobbly about it, Nordgren would whip out his diary with the little map. 'I would show people where Malmö was and where Copenhagen was and they

would say, "Oh! It's not that far. We can fly there." I intend to do the same with Gateshead.'

Nordgren wants Baltic to tell the story of contemporary art. 'I feel I have a responsibility to anchor, to root things with what's gone before. To place contemporary art in a tradition, even if it looks to some people as if it has just fallen down from the moon.' He considers the art world to be both calming down and flattening out, which suits him fine. 'Too much has been about entertainment. It is five or six names which have been constantly hyped. To me it is wider than that. There is art which is not completely accessible, or not completely scary. There is unspectacular contemporary art, which is equally important. I want to show the heartland of the YBAs, but also the quieter story. It is time to put them into context.'

His opening show will have a Tyne bridge built of Meccano by Chris Burden, a piece from the Wilson twins, born on Tyneside, and road signs by Julian Opie. And even if you don't like the work you might still enjoy Baltic by virtue of art's close cousin in the modern leisure package, namely food. Baltic will boast not only a rooftop restaurant, but also a riverside café beside the extraordinary new pedestrian Millennium Bridge across the Tyne, whose high arch and low walkway open and close to let boats through like the winking of an eye. Baltic may have come at the perfect time.

Stephen Snoddy, in another Lottery-funded gallery down the road at Milton Keynes, says he and Peter Jenkinson applied at the same time for revenue funding from the Arts Council for their first year. 'And we received the money on the same night. 14th December. I got £80 grand. Peter got £200 grand, which is fine since he is twice as big as us. It was important that we get national funding, since our remit is to have a national influence.'

The Milton Keynes Gallery is next door to the Milton Keynes Theatre; they were built out of the same Lottery grant. And although Snoddy concedes that the luvvies in tights got the lion's share of the dough (£18 million) and the gallery only cost £1.5 million, he clearly believes that regional art can achieve a wider pull. 'People in Milton Keynes are very pleased to have a fantastic theatre. The

theatre sells tickets within the region. But the gallery can project beyond the region. With a national programme of work.'

The Milton Keynes Gallery opened in October 1999 with a new show by Gilbert and George; since then Snoddy has shown Adam Chodzko, Mark Wallinger and Richard Ross, with Sarah Lucas and an exhibition curated by the critic Matthew Collings to come. He takes pride in the fact that people come from London, Oxford and Cambridge to his preview nights. He loves the fact that some Japanese people (probably on their way back from Walsall) came to see Gilbert and George. On leaving the gallery, they inquired as to the whereabouts of the nearest Tube station. Whether this is a compliment to Milton Keynes or not is a moot point, but as far as Snoddy is concerned, it reveals the eminent portability of sophisticated contemporary art around Britain. You just have to show it off in the right space: what he rightly calls a 'beautiful, minimal and simple' gallery. And if you conjoin the space with the right artists and the right crowd, national status will follow. Or that's the idea.

It's a long way from the early days of White Cube, when Jay Jopling noted that the broadsheet arts pages would only perk up for historical shows at the capital's main museums. Like Walsall and Baltic, Milton Keynes is benefitting from the snowballing craze for contemporary art as a national, going concern. So even if it happens outside London, it will still get coverage.

Interestingly this is probably only true for contemporary art exhibitions, not historical ones. And of course not every new centre outside London has thrived. The Cardiff Centre for Visual Arts had such a miserable time that it has closed. And we won't venture into the poor Sheffield Centre for Popular Music. But that doesn't mean to say you shouldn't have a go.

Cue Eddie Berg, Liverpool genius, a man with the same amused enthusiasm as Peter Jenkinson, only in a stockier package. Ten years ago, Berg ran Merseyside Moviola, an annual festival of video and film, which then became Video Positive. Now he has got a rather bigger fish to fry, namely the £9 million Foundation for Art and Creative Technology (FACT). Although he's not sure about the name for such a funky, zinc-tiled, shiny, cousin-of-Guggenheim-Bilbao

THE MISSIONARIES

building. 'We are grappling with new names at the moment, and we might change it,' he says.

Like Peter Jenkinson in Walsall, Berg has constructed FACT with support from the ground up. And he, too, has national ambitions. As with Philip Dodd at the ICA, Berg is determined that the FACT Centre will give people ... what they want. But FACT will not be for anoraks. 'It is not about technological fetishization,' says Berg. 'It is about ideas which are realized through technology.'

Described as 'an arts centre for the digital age', scheduled to open in summer 2002, the FACT Centre is intending to have three cinemas dedicated to 'arthouse, independent, repertory cinema and film art'. (Currently there are no arthouse cinemas in Liverpool.) It will have a cosy 'media lounge' where people can loll about enjoying 'live video streaming', DVD players or online archive facilities. The Box, Britain's first micro-cinema for live shows, will have casual seating for 'late night ambiance'. There will be a huge bar and a café (natch), and two galleries showing an international programme of artists associated with New Media. Which does not mean designs for boring old screen savers. 'We could show an exhibition of work by Dan Hayes, for example, because he paints pictures from computers,' says Berg.

In rooms at the top of the 100-foot-high building there will be space for emerging forms of media technology, with rooms and equipment hired out to New Media companies locally or nationally. The company already generates £150,000 a year doing this; from its temporary base in the Bluecoat Arts Centre, it's busily putting chunks of Tate Modern's video archive onto DVD. This commercial nous, plus Berg's long experience as Liverpool's media guru, might mean that the FACT Centre does not go the way of so many other worthy but doomed local arts projects, such as the Cultural Quarter (went bust), or the 051 Cinema (ditto).

The site is in the midst of a £70 million urban regeneration programme, much of which is being carried out by local developers Urban Splash. As their name implies, Urban Splash are urban, splashy and specialize in doing hip conversions with stainless steel kitchens, stripped wood on the floors and Art on

the walls. Thirty of these plus matching restaurant are being thrown up next door. The heart of Liverpool has had many false starts in its journey to join the centres of Manchester, London, Edinburgh and Newcastle in economic prosperity, but this time it looks serious. Berg has also linked up with Cream, the huge nightclub empire whose HQ is round the corner. These liaisons are not just desirable. They are essential.

'Something cool on its own might struggle in Liverpool. Here, we have something which is much more complex. We will have a visual arts audience, the standard arthouse cinema audience, and a high student population. You need a wide infrastructure. You need coffee shops and clubs. You need the proximity to where people live and work. You can't build an arts centre in the middle of a wasteland and expect people to turn up,' says Berg.

What you are hearing is a new voice. It is the voice of the realistic arts entrepreneur. This person may well be on the road to fulfilling a personal mission but is not expecting other people to don a hair shirt, too. People like to experience art in unusual places. But successful unusual art places tend to be near to a branch of Starbucks. Why is this? It's because Michael Morris and Jonathan Kent and Eddie Berg have realized what we, the punters, have been trying to tell them for years. Art is *supposed* to be enjoyable. It's *meant* to be an entertaining leisure activity! It's what we do on our time off. So, please. Give us leather sofas and nice cafés and decent bars to surround us while we get cultured.

Berg has clearly taken a recent flight from Speke to Spain, for he believes that art can transform Liverpool in the way that the Guggenheim has done for Bilbao. He is one of the founder curators of the new Liverpool Biennial of Contemporary Art. It's hoped the Biennial might become as internationally important as its big Venetian sister. The Liverpool Tate has been reopened and relaunched. The city is competing for the City of Culture title. Liverpool is attempting to refloat itself with art at the helm.

Berg introduces me to Jane Casey, who looks like she has just dropped down from Planet Vogue. She is dressed from head to toe in a coffee-coloured

leather trouser suit. She has perfect hair and nails. Formerly Director of the Bluecoat Arts Centre, and currently Director of the Cream Foundation, Casey is an emblem of the club-culture nexus that Berg is attempting to hook into.

'Cream is Europe's leading youth brand,' says Casey. 'Young people listen to Cream. They hit our web pages. We have a massive infrastructure, and that infrastructure could be very important. We want to use it. To help organizations like the Tate and people like Eddie. There has been a sea change with young people. They have become interested in things that have meaning. They are interested in video art and arthouse cinema but it has never been marketed properly to them. They might feel intimidated walking into an arthouse cinema. Art was always quite insular, and had its own group of people it dealt with. It hasn't developed new audiences. But Cream can provide the new audiences. Club culture is all about visuals. Young people know about experimental films; they just don't know where to find them.'

So, marry arthouse cinema with club culture. It's what Vivienne Gaskin at the ICA discovered. And it is that simple. 'One of the reasons Cream is so successful is that we send out a sophisticated message,' says Casey. 'We take a lot of ideas from art and regurgitate them back to our audience.' The Cream crowd is a hungry being simply waiting to consume the right kind of product. 'On a Saturday night there are 3,100 people in the club. And 630 will have come in coaches from out of town. We manage the movement of those people. So in the letter to the coach company, we will put out a flyer saying why not come and see this art movie at FACT? Or on our website. 300,000 people a day hit our net page. We already advertise what's on at the Tate.'

There are 100,000 people in the area on a Saturday night. And if they aren't already interested in what he has to offer, Berg will convert the art form so that they will be. He is no more or less committed to culture than previous art pioneers. It's just that he has tried to bring art to the audience rather than the other way round.

CHAPTER SEVENTEEN

# THE LOOK

## how the high street was won

From the front page of 'The Guide', *The Guardian*, 6–12 January 2001.

> ## THE £50 WEEKEND
>
> 'Why do people keep going back to Tate Modern? For the art of course, but could it also be because it boasts our favourite museum shop in London? Best New Year buys have to be its oh-so-tasteful **2001 calendar** (£9.99), the **Redstone diary** interspersed with travel images (£11.99), and the George Maciunas Hand in Glove **stationery by Fluxus** (£8.50) – perfect for all those thank-you letters. And if your credit card bills mean you won't be eating out much this month you can give your kitchen a style boost with great **fridge magnet sets** (£12) featuring images from the '60s, '70s and new British artists.
>
> TOTAL £42.48

'The Guide' is a listings booklet published every weekend in London by *The Guardian* for people interested in what's on in the capital. The bright, breezy style of these 101 crisp words establish everything you need to confirm Art as

Lifestyle Accessory Number One. Let's examine them. The opening question is merely rhetorical. We know people keep going back to Tate Modern for a multitude of reasons. Crucially, the 'art' in question is immediately followed by 'our favourite museum shop'. Just a moment. When were museum shops ever in favour? Right now. Museum shops have become more people-friendly, but they also happen to stock things that are currently in fashion, namely art-related consumables. Then there is the list of items, bracketed under the classic daytime TV moniker 'oh-so-tasteful'. As if we needed reminding, this list emphasizes that museum stuff generally, and Tate stuff especially, is just the sort of thing that discerning *Guardian* readers should be buying. Finally, the description of the fridge magnets crucially associates the visual arts with the two key crazes currently gripping the nation: a) eating out, and b) interior design. The magnets also importantly link 'new British artists' with those other moments when British culture was indisputably fashionable, namely the Swinging '60s and the now-Ironic '70s. There you have it. The zeitgeist. In just 101 words.

Courtesy of expanded media, the whole invention of 'lifestyle' and a greater appetite for consuming it, the art phenomenon has appropriated itself as the culture of choice on the High Street, just as it moulded itself to suit the corporate sponsor and the fashion-conscious individual. There is a revived awareness of the aesthetic, but at the same time the aesthetic has incorporated street culture to provide an exulted democracy in which high art and popular culture are blurred and bonded.

Firstly, the buildings. The British Council's quartet of practices chosen for the Venice Architecture Biennale 2000 have reawakened the notion that buildings can be beautiful as well as big. Zaha Hadid, with her explosions of space and line, her ribbons of concrete inspired by chewing gum or spaghetti, her radical playfulness and the daring to translate a drawn line directly to a built form. Will Alsop, whose motto is 'No Style, No Beauty', has plenty of both, with his notions of architectural delight and close association with contemporary artists such as Bruce McLean. David Chipperfield, whose international museums have conjured up spectacular spaces, wishes to 'encourage an architecture that does

not look like built drawings. Material, volume and light must occupy the very centre of our craft.' And Branson Coates' Nigel Coates collates his ideas into the notion of 'Ecstacity', the all-embracing nexus of 'crossed scales and dissolved boundaries', in which architecture can be a fluid and responsive medium embracing new technology and social change, where everything connects. On his website ecstacity.com, he explains it thus:

> 'Organisations are no longer cast in concrete, but are responsive cybernetic organisms in which people are the current. Meanwhile architecture lags in its refusal to embrace these ephemeral forms. Enough marble, enough glass. Where is the architecture of our flickering collective minds? ... There will be a new species of architect whose job it is to cut and stitch. This species will consider the urban landscape as a giant urban interior that exists between buildings. Their efforts will range from the facility structures (new lamp posts and support systems) to the multi-use schema that prepare a square to be simultaneously sports field, swimming pool or theatre ... they will practise a new 'soft planning' ... give the city overlapping thematic drifts that spur a plethora of complementary variations.'

Look at the new arts complex in Somerset House. It is already happening: the central square can be theatre, café, ice-rink or fountain display.

Meanwhile at a hairdresser's in London, Zoë Smith and Graeme Williamson have built in CCTV screens so customers can see the backs of their heads while they are having a No 3, and Softroom who came to fame designing virtual homes for *Wallpaper\** magazine are creating shops like John Smedley in Brook Street and restaurants like Nobu, with a similarly fluid sensation of pixelated light. Down a street in East London, Jake and Dinos Chapman and Chris Ofili are each living in three adjacent houses designed by architect David Adjaye, who also put in a layered, light, white gallery downstairs at Jake's.

The confidence isn't confined to London. Vittorio Radice has chosen architects Future Systems to build the new Birmingham branch of Selfridges.

His introduction to their work was seeing the practice's extraordinary pod-like media centre for Lord's Cricket Ground while sitting on the top floor of a double-decker bus.

Future Systems' Amanda Levete pads around in socks at the company's huge warehouse studio, showing me the maquette for the new shop. According to her, the 250,000-square-foot building will reinvent the department store just as the original Selfridges did. And the new one is just as decoratively ornate. 'The ambition,' she says, 'is to give people a sense that you are uplifted when you walk in. It makes you feel good.' It's become a sort of alchemic algebra. Big Building Site + Art = Magical Experience, capable of changing a city.

From department stores and hotels (St Martins Lane, the Sanderson, the Westbourne, which proudly announces that all its paintings are 'real BritPack art') to loft apartments, the contemporary Culture look is the only choice for the fashionistas. Witness the arrival of the Philippe Starck 38-flat development YOO NW8. The guests at the launch party represented a perfect connection of art and power, namely Elisabeth Murdoch, Jenny Saville, Bruce Oldfield (also doing the same thing in Kew), Norman Foster and Gwyneth Paltrow. YOO's interior decoration style is filed under two 'palettes', Classic and Culture. There are no prizes for guessing which one everyone chooses.

Even if you can't stretch to a weekend at the Westbourne, you can still get your fix in any number of restaurants and bars. In a spot-on piece of observation, the Evening Standard's architecture critic Rowan Moore has wearily listed the things all contemporary bars now have to have. Otherwise, you might as well exhume the horsebrasses and inglenook and return to the ghastly state of Pubness. According to Moore, these 'stylistic tics' are now as 'recognizable and codified as the architecture of Egyptian temples'. White walls with a plane of colour. Changing coloured lights. A row of living shrubs. A long bar in glass-reinforced concrete. The kitchen-as-theatre. Banquette seating. And BritArt, loads of it. 'Here,' writes Moore, 'the lineage can be traced via the Pharmacy (1998) [Damien Hirst's restaurant and bar venture], to Angela Bulloch's instal-lation in Oliver Peyton's lost city of Coast (1995), though serious scholars may

The day's special dish: a Richard Prince artwork.
Oliver Peyton at Isola.

wish to note the somewhat clumsier attempts of the Westbourne (2000), to enlist the cool of Damien Hirst and others.'

I seek out the perpetrator. Oliver Peyton and I sit in one of his latest incarnations, Isola. It is very lovely. Designed by Andrew Martin. Not much art around, though. 'We have pulled back from it a bit,' agrees Peyton. 'I am not in the business of doing what everyone else does. So now we have moved more onto *installation* stuff. At Mash Great Portland Street [another part of Peyton's empire], we have specially commissioned pictures from John Currin. And here, we have just one piece of art, that big Richard Prince upstairs. Which is my way of dealing with art in restaurants. Now.'

But what about when you started? 'When I opened the Atlantic Bar and Grill in 1996, no restaurant had used art. Other than as wallpaper. We put in pictures by Douglas Gordon. Things that people would look and wonder at. When we did Coast we took it to another level. The designs were by Marc Newson, and we had the Angela Bulloch piece [*Luna Cosine Machine*, a vast drawing machine on the wall]. But by the time Coast was open a lot of restaurants had decided art was the way forward. It started becoming like wallpaper again, which defeated the point of doing it in the first place. Art has been packaged a bit. People are not interested in quality, just the whole package. Which I find a bit disturbing.'

Disturbance is very Peyton, however. 'I like the idea of doing some things which slightly disturb people. I don't think people look at art any more. That's how we came to this Richard Prince installation. You can't fuckin' miss it. You have to attack people with things.' Not too much, though. 'We had some pictures in the Atlantic last week. We had to take them down. They were these pictures of kids... People thought they were paedophilic. I say you could read them how you want, but...' he shrugs his shoulders. Art and eating out, Peyton's update on Picasso at the Lapin Agile. With the fashion for contemporary art and an unprecedented temperature change in British food from tepid to hot, it was a brilliant combination.

'There has been a mad rush to buy art, like there has been a mad rush to go to restaurants,' says Peyton. However, he suggests that it has sort of come to

a natural end. 'There is a lot of money washing around. But I don't think that it's very good for creativity. Everything is getting too style-driven. People are buying this whole style thing, which is a bit sad really.' With Sadie Coles at his side, he buys art for himself, not for secondary sale. He collects British and international art, and commissions it; Mat Collishaw did a one-night-only installation for the Atlantic Bar and Grill, while the labels on Peyton's house wine have at times boasted bespoke designs from artists ranging from Collishaw to Sarah Lucas.

I am sitting on a cream leather banquette at Isola with art polymath, the glamorous Jibby Beane, who has arrived in signature dark glasses, sporting a red baseball hat which once belonged to Elton John. 'I am interested in embracing all art forms,' says Beane. 'Design, fashion, live art, painting. I have just been showing at Art 2001 and I was offering something for everyone. Painting, neon, video, drawing, design. It's all about creating a buzz and giving something for everyone. I like to be flexible and in touch and embrace what's going on.'

Beane, who started showing art in her house as early as 1993, is a walking embodiment of the all-inclusive nature of the contemporary art scene. 'I get 150 invitations to art events a week. Obviously I can't do them all but it's not unknown for me to attend five or six in one night. Even if you can only be there for half an hour, at least you've made the effort and given your support. I am an instinctive person. When I started showing my art all these people said, "Who is this housewife from suburban Surrey?" I am not establishment, but I don't give a stuff. It's about encouraging young talent. I am a bit fed up with this YBA nonsense. What I am really about is art for everyone. All the time. Everywhere.'

Although King YBA Hirst has published it ('I want to spend the rest of my life everywhere, with everyone, one to one, always, forever, now'), Joshua Compston felt it, and Vittorio Radice is trading off it.

I chat to a woman called Jo Christie who edits *Theme*, a magazine for bar and magazine design. Bar design is now so important that there is a monthly *magazine* charting it. According to Christie, back in the olden days there was lots of 'heavy theming'. 'Everyone was doing the Chicago Rock Café, Americana, lots of bric-à-brac. Then suddenly people who kickstarted everything arrived. Conran

and Oliver Peyton with their restaurants. At the same time you had a big influence from club culture. Great design happened because there was a confluence of people who wanted to eat in really nice places but not necessarily have an expensive meal, and people who had done a lot of clubbing, looking for an alternative with good music and lots of style but which wasn't a really loud sweaty club. Bars were where those two different cultural elements met.'

I am at 100% Design in Earl's Court, 'the UK's leading interior design extravaganza, showcasing our choice of the most promising young design graduates'. The last time I was at this arena was reporting on the BRIT Awards, but it's clear that design is now the new Robbie Williams. Or at least it would like to be. My theory is that designers are the inheritors of what contemporary artists created: irreverence, confidence and influence on a truly global scale; the cult of personality, ambition for fame, that sort of thing.

As one would expect from a design show, everything is perfect. Even the soup bar has its range of offerings illustrated with funky little photographs. Alongside the photographs are witty graphics with the size of portions. 'Peckish' means small, and 'Hungry' means big. *Très amusant*. Two girls are sitting beside me, eating noodles with chopsticks. 'Mmm,' says one. 'I'm really enjoying this. I feel replenished. And hydrated.' Her comment rings both with televisual jargon and the essentially paradoxical nature of successful British culture. This soup is both groovy and good for you. It's aspirational and Protestant. It's like doing a tough workout in a gym decorated by Future Systems.

I walk past ceramics company Shakir Chaker, where Danielle Chaker explains how it is. 'Instead of bringing art into painting, why not have it in everyday objects as well? Like ceramics.' The Shakir Chaker plates are very trendy. Some are painted with huge eyes, others with retro '50s designs. 'We have had a brilliant response from shops so we know we are on the right track. Our price point is high, but we have to make our ceramics appear expensive, because we are marketing a lifestyle of young affluent individuals who enjoy modern living and who are cultured enough to be able to understand the concept of image.' But no 13-piece dinner services? 'Dinner services are out. We

do things like a bowl and a tray,' says Danielle. 'One day we will be a whole lifestyle brand. We are doing our first refurbishment on a bar in Birmingham.'

I seek out CA1, who I am told are the cat's whiskers for arty refits. CA1's Richard Martin tells me the initials stand for Contemporary Aesthetics. 'And our first collection was One. So, CA1. There is a general creative change across all lifestyle brands and markets,' announces Richard. 'Ten or fifteen years ago M&S provided quality. The rest of the high street was pretty much tat. That's all changed now. It's completely design-led. People are a lot more aware of what's around in terms of style, what wallpaper they choose, what bed they buy, what colour they paint their walls. Nowadays it's not buying a Barratt Home and painting it magnolia, but buying a Barratt Home and painting it red, or orange, or yellow. And having a green sofa. Whether because of *Changing Rooms* or *Elle Decoration*, the public is much more educated about design. Most interior sections started in women's magazines. Now *FHM* and *GQ* have sections. All the papers have design supplements. They may be showing off four quid vases from The Pier, but it's still information. And that's what's changed the market.'

Martin tells me to go and speak to 'cutting edge' designer Ou Baholyodhin. The latter's stand is fantastically Oriental, like a sort of Zen garden, all falling water and dark green plants and long low lines. He designs interiors and also 'projects', such as parties for Madonna and The Corrs, and the Christmas party for Warners, and Sade's latest album launch. He's pretty high-end. Only he says it's not about that. 'It is not about people with money. Everyone has high aesthetics now. It's about having a design awareness and generally being more stylish.' We discuss the Pret à Manger syndrome. Getting a sandwich with perfect rocket or a fantastic box full of sushi rather than some stale baguette. 'Absolutely. The quality level is just much higher. Take the food in Marks & Spencer. The graphic designs in the food area are just beautiful. And when I see great design, it makes me buy things.'

Out of Earl's Court, and into the High Street. I go to the opening of Purves and Purves the furniture store, which has just moved into a huge new building in London's West End. While having a quick latte in the in-store café (another

This man will curate your sitting room.
Ou Baholyodhin at 100% Design.

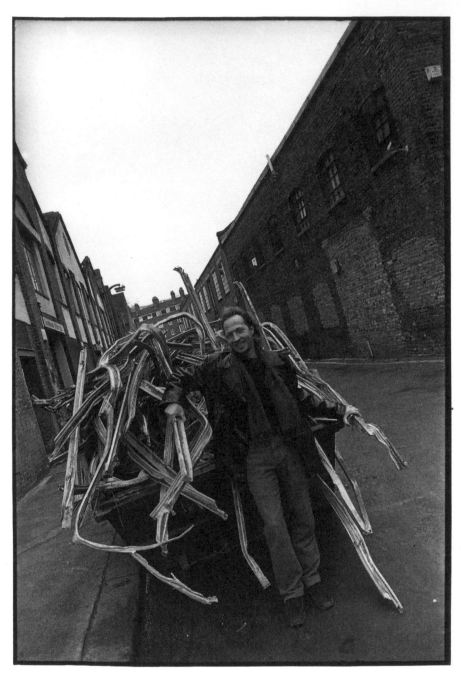

'My inspiration.'
Tord Boontje plus waste material in a London street.

lifestyle essential), I bump into co-owner Andrew Purves, who tells me in a languid manner not at all typical of someone who has just opened a 20,000-square-foot showroom, that the design boom was bound to happen. 'It was only a matter of time before people started looking at their houses and saying, "Why are we putting up with this chintzy, ten-year-old sofa?" They are discerning. They are saying, "We are interested in this *piece*. It will complement what we have got."'

It's a bit like talking about an art collection, I say. Andrew agrees. 'There is more of a collecting atmosphere and that is why the designer is very important now. I am sure there are people who actually *curate* their sitting rooms.' Wow. Move over, Iwona Blazwick, David Thorpe, Nick Serota. People are doing what you do with three-piece suites. Your ideas have been complemented.

I go to an exhibition at glassware shop – sorry, 'gallery' – Vessel, which has teamed six British designers with the Murano art glass company, Salviati. The designers are typical of the eclectic 'crossover' terrain: furniture maestro Ron Arad, architect Nigel Coates, artist Anish Kapoor, glass designer Simon Moore, design head of Habitat Tom Dixon, and furniture designer Tord Boontje.

The launch is in an extravagant West London hall. A long table down the middle of the hall shows off all the lavish and gorgeous glass. Funky music plays. People are handing out copies of *Bare* magazine. On a side table people are carving into a huge hunk of Italian cheese and eating it with charred peppers and olives. Ou Baholyodhin arrives, with a dalmatian on a lead. He and the dalmatian pose for photographs. The Vessel designers look on amused.

I meet Tord Boontje, whose jewelled, bobbled vases make glass look as malleable as knitwear. He tells me about his invention: creating glasses and carafes from discarded wine bottles. He cuts the necks off bottles and files down the raw glass to make a serviceable lip. The lip is high and pointed for pouring from carafes, low and rounded for drinking from glasses. He invented the technique at art school. Now he has found factories flexible and nimble enough to do this kind of work on a huge scale, resulting in the idea springing almost directly from Boontje's studio onto the High Street. Via the rubbish bin.

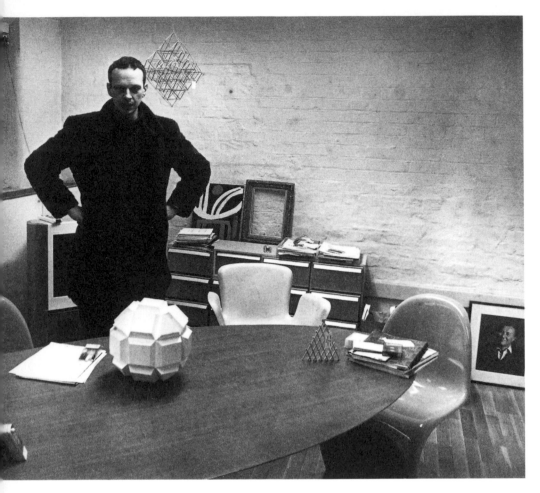

Mr Wise Guy.
Tom Dixon, and his mentor, at Habitat.

Meanwhile, Tom Dixon is holding court with ultra-fashionable Marc Newson, who has just made him an ash-tray for Habitat. Newson has his photograph taken, after which he is leapt upon by a journalist from the *Financial Times*, who knocks his cocktail out of his hand. He seems to like the attention, though he admits to me later, 'It was a pity about the Campari. It was a pity I chose this evening to wear my £800 Hermes jumper.' Two policewomen turn up, and spend most of the evening fending off drunken designers convinced they are Strippergrams.

The next day, I have lunch with Tom Dixon. I arrive as he is having his photograph taken by a French magazine. 'It happens all the time,' his assistant tells me sheepishly. Next to Dixon's office is a large piece of paper revealing the colours and fabrics Habitat will sell in 2002. I can exclusively reveal now that brown corduroy is going to be BIG. Groovy young people are sitting around iMacs, designing. Dixon appears in a long fur coat. 'You shouldn't be looking at that, you know,' he says.

We go to the Habitat café. On the wall beside us is a large print by Georgina Starr. I quickly discover that Dixon is charming but has opted to be a nightmare to interview. In the course of the meal, the dialogue runs something like this.

So, what about this new design trend in Britain?

'It's not new.'

Surely it's on a much wider scale?

'Yeah?'

Well, you're the designer.

'Candles. People buy a lot of candles. Yeah.'

Would you say that was a trend?

'I don't know. We have 5,000 things here I never ever handle. Like duvet covers.'

Can you influence taste?

'Yeah. I can affect taste. Why not? I can because I am working for a company with 100 shops in the UK and France and that is enough critical mass to influence taste. I can't change the way people live.'

What about things like your Jack light (made from the recycled and welded plastic of rubbish bins)?

'I like welding. I like industry. I was always over-ambitious. But I always get bored with the thing I am doing. I always wanted to expand. This is a great playground for me.'

What is next year's look?

'You are too nosy for your own good. You have only seen some swatches for some textiles. OK?'

OK. Sorry. Just tell me about Habitat.

'Fifteen, twenty years ago we were the only kids on the block. Now we are being squeezed from above and below. There is more interest now. But fifteen years ago people still wanted their Dieter Rams alarm clock. I have heard about this design revolution so many times, I am a bit cynical.'

What about all the art projects that Habitat does? Is that new?

'We have been doing that for 35 years. Look, do you want a coffee? Is that the time? Is your watch five minutes fast? It is? I have to say your watch is very much last year's model. Probably the year before.'

Isn't there a greater understanding about design these days. Like food?

'I have seen exactly what you are talking about in the food industry. You are probably right about design. I am just being devil's advocate. There is a parallel. The choice is increasingly wide, and the quality is a mass one. Listen. We should get a coffee outside. We'll never get one here. There's a café opposite.'

According to Nigel Coates, design became big when the ideas behind it stopped being mere ideas. 'There is no point in designing stuff which never sees the light of day,' he says in his offices which are almost next door to the design team FAT. 'I spent years teaching at the Architectural Association, but there came a point where I just thought, "Fuck intellectual theory. Let's put our thoughts behind creative ideas for the city."' Coates's turning point, he says, came in 1984 when he was hired to design a restaurant in Japan. 'I sketched the chairs which I thought would look good, and they said, "OK, we'll make them." So I did a set of chairs. That was the beginning of seeing the possibilities.'

The possibilities mean that Branson Coates has now designed not only huge buildings in Britain, and the Body Zone for the Dome, but a range of furniture, rugs, glasses, jewelry and clothes. Nigel has himself done a set of glasses for John Lewis. They are marketed under his name. 'The personalization of designers began with Philippe Starck,' says Coates. 'The Italians could see the benefit of promoting him.' And it's true. Philippe Starck is a name to drop, whether in the context of a chair, a night at the Paramount, a lemon squeezer or an apartment at the YOO complex. 'Celebrity and design is a global phenomenon,' says Coates.

He stretches out at the big table in his basement office. Upstairs is a show of art by Stewart Helm in his showroom gallery. 'My interests are art, clothes, music, and how you can carry ideas through things,' says Coates. 'In the 1970s, there was nothing and nowhere to match my aspirations. There has been a gradual increase in the appreciation of design. I'm delighted that our first sofa system has gratifyingly sold out at Purves and Purves, and other design shops. It was the first chair I have done which genuinely reached the marketplace.'

Once you start looking, you see it everywhere. The artists have borrowed from the street and the high street has repaid the compliment. Sculptural forms in IKEA. Adverts that look like something by Bob and Roberta Smith. It's almost enough to make you run to an auction house and see old-fashioned art which is content on its high perch. Or go home. But here the story only continues.

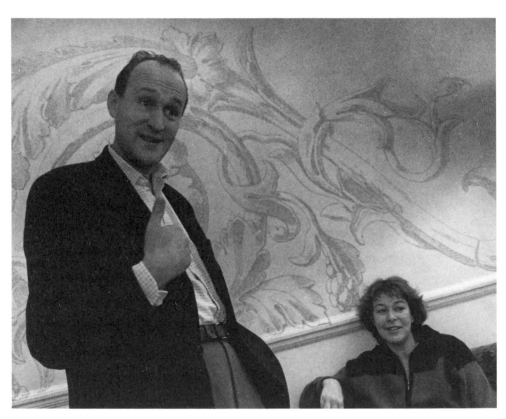

Peter Bazalgette and Linda Clifford, who gave Laurence Llewelyn-Bowen to the world.

# CHAPTER EIGHTEEN

# PEAK TIME

## sitting-room art

You get home. It's peak time, which, in the early twenty-first century, means Home Economics on TV. Cooking, gardening, interiors. The consultants tell us our newfound delight in this wartime subject is all due to the search for self-fulfilment. This in itself is nothing new, except historically we have tended to seek it from ancient religions and social structures rather than from fulfilling the potential of our patios. Still, as it has enabled a normal-sized woman, i.e. Charlie Dimmock, to be a celebrity, I suppose there is a progression of sorts.

The Home Economics programme makers, however, believe that by realizing the potential of your patio you will achieve something similar to what the old religions offered.

'*Changing Rooms* works on several different levels,' says Peter Bazalgette, inventor and executive producer of the show now watched by 12 million people. It gives you tips on changing your house. It shows you can do it for very little money. But at a profound level it's quite clear that the way in which someone's room is decorated is really an extension of themselves. And that if you change your room, you are changing your life. Just imagine someone at a bus stop dressed in rather dull clothes going to a rather dull job. And thinking they would rather be in the Caribbean or writing poetry. They can go and buy a pot of paint

and do something outrageous. The day job carries on but in their inner sanctum they have done a piece of expression that somehow liberates them.'

The *Changing Rooms* team receives thousands of requests from viewers to have their houses transformed. 'There is a greater spirit of adventure these days, and there is a greater sensitivity to the aesthetic side of our lives,' says Bazalgette. 'Look at the way high-end design filters through. Like the current fad where, instead of a basin, you just have a tap which comes out of a wall above a free-standing bowl on a piece of slate. That started in chic London and New York hotels. It is now in all the bathroom catalogues. I was even in a tiny town in Devon and went into a bathroom shop, and there it was.'

While it is clearly facile to suggest that just because contemporary artists use bright colours, and bright colours appear on *Changing Rooms*, people's houses are therefore works of art, it is obvious that a greater sensitivity to and interest in visual culture as evinced on the high street has also wandered up the pavement and into people's homes.

'It's about having a view,' says programme editor Linda Clifford. 'It's like the controversy over whether Damien Hirst is an artist or not. It's art; it's not art. People are involved. Most people ignored modern art before. Now they will have a conversation about it. Equally *Changing Rooms* forces people to have a view. You do something to someone else's house. They come back. They love it, they hate it. Laurence Llewelyn-Bowen puts in almost outrageous ideas. Everyone who watches him is making an aesthetic judgment, when previously they might not have bothered.'

Into this excitable atmosphere of aesthetics there is also Shopping, our most fervent pursuit. 'Everyone wants to acquire things,' says Bazalgette. 'But now they want beautiful things. And we all know what is beautiful because we are told what is beautiful by the media. It's about the consumer society, but also wanting to show off your own good taste.'

Taste has become a seemingly inescapable aspiration. I pick up the February 2001 copy of *Elle Decoration* (on whose Editorial Board sit Nigel Coates and Tom Dixon), and read an article by Polly Vernon advising readers that

'tasteful homes have come within the grasp of us all'. According to Vernon, everyone who is young, works and lives in a city is in the dogged and endless pursuit of Taste in the form of white-painted floorboards, Feng-Shui-ed chairs and leather cube seats. Or roll-top baths and limited edition graphite iMacs. It's all in the detail, down to the 'exorbitantly priced extra virgin olive oil masquerading as a minor work of art'. In the 1980s our homes were a 'showcase for expensive electrical goods'; Vernon observes they are now 'temples to taste'.

This is backed up by an article in *The Observer*, headlined 'Taste Revolution Hits the High Street'. Here, it's not just young professionals. It's everyone. The piece compares the slough of despond currently suffered by middle-brow retailers with the peaks of economic elation going on at the high end. Boots, M&S and Littlewoods have announced some of their 'worst ever trading figures', whilst the luxurious likes of Burberry, Gucci and Armani have reported growth from 20 to 35%. According to *The Observer*, 'demand at Louis Vuitton is so great it is being forced to ration its logo-print bags'. Which is serious. Consumer analysts The Henley Centre suggest that the average household is 40% better off than in 1986, and disposable income is expected to rise by 3% in 2001.

What a Petri dish for culture to thrive in. Alright, a bad joke. But within this atmosphere, is it any surprise that art is booming? That over £10 million's worth of trade went on at Art 2001, compared with £2.4 million in January 1998? Art has the rare uselessness of a belt by Gucci; it has the beauty of a Burberry shoe; it has the envy-pricking brand of a Louis Vuitton logo-print bag. And it has the inherited celebrity of an Armani-stamped suit. All art is original; not all art is also famous, covetable and popular. Successful British contemporary art can be all these things.

Even visiting artistic enterprises can be a signifier that you have Taste. 'It's like the shop at Tate Modern,' says ardent Tastemaker Vittorio Radice. 'Why does that shop do so well? You want to take the experience of Tate Modern home. No one needs another mug or another T-shirt. But we still buy mugs and T-shirts because Tate Modern has created a place that people want to be part of.' Why do they want to be part of it? Tate Modern is fashionable, it is aspirational, it is free;

it is accessible and friendly and famous, while also revealing objects sometimes of beauty, always of value, to which we innately respond.

As has the market; the originals can now be morphed into replicas. You can buy Nigel Coates glasses from John Lewis. You can pick up and make a Tord Boontje chair, 'as seen' in the big 'Century City' show at Tate Modern. Or you can buy art which arrives in a tube at your home the very next day. Even from chief YBA Damien Hirst. This is an e-mail from top art online provider, eyestorm.com.

> Dear eyestorm user,
>
> Due to rapidly diminishing stocks of Damien Hirst's Valium the unit price for this item will increase from $1,500.00 to $2,500.00 with effect Thursday 1st February. As a registered user, we are delighted to be able to offer you the opportunity to purchase Valium at the existing price of $1,500 prior to the February increase.
>
> Less than 100 signed prints remain in stock and these will be sold on a first come first serve basis. We are pleased to extend our easy pay scheme to this product which enables the cost of the print to be spread over 3 months.

I'll admit, it's tempting. *Valium*, a signed print of one of Hirst's 'dot' paintings, comes in an 'edition' of 1,000, although that term is somewhat problematic. According to print experts, anything over a run of 250 is tantamount to a poster. And in one newspaper there was the shame-faced admission from a marketing executive who had bought *Valium*, that when he took the 'distinctive tube' into a framing shop the shop assistant burst out laughing and admitted that he had already had eight *Valiums* to frame in that week. The same thing happened to me when I took along my poster of Simon Patterson's *The Great Bear* – his witty and, I thought, cultish reworking of the London Underground map, with famous names replacing stations – to be framed.

Eyestorm.com and its rivals britart.com and Counter Editions, which all sell editions of contemporary art, have invented the perfect formula. Suddenly, contemporary art is easily and readily available on the streets. Well, to be more accurate, on your limited edition graphite iMac, but the analogy is there. Buying Culture on the Web has been likened to the great Internet revolution in share

broking, only with art instead of money. 'It's about getting blue chip art out of the galleries and into people's homes. "Over the sofa" is a phrase we use a lot,' says eyestorm's Head of Special Projects, Heidi Reitmaier. 'We want to get art over the sofa.'

So do the rest of them. The market for British art is now as accessible as the art itself. Britart.com sells paintings as well as prints from the likes of Eduardo Paolozzi and Peter Blake, while Counter Editions has a huge roster from most of the YBA generation, from Emin to Turk via Ofili. Artwork which in its original form could sell for nearly £100.000 can be snapped up in a decent reproduction for £300. It was reported that Counter Editions sold 100 editions of a Gary Hume print in less than five hours.

Eyestorm not only sells a vast array of artworks from a vast list of contemporary artists – Hirst, Jeff Koons, Darren Almond, the ubiquitous Tim & Sue, etc – but it also provides information on art, sponsors events and has high 'terrestrial' visibility. Its product appears to be popular. It has 70,000 'visitor sessions' a month, with apparently a 1% conversion rate from visitor into purchaser. Head of UK Content Judith Nesbitt says that in the site's first year it made 1.5 million sales. 'We try to close the loop between the education you can find in public galleries and the art you can buy in private ones. The idea is that eyestorm.com is a parallel world to the existing gallery sector.' With the same charges: like most dealers, eyestorm takes a 50% cut of any art sold.

Mindful perhaps that you can't simply expect to sell limitless ranges of prints and keep people satisfied, eyestorm is ambitious for more. Its Special Projects unit produces ranges of special editions to be sold on the net: screensavers, badges and posters. It works with artists like FAT to provide merchandise which is then marketed through hangouts like Coffee Republic. Eyestorm knows its target market – the *Valium* market – is not only able to surf the net but hangs out at bars and cafés, and would like to wear badges produced by artists. Because art is fashionable and glamorous and famous. 'These new coalitions are very important,' says Reitmaier. 'They indicate to the user how sophisticated they are. People feel they are participating in the contemporary culture that is on the

pages of the magazine before them, which they are reading as they drink their latte in Coffee Republic.' It's enough to make your head spin.

Eyestorm has just done an exclusive deal with the Magnum photographic agency. It is speaking to the Warhol Foundation. It is talking about an animated film with Paul Noble. The curator Hans Ulrich Obrist is preparing an extraordinary project called 'Do It', wherein fifty artists have written instructions on how to make an artwork. 'You download the instructions,' says Nesbitt. 'You make the artwork and we will send you a signed sticker for $100. So if you have downloaded Yoko Ono's *Wish Tree*, and made it, you can have a limited-edition Yoko Ono piece in your home.' Which would go perfectly with your Ron Arad Book Worm bookshelf or your Jasper Morrison Low Pad chair, as seen in Tate Modern. See how it all fits together? Eyestorm is even preparing to broadcast art videos when broadband becomes a reality. So you can have a Damien Hirst wobbling away on your plasma screen when people come round for tea. It's the way forward; the artists in the Tate's 'Art Now' programme of spring 2001 were all involved with online work, accessing turbulent on-line financial trading, playing with computer graphics and intervening in existing sites.

Back to the over-the-sofa art. Don't the artists mind that they might become as ubiquitous as ... as an Athena poster? 'Artists want audiences. And they want as big an audience as possible,' says Nesbitt. They probably wouldn't even mind the Athena tag, as long as it doesn't diminish the market for their bespoke work. For, as the artist Richard Wentworth so acutely and accurately explains, the thirty-something YBA vision was itself curated originally by Athena, and Benson & Hedges, and all that fantastically intricate advertising which blossomed in the late '70s, when the retina of the average YBA was a veritable sponge in the eye of a curious teenager.

'It isn't an accident that when Damien Hirst and the others were young, punk was the excitement of their day,' says Wentworth. 'They grew up with a punky government, which was Thatcher. And the wallpaper of their teenage years was Benson & Hedges Gold, that high street surrealism which itself came from record labels.' Of course. All those Pink Floyd pyramids, and cigarettes

raining down on umbrellas, and fag boxes shooting out of fireplaces. 'It was a text-book popularising force. It was Magritte in popular form. Because cigarette posters couldn't show people smoking, they pillaged easy, late Surrealism. It was the moment that photography in posters really took off, when illustration in advertising almost ceases.'

So now we all want to have these things in our homes, these cod-B&H posters, the brands of art which show how in touch we are. 'There is now a huge mass market available for art, probably because wealth is more democratized,' says Wentworth. 'If you can imagine the old pyramid where the wealth was at the top, well, a giant hand has come and squashed that pyramid down, so there is now a huge bulge, like a gut in the middle. And you need stuff to fill that gap. That is all that has happened. I am not being snooty or over-protective, but the real artists, real tastemakers, have fled that space. They may all have Muji notebooks, but they are not full-time subscribers.'

He might be right. Perhaps pure art, unmediated through the calming pages of *Elle Deco* or the reassuring Amazonian experience that is eyestorm.com, is too prickly for our sitting rooms. Earlier this year *Changing Rooms* featured curator and artist Laura Godfrey-Isaacs, whose salon 'home' has been discussed. With her was fellow performance artist Joshua Sofaer. The union of home-making TV and artists for whom domesticity is a key issue should have been perfect. In the event, although the show had invited Godfrey-Isaacs on, it was not a particularly happy one. The presenter and designers referred to their guests as 'artists' (quote, unquote), 'creatives' or 'luvvies'. Forget sponging and stencilling. All that was being created here was a distinct *froideur*.

I am at a conference called 'The Future of Art' which is run by the consultants Wolff Olins. They have a fantastically fashionable office right on Regent's Canal in London. Head honcho Wally Olins stands up and gets us all going. 'In America many train companies went bust, because they couldn't understand the meaning of the highways which were being built right alongside them. Are there similar artistic highways being built right now alongside the train tracks which we are simply not seeing?'

Andrew Brighton, senior curator at Tate Modern gets up and says that since 1800 there have been many different kinds of art, 'all of which are being practised at the moment. But what is being attended to?'

Probably all the wrong things. Everyone is desperate to find the next big Emin, the next wave of Hirst. On-line, digital, video art; each advance has been picked up, examined and put down again. So has the advent of contemporary art on peak time meant that the art itself has actually, well, peaked? I go back to Matthew Higgs's suggestion that the opening of Tate Modern was actually the moment that the curtain came down on the great, grand British contemporary art phenomenon.

'I am on record as being pessimistic about British art,' he agrees, pessimistically. 'The inevitable international backlash about British art has begun. The international art world is moving its spotlight to Scandinavia. No one knows why.' According to Higgs, the thing to think now is local. 'Everywhere from LA to New York to London, art all looks the same. Everything is produced in editions. The same galleries are showing the same work. You could talk about British art, but I think the local is ultimately the territory that is the thing to be recovered. You can only be in one place at one time. Everyday life is quite mundane, and that itself is quite exciting. You return to the basic things of life.'

'This town thing, it covers lots of angles,' says Paul Noble, inventor of Nobson Newtown. 'It's about peripheral experiences of the city as well. If you haven't got much money you get used to not going into the town centre. I cycle around the town centre.' Having won a £20,000 award he might possibly change his ways, but it is a good analogy all the same: while the curators and galleries and shops peddle art in the centre, the artist pedals around the outside.

A certain backlash has indeed already begun. Already critics are complaining about gallery directors being overly concerned with visitor numbers and monumentality, at the expense of the true art experience. Lottery pay-outs have certainly increased the amount of big foyers and spectacle, and there are of course the budgetary necessities of restaurants and gallery shops which must be negotiated before a whiff of art is sensed.

Yet why this should be something to criticize is not clear. It is wholly fitting that public money, in the form of Lottery grants, be used to encourage the public to go to the institutions to whom it is given. Nationally owned art ought to be enjoyed by the nation. 'Bored' critics, slamming Tate Modern for encouraging five million people to turn up in its first year, are also suspiciously typical of the British aptitude to find fault. I don't recall the French criticizing the directors of the hugely popular Musée d'Orsay for hanging *Olympia* in a train station.

However you view the new breed of super galleries, the art is still there. A Monet *Waterlilies* is as beautiful hanging in its quiet gallery at the sparkly Bellagio Casino, Las Vegas, as it would be if transported to the columned solemnity of the Frick Collection, New York. It certainly shows its charms to a different but equally attentive section of the public, which is no bad thing.

And if the collections at the latest Guggenheim or Tate franchise are considered below standard, there are always the tried and tested favourites: the National Gallery in London, the National Galleries of Scotland or the British Museum. Which, on a weekday morning or a late-night opening, are not the crowded shopping malls the nay-sayers would like to have us believe they are.

In the meantime, contemporary art will continue as it must – contemporaneous to our lives. Artists have been affected by the mighty faces of media, money, merchandise and museums turning on to them, like a quartet of vast suns. Should the light start to shine onto something else, artists will not wither away. They will just attract less fuss. Although the light has been so strong, I doubt an eclipse will happen for a long time, and if it does, whether it will ever be a total one.

This book gives a snapshot of contemporary British art, of a time when it coincided truly and accurately with the yawning centre of society, with the streets and the bankers, the shops and audiences, with peak-time programmes and the Sunday supplements. It may continue to intrigue and delight this centre ground. It may not. Either way it will keep moving – a visible or sometimes invisible highway – running alongside the train tracks.

PEAK TIME

# INDEX

Figures in *italic* refer to illustrations